IN THE
NOUVEAU
STYLE

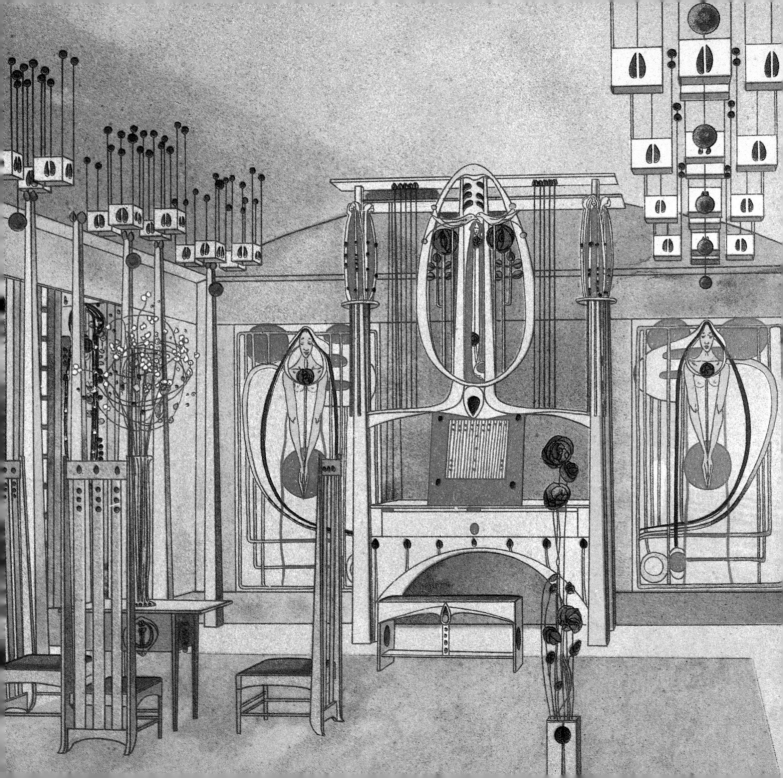

IN THE NOUVEAU STYLE

MALCOLM HASLAM

With 315 illustrations, 160 in colour

THAMES AND HUDSON

Typeset in Linotype Goudy Old Style

Printed and bound in Singapore by C. S. Graphics Pte Ltd

FRONTISPIECE
**Detail of a lithograph showing a perspective view of a music room for the
House of an Art Lover, part of Charles Rennie Mackintosh's entry for a
competition organized in 1901 by Alexander Koch, editor of a
Darmstadt decorative arts journal.**

CONTENTS

Anthropomorphism is an element of the Art Nouveau style which has been revived by several designers in recent years. Traces of the furniture created by Antoni Gaudí at the turn of the century, which had already inspired Carlo Mollino during the 1940s, are apparent in Roberto Lazzeroni's 1988 chair for Ceccotti (*right*). The same line of descent is acknowledged by the Spanish designer Oscar Tusquets Blanca who gave the name 'Gaulino' to a 1988 chair (*below*).

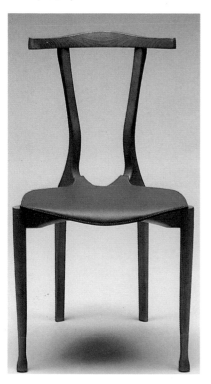

In all the mass of publications about Art Nouveau which have appeared over the last two or three decades, there has been no attempt to describe one very important aspect of the style: its continuity. Art Nouveau has always been treated as a historical phenomenon, which flourished at the turn of the century and had withered and died by the time World War I began. But the ideas behind the style are permanent, and the philosophy lying beneath the surface of Art Nouveau has persisted through many transformations to the present day. This book is an account of those transformations.

The Art Nouveau style, in its various forms and at various levels of sophistication, has been a recurring phenomenon of twentieth-century culture. Whenever artists and designers have felt the same aspirations and restraints which affected the creators of Art Nouveau, some if not all of the forms and motifs which first achieved currency in the years around 1900 have made a reappearance. Not only general characteristics such as an arrogant originality and a subversive defiance of all conventions – whether artistic, social or moral – but even motifs as specific as flowing hair and writhing vegetation have recurred throughout twentieth-century art and design. The Surrealism of the inter-war years, the organic Modernism of the mid-century, the hippy art of the Sixties and some of today's Post-modernism have roots in the decorative arts and architecture of the period around 1900; the visual and stylistic vocabulary of the later movements owes a distinct debt to Art Nouveau.

It is often more effective to look at style as the product of contemporary feelings and opinions rather than as so many links in a historical chain. Art Nouveau has often been shaped by historians and critics to fit into a predetermined historical pattern. If certain aspects of the style have been found inconvenient in the context of the unfolding Modern Movement, such as the seductive nymphs lying voluptuously beside inkwells or crouching timorously in the corners of mirror frames, then they have usually been ignored. The significance and symbolism of the frogs, mushrooms, dragonflies, lilies, trees and all the other flora and fauna which adorned everything from jewellery to architecture were suppressed, and the greatest prominence given to abstract curves and geometrical figures. Other aspects of Art Nouveau which have never tallied with its role as the herald of the Modern Movement are the emphasis which many of its leading practitioners put on handwork rather than machine production, and the insistence of many others on individual creativity rather than the standardization of style called for by early Modernists such as Walter Gropius and Le Corbusier.

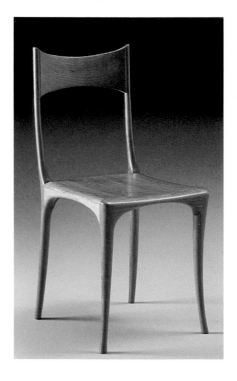

When one begins to consider every aspect of Art Nouveau, elements emerge which help to explain not only the appearance of the style at the turn of the century but also its subsequent manifestations. One characteristic, for instance, was opposition to the Classical tradition which had reigned supreme in western art almost unchallenged since the Renaissance. During the second half of the nineteenth century some designers and artists began to distrust the noon-day clarity that the rules of Classicism demanded; it seemed inappropriate in a post-Darwinian world where the existence of God was widely doubted and where hints of the darker side of the human psyche had begun to appear. The artists and writers of the *fin de siècle* preferred the mystery of dawn or dusk to the broad light of day. They favoured the soft illumination of the moon in which, as Oscar Wilde wrote, 'One could have said that silver and shadow had fashioned the world anew.' It is a similar pale light that the Surrealist writer Louis Aragon admired, some thirty years later, in the covered arcades of the Passage de l'Opéra in Paris; using imagery which is a powerful evocation of Art Nouveau, Aragon wrote (in *Le paysan de Paris*): 'The whole fauna of human fantasies, their marine vegetation, drifts and luxuriates in the dimly lit zones of human activity, as though plaiting thick tresses of darkness.'

This was written in 1924, just a year before Paris hosted the international exhibition which marked the triumph of Art Deco. The Surrealists, however, were more in tune with the obscure nuances of Art Nouveau than with Art Deco's gleaming frankness, and when Aragon came to review the exhibition he suggested that it should all be blown up.

Turning their backs on Classical art, the artists who created Art Nouveau sought inspiration in nature. The flower was the motif probably used more than any other for the style. Poppies, roses, irises, orchids, cyclamens, fuchsias and lilies were among the blooms most frequently depicted. They covered the façades of buildings and grew out of pieces of furniture; they were found on glassware and pottery; they were cast in bronze and carved in wood. Indeed, one of the names given to Art Nouveau in Italy was *Stile Floreale*. During the 1960s another generation expressed its longing for a friendlier, gentler world by again resorting to floral motifs. The graphic art created by the hippies, which owed so much to Art Nouveau, was an expression of the cultural energy called 'flower power'.

Art Nouveau designers tried to convey a feeling of the dynamic forces in nature, unlike their predecessors who had tended to use plants, birds and animals as static forms arranged in regular patterns.

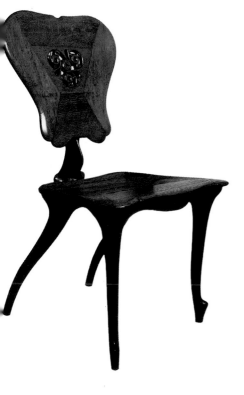

The chair which the Spanish architect Antoni Gaudí designed about 1900 (*below*) inspired the Italian designer Carlo Mollino who created the other chair (*right*) in 1944.

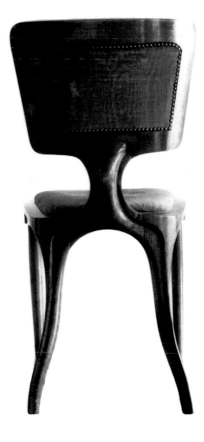

Recognizable only as plant-like forms, the stands grow out of the buffet designed by Hector Guimard.

Fin-de-siècle artists expressed a new attitude to nature, which had been formed as a result of Darwin's theory of evolution through natural selection. Half a century later, designers again turned to science to supply them with themes and motifs through which they could express a contemporary perception of the natural world. The organic Modernism of the 1940s and 1950s reflected advances in biochemistry and nuclear physics which were being made at the time. Furniture designers and glassmakers in particular created a biomorphic style that was often very reminiscent of Art Nouveau.

One of the forces of nature which much preoccupied the *fin-de-siècle* mind was sexuality, both in its physical and its psychological aspects; the year of the Universal Exhibition in Paris, 1900, was also the year of the publication of Sigmund Freud's *Interpretation of Dreams*. During the 1930s the Surrealists, who sought to investigate and analyse their hidden desires, were the first artists to revere and revive many dominant aspects of the Art Nouveau style. Among the more significant features of hippy culture was sexual permissiveness, and a kind of psychedelic Art Nouveau became a decorative style of the late 1960s. In the west, sexuality has always been stressed by rebellious intellects because such emphasis tends to upset a civilization which only manages to maintain its equilibrium and smooth running through a systematic repression of the libido.

An aspect of western civilization which the rebellious spirit finds particularly odious is its materialism. People are surrounded by their possessions, and a person's status is often judged by the size and solidity of his or her house and furniture. This has affected the various manifestations of Art Nouveau at two levels. First, it has influenced the dimensions and proportions of furniture. Chairs and tables designed by, for instance, Georges de Feure during the 1890s and Ernest Race during the 1940s have an appearance of weightlessness; they look as if they might become airborne at any moment. The second, more profound, effect of western society's materialistic standards on many twentieth-century designers has been a mystic, visionary quality in their work. From the *japonaiseries* in art and design at the end of the nineteenth century to the Zen Buddhism of Sixties psychedelia, both the original Art Nouveau and its revivals have often drawn on the spiritual values of eastern art.

Art Nouveau, in its various manifestations from 1890 to 1990, has always made much the same comments on how people are thinking and dreaming. Those that find the style objectionable should perhaps ask themselves what it is that they do not want to hear.

The German artist Rudolf Altrichter's political propaganda poster of 1965, with its schematic depiction of hands, represents the geometrical version of the Art Nouveau revival prevalent among graphic designers of the 1960s.

A primary concern of designers working in the Art Nouveau style has often been to disturb, or even shock, the public. This has sometimes been achieved through the impact of visual novelty, sometimes by deliberately flouting moral conventions. In the three examples shown here, the artists have exploited both means at the same time. Liane de Pougy, the subject of Paul Berthon's 1898 poster for the Folies Bergère (*far right*), was among the most notorious of Parisian courtesans; the orchid, with its erotic connotation, underlines the designer's message. The Surrealists adopted many of the elements of the Art Nouveau style. They too used the female body and overt sexual imagery as a means of disturbing the spectator. Max Ernst painted *The Robing of the Bride* (*right above*) in 1939. Some thirty years later, Bob Massé designed a poster for a pop concert at the Kitsilano Theatre, Vancouver (*right below*) and again used sexual imagery to make an impact. The style of this poster is the revived Art Nouveau which was widely used by 1960s graphic designers.

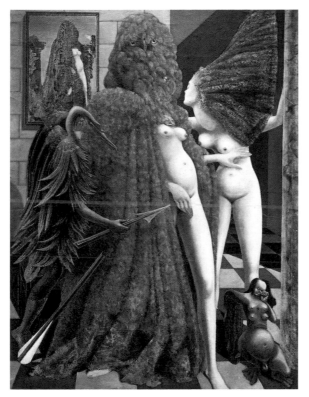

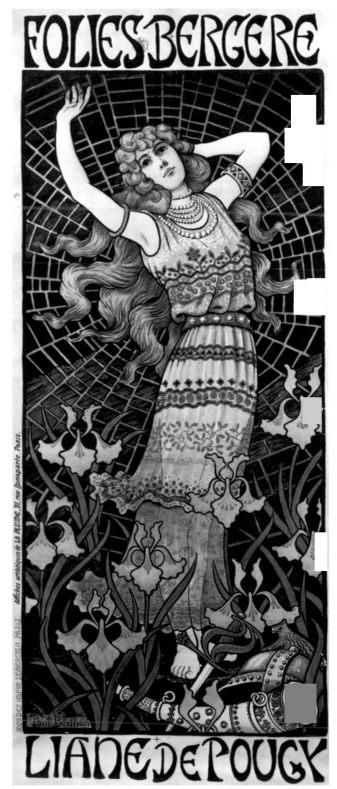

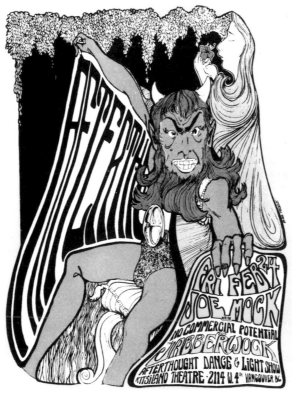

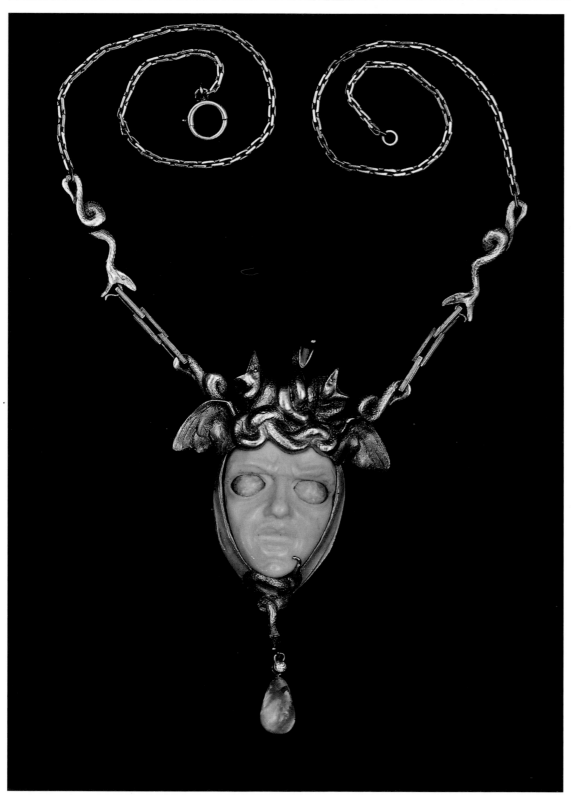

Art Nouveau was not only dispersed around the globe, it has also continually recurred through the last hundred years. The gold and opal Medusa's head pendant (*left*) was made by Philippe Wolfers in 1898, seventy years before Andrew Grima created his gold and opal brooch (*below*). Apart from using the same combination of materials, both jewellers have based their designs on curved forms.

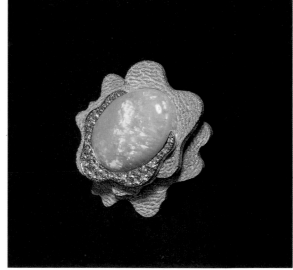

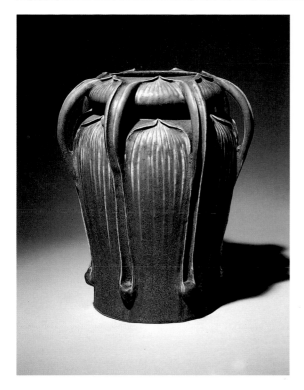
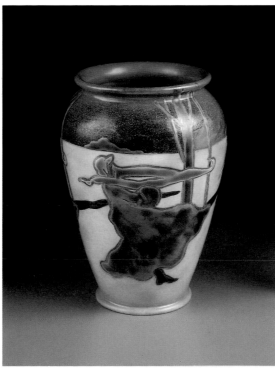
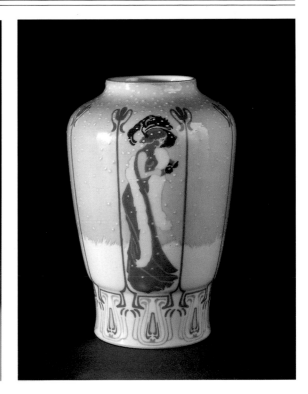

These four vases, all made within a ten-year period, show how international the Art Nouveau style quickly became. The two decorated with muffled ladies were made in France and Hungary. The French vase (*above right*) was designed by the Dutch artist Georges de Feure and made in Limoges; the Hungarian one (*above centre*) was designed by the artist Josef Rippl-Rónai and made in Pécs by the Zsolnay pottery. Of the two vases with floral decoration, one was made by the Grueby Faience Company in East Boston, Massachusetts (*above left*) and the other, modelled by the Belgian sculptor Philippe Wolfers, was manufactured by the French potter Emile Müller in Ivry, France (*right*). The rapid dissemination of Art Nouveau designs and motifs was due to improving communications and the wide distribution of a plethora of books and magazines devoted to the new style.

Art Nouveau designers frequently used a language of abstract shapes based on biological forms. The pewter tea service made by the German firm of J.P. Kayser & Son about 1900 (*right*), the etching by the Surrealist artist Kurt Seligmann of about 1935 (*below right*) and the steel sculpture by the American Theodore Roszak (*below*) of about 1960 all share a common derivation from natural forms without representing any specific plant or animal.

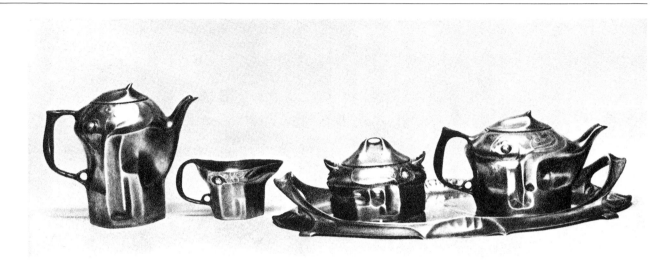

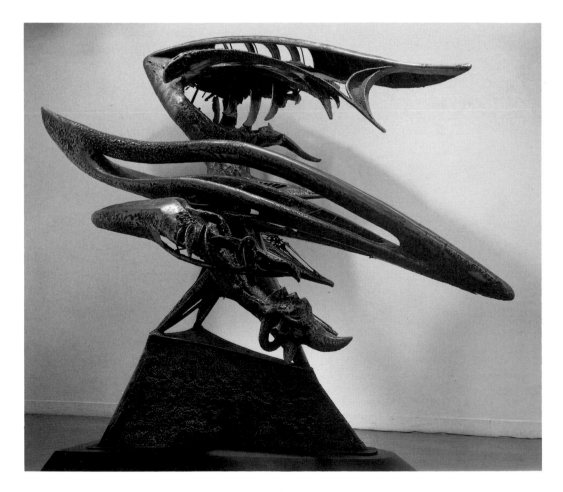

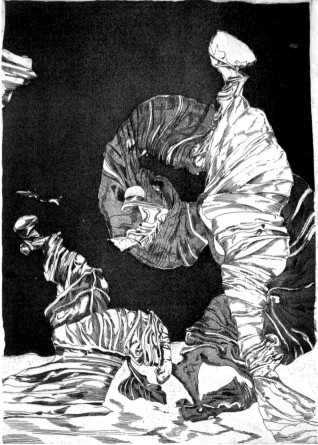

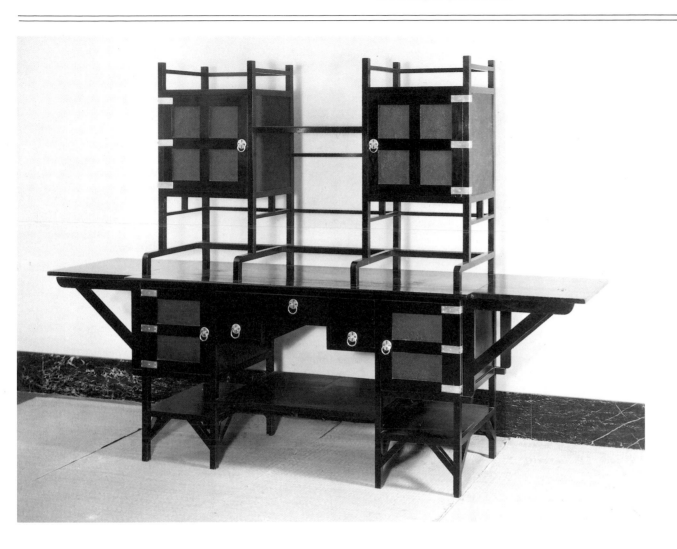

The austere geometry of much Art
Nouveau design was as original and
revolutionary as the swirling,
convoluted version of the style. The
sideboard designed by E.W. Godwin in
1877 (*above*) was influenced by
Japanese design, just as were many other,
more curvilinear pieces of early Art
Nouveau. Similarly, the chair designed
thirty years later by the Austrian
architect Josef Hoffmann (*right*) was
intended as a statement of disgust with
contemporary bourgeois taste, just as
were the floral and animal forms used by
other Art Nouveau designers.

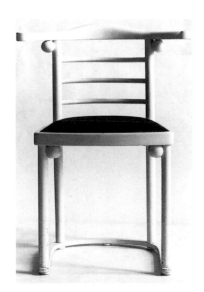

Plant forms dominated much of Art Nouveau. They are found across the whole range of media and with many different functions. The mushroom lamp designed by Emile Gallé (*right*) presents the plant with a high degree of realism. The book illustration by Walter Crane (*opposite left*) and the lamp by Leo Laporte-Blairsy (*below centre*) show flowers, lilies and chrysanthemums respectively, together with their female personifications, a common theme in Art Nouveau decoration.

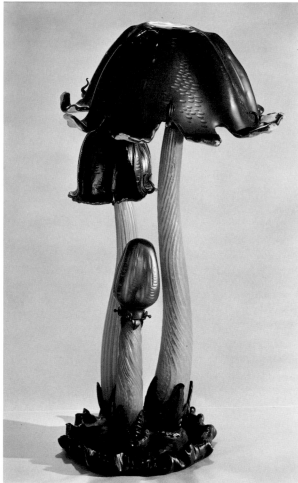

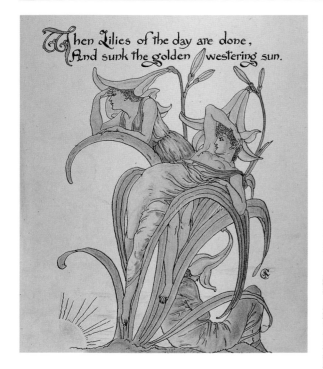

When Lilies of the day are done,
And sunk the golden westering sun.

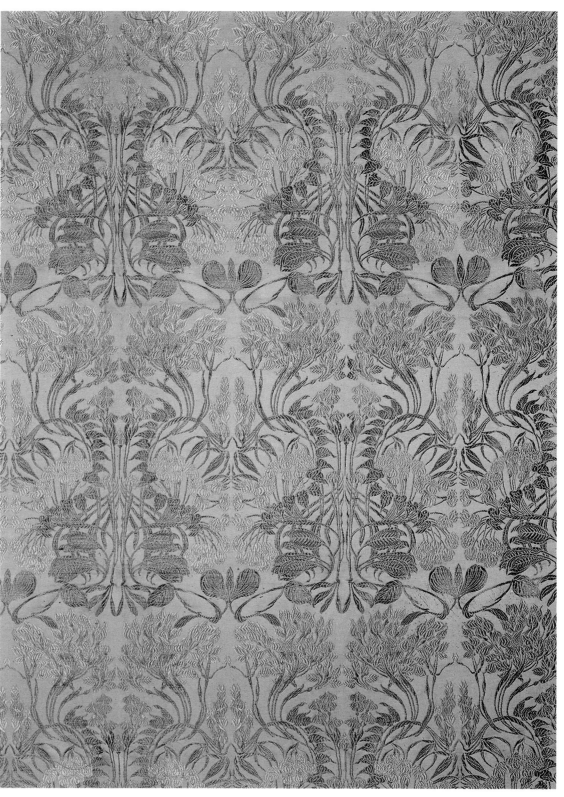

In the textile designed by Georges de Feure (*right*), flowers have been more formally arranged to make a pattern, and on the vase by the American potter Artus van Briggle (*opposite left*) they have been so conventionalized that they are hardly more than decorative shapes.

A NEW STYLE

Like all significant styles in the history of taste, Art Nouveau embraced a wide selection of disparate elements. It arose at the end of a century that had seen momentous upheavals in religious, scientific and political thought. The generation reaching maturity between 1890 and 1900 demanded a style which expressed both moral anxiety and a new vigour in the arts and design.

One style which no longer seemed either adequate or apt as an expression of the age was the Classical. Its clarity mocked uncertain minds and its prestige was as questionable as the authority of church or state. In 1884 Henri de Toulouse-Lautrec painted a parody of a work by Puvis de Chavannes called *The Sacred Wood* which showed Classical maidens in an Elysian landscape. In Lautrec's version the maidens were less ideally proportioned and less modestly robed; he introduced into the hallowed grove a line of his more raffish friends, with a gendarme keeping a supercilious eye on them. Puvis' vision of Classical serenity had been transformed into a depiction of modern-day libertinage. Such an assault on the conventional verities became a hallmark of *fin-de-siècle* art and literature.

Without the Classical canon to determine the appearance of everything from public monuments to domestic furnishings, designers and consumers tried every other style known to them, whether from ancient times, such as Egyptian and Assyrian, distant places, such as the Far East, or from sources closer to home, for example folk art, and of a more recent vintage, for example rococo. All these styles and many more had their adherents during the nineteenth century, but unfortunately little attention was paid to matching them in the setting of a room or even in the design of a single object. A drawing-room might contain examples of half a dozen different styles; a coal scuttle, decorated with Elizabethan strapwork, might stand on Louis Quinze scroll feet.

Max Nordau's *Degeneration* was among the best-selling books of the 1890s. It was first published in Leipzig in 1892 and translations into French and English followed within three years. The book is a sweeping indictment of contemporary culture. Nordau criticizes the current mania for outlandish effects in interior decoration and describes the rooms of a typical home: 'Here are at the same time stage properties and lumber-rooms, rag-shops and museums. . . . All is discrepant, indiscriminate jumble. The unity of sticking to a single, definite historical style is considered old-fashioned, provincial, Philistine. . . .'

'The study of the master of the house,' wrote Nordau, 'is a Gothic hall of chivalry.' During the nineteenth century there had been a

widespread revival of the Gothic style. Many of its elements tended towards Art Nouveau; for instance, the sinuous lines of tracery, the incorporation of figures – often grotesque – into structure and the reverence in which the style held the works of nature. It was often counted as the antithesis, if not the antidote, to Classical art, and during the nineteenth century there were many artists who considered that the triumphal progress of Gothic art had been rudely interrupted by the imitation of Greek and Roman antiquities at the time of the Renaissance. The Catalan architect Antoni Gaudí, whose buildings in Barcelona were among the earliest instances of Art Nouveau anywhere in Europe, lamented that the 'sublime' Gothic had been halted by the 'deplorable' Renaissance. 'Today,' he said, 'we must not imitate, or reproduce, but continue the Gothic.'

In England the Gothic revival in architecture which had been initiated by A.W.N. Pugin during the 1830s was complemented by the paintings of the Pre-Raphaelite school. Its very name suggests scorn for the Renaissance and admiration for the art of the Middle Ages. One of the Pre-Raphaelites, Dante Gabriel Rossetti, introduced into his paintings an element of obsessional eroticism which was to become characteristic of much Art Nouveau. Although his disciple Edward Burne-Jones never expressed in his work the same degree of simmering sexuality, the languorous female figures and the writhing vegetation he depicted were to be widely imitated during the Art Nouveau era. The same thick, twisting vegetation was incorporated by Burne-Jones's closest friend William Morris into his textile and wallpaper designs. Morris stated that the aim of textile design was 'to combine clearness of form and firmness of structure with the mystery that comes of abundance and richness of detail', an assertion echoed by many Art Nouveau designers.

In France the principal evangelist of the Gothic style was the architect Eugène Viollet-le-Duc who wrote many books on the subject and taught for a time at the Ecole des Beaux-Arts in Paris. He was soon dismissed for his anti-classical opinions, but his heterodoxy had taken root among a generation of young artists. One of his most strongly held views was that the fine and applied arts should have equal status, and his loyal disciple Anatole de Baudot was appointed in 1887 to teach the history of French architecture at the Ecole des Arts Décoratifs. The popularity of Gothic among art students in Paris during the 1880s is shown by the number of *café-concerts* which were being decorated in the style. Eugène Grasset, who became one of the leading Art Nouveau designers in Paris, contributed to the decoration of the café called Le Chat Noir a design for a wrought-iron

The Dutch artist Richard N. Roland Holst made this lithograph in 1892 to illustrate a catalogue of paintings by Vincent van Gogh. Its symbolism commemorates van Gogh's obsession with the forces of nature, shared by many of the pioneers of Art Nouveau.

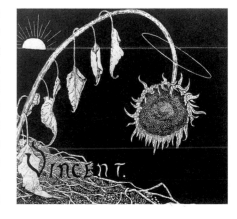

lantern adorned with gargoyles in the form of snarling cats. The attention of the young Parisian designers had been drawn to the grotesque carvings on Gothic buildings by the extensive restoration of the cathedral of Notre-Dame, then being carried out under the supervision of Viollet-le-Duc. The grotesque did become a significant ingredient in French Art Nouveau, featuring strongly in furniture designed by François Rupert Carabin and pottery by Jean Carriès.

Nordau berated Oscar Wilde for his 'hysterical craving to be noticed' and mocked his 'queer costumes which recall partly the fashions of the Middle Ages, partly the rococo modes'. Towards the end of the nineteenth century, both styles attracted people who wished to convey their adherence to a modern outlook. In his description of a fashionable drawing-room in the early 1890s Nordau included 'an inlaid writing-table of graceful rococo', from which it is only a short step to the furniture of Emile Gallé. In some areas of Europe where rococo had flourished in the eighteenth century, the artists and designers who created Art Nouveau took up asymmetrical arrangements of scrolls and arabesques characteristic of the eighteenth-century style. For example, the town of Nancy, where Gallé worked, was rich in rococo masterpieces, and much of the ornament he designed for his early china and glass was in a neo-rococo style. In Germany during the 1890s a style known as the Third Rococo was popular, and it is reflected in the work of the Munich designers Bernhard Pankok and Hermann Obrist. Munich at that time was still dominated by the magnificent rococo buildings which had been designed by the French architect François Cuvilliés.

In 1874 the French writer J.K. Huysmans entitled one of his early prose poems *Rococo japonais,* thus neatly bracketing two styles which significantly influenced Art Nouveau. To many artists' minds, Japanese art had one valuable characteristic in common with Gothic; it was ignorant of the Classical-Renaissance tradition. The English architect William Burges who organized the Medieval Court at the International Exhibition of 1862 in London was very impressed by the work displayed in the Japanese Court; he called it 'the real mediaeval court of the exhibition'.

There were many aspects of Japanese art which made an impact on western taste and helped the formulation of some of the major characteristics of Art Nouveau. One was its penchant for the grotesque, another feature which it had in common with Gothic. In the imaginary study which Nordau described as 'a Gothic hall', he placed on the mantelpiece 'fierce or funny Japanese masks'. Its asymmetry was perhaps the most influential aspect of Japanese art. For instance,

This iron and copper grille was designed by the American architect Louis Sullivan for an elevator in the Chicago Stock Exchange, built between 1893 and 1894. The rationalist aspect of Gothic design, which Sullivan had assimilated while studying at the Ecole des Beaux-Arts in Paris, is detectable in his ornamental style.

ceramics produced during the 1880s in factories as far apart as Cincinnati and Copenhagen were decorated with asymmetrical arrangements of animals, birds, insects and flowers, in the Japanese manner. Traditional perspective, too, was ignored by the artists of Japan.

Western designers were impressed by the use of geometrical decoration in Japanese art. The *daimio* (circular badges), which either featured flora or fauna represented in diagrammatic form, or were completely abstract geometrical compositions, were a significant contribution to the Art Nouveau designer's vocabulary. Japanese architecture, which is largely rectilinear, affected the work of many European and American designers, and was an important source of inspiration for the geometrical version of Art Nouveau which flourished especially in Vienna, Glasgow and Chicago. In 1888 Siegfried Bing described Japanese art as an '*art nouveau*' and he used the same phrase for the title of the shop he opened in 1895 for the sale of western decorative art in the avant-garde style.

Gothic, rococo and Japanese were three major sources of stylistic devices, then, which contributed to Art Nouveau, but there were other influences at work which were outside the realms of art and design. During the nineteenth century, the tenets of Christianity, which had dominated religious belief in Europe for nearly two thousand years, began to be undermined by scientific discoveries. First geology, and then biology, called into question the truth of the biblical account of how the universe had been created. As faith in God withered, people started to put their trust in science which seemed to be so omnipotent and beneficial. A philosophy was founded, called positivism, which held that every aspect of human behaviour and experience should be submitted to the logic of scientific method.

Positivism affected Art Nouveau at two levels – the intellectual and the visual. The philosopher and historian Hippolyte Taine, who became professor of aesthetics and the history of art at the Ecole des Beaux-Arts in succession to Viollet-le-Duc, claimed that it was illogical to accept any ideal in art, and asserted that each generation, existing in its own environment during its own era, will always have its own artistic preferences. Taine published his *Philosophie de l'art* in 1865 and *De l'idéal dans l'art* two years later, and both books were widely read over the next twenty-five years and strongly influenced most of the future masters of Art Nouveau who were about twenty years old in 1889. Among Taine's students at the Ecole des Beaux-Arts were such prominent and influential artists as Louis Majorelle, Hector Guimard and the American architect Louis Sullivan.

Antoni Gaudí built the Güell palace in Barcelona between 1885 and 1890. The parabolic arches of the entrance and the whiplash wrought-iron ornament are among the earliest instances of Art Nouveau decoration.

The visual stimulus to Art Nouveau provided by positivism came from the scientific research carried out in support of the new theory of evolution. Followers of Darwin, such as Thomas Huxley in England and Ernst Haeckel in Germany, investigated the area of marine biology and made detailed studies of the protozoa, the most primitive forms of life. Haeckel, who taught at the University of Jena, produced a series of monographs on various submarine species, which he illustrated himself. According to one contemporary critic, Haeckel's drawings 'display inborn artistic talent', and designers such as Hermann Obrist (who had himself studied biology), August Endell and the French architect René Binet were all indebted to the German scientist's illustrations. A.H. Mackmurdo, an English architect and designer, was a firm believer in Darwinism, and his chair of about 1882, one of the earliest Art Nouveau designs anywhere, is decorated with fretwork depicting seaweed and protozoa.

In 1889 the French writer Charles Morice claimed that science had obliterated all sense of mystery. 'With the same stroke of the pen,' he declared, 'she had expunged the words beauty, truth, joy, humanity.' Morice was a supporter of the Symbolist poets whose tendency was to regard poetry as a means of transcending reality; they considered that words themselves possessed magical properties. Their aim was to suggest, but never to specify or describe, states of mind. Although antithetical to science, Symbolism also exerted considerable influence on Art Nouveau. In 1891 Stéphane Mallarmé wrote: 'The symbol is the perfected use of this mystery, namely, to conjure up an object gradually in order to show the condition of a soul; or, conversely, to choose an object, and out of it to reveal a state of the soul by a series of interpretations.'

Much of Art Nouveau was literally designed 'to reveal a state of the soul'. Emile Gallé, who counted several Symbolist poets among his personal friends, made glass vessels which were intended to express a mood – joy, calm, melancholy or conflict. Sometimes he carved a line from a poem by Hugo, Baudelaire or one of the Symbolists to help convey the emotion he was trying to create. Charles Rennie Mackintosh created a music-room for Fritz Waerndorfer in Vienna which was decorated with a frieze of gesso panels inspired by Maurice Maeterlinck's *Seven Princesses*. So close was the kinship between Symbolism and Art Nouveau that sometimes the current of influence flowed in the reverse direction; for example, a ring by Lalique plays a significant role in Jean Lorrain's novel *L'Aryenne*.

Affinities between the different arts were assiduously explored by the Symbolists. They inherited from Richard Wagner the notion of

Although this 1853 design for a window by John Everett Millais was never executed, it signposted several elements of the future Art Nouveau style – for instance, the sweeping curves of Gothic tracery, the incorporation of the female figure into the structure, and a mild eroticism.

the total work of art which combined music, poetry, painting and sculpture, and the principal journal published by the Symbolists in Paris during the 1880s was called *La Revue wagnérienne*.

Instances of the influence of Wagner's music-dramas on Art Nouveau designers are myriad. The Munich artist Otto Eckmann designed a tapestry illustrating a scene from *Die Meistersinger von Nürnberg*, the Spanish jeweller Lluís Masriera made an elaborate pendant to commemorate the first performance of *Tristan und Isolde* in Barcelona, and Aubrey Beardsley drew illustrations to *Siegfried*. Perhaps the most impressive of all Art Nouveau monuments to Wagner's music would have been the shrine that the Princesse de Scey-Monbéliard wanted to build for the score of *Parsifal*, of which she was the proud owner. The project was never completed, but some of the stoneware tiles intended for the principal doorway were executed by the potter Jean Carriès, each one modelled with a grotesque human head in high relief.

Wagner provided Art Nouveau with one of the style's most prevalent motifs – the maiden in the form of a flower. The scene in the second act of *Parsifal*, where the hero resists the charms of the flower-maidens who try to seduce him in Klingsor's magic garden, seems to have made a deep impression on the susceptibility of the late nineteenth-century middle-class male. Art Nouveau designs for a wide range of objects from hand-mirrors to lamps incorporate girls emerging from flowers, girls as flowers or girls turning into flowers.

The French writer Joséphin Péladan, who called his novels 'wagneries', expressed in *La Victoire du mari* (The Husband's Victory, 1889) the strong sexual passions which Wagner's music aroused in him and, no doubt, many of his contemporaries. He describes how the audience at a performance of *Tristan und Isolde* is made to 'pant and writhe with lust' by the music and drama which are a 'whiplash' to the heart and senses. Two years later Georges Seurat painted *The Circus*; the artist has carefully given prominence to the rippling line of the ring-master's whip. The swirling curve of the whiplash assumed a great significance during the 1890s and became almost a hallmark of Art Nouveau. When Hermann Obrist exhibited his tapestry depicting – quite clearly – a wild cyclamen plant in 1896, it was immediately dubbed 'the whiplash' by the critics. Earlier, the American painter Elihu Vedder had frequently used the motif of a swirling double curve which for him symbolized the concentration of the paradoxical elements that combine to form life. Vedder took this swirling line from the designs of William Blake, which had also had some influence on Rossetti and Burne-Jones.

When artists depicted the American dancer Loïe Fuller they often emphasized the rippling, whiplash line made by the hem of her silk skirt as she manipulated it with wands. François Rupert Carabin made a small ceramic statuette of her in this posture, while the American sculptress Anna Valentien modelled a ceramic tray in the form of the dancer, again showing the rippling hem. Two of the earliest posters advertising her act at the Folies Bergère, one of 1892 designed by Fernand Bac and another of 1893 by Alfred-Victor Choubrac, both focused on this feature, and so did the lithographs of her made by Henri de Toulouse-Lautrec.

The suggestion of the erotic in the guise of aesthetic experience was particularly appreciated by the *fin-de-siècle* sensibility, and this contributed largely to many of the forms and motifs found in Art Nouveau. The sexual connotations of long, flowing hair may not always have been consciously intended, but tresses appear in Art Nouveau in such profusion that is is difficult to believe that most people were not fully aware of their significance.

Another motif which occurs again and again in Art Nouveau decoration is the tree-trunk, sometimes shown with its branches, sometimes without, but more often than not rigidly vertical. When artists and designers abandoned Classicism they lost the use of that convenient phallic symbol, the column. It was replaced with the tree-trunk. When a poster designed by Gustav Klimt was censored by the Viennese authorities because the male organ was clearly visible on one of the figures, the Austrian artist altered it so that a tree-trunk crossed in front of the lunging nude and hid the offending member.

One of the most common decorative designs in Art Nouveau shows a forest glade, the tall trees reaching to the top of the decorated space, water flowing at their roots, and a misty crepuscular light shrouding the scene in mystery. This image, that Arnold Bennett might well have found a 'disturbing vision', occurs on, for example, glass by Daum and Gallé and pottery by Rookwood; it is featured on countless friezes and in many stained glass windows; it appears in marquetry on furniture and carved in stone on buildings.

Perhaps it was the element of eroticism that made Art Nouveau such a truly new style. Towards the end of the nineteenth century people in Europe and America felt that they were losing, if they had not already lost, natural, uncomplicated attitudes to sexuality. They realized for the first time that sex had become as much a problem as a pleasure, and they needed an artistic style to express their *angst*, just as they needed psychiatry to rescue them from it.

Woodcut illustration by William Blake to his poem *Europe* (1794) (*opposite*); interest in Blake's graphic style was renewed during the second half of the nineteenth century. His sinuous line and integration of human and plant forms appealed strongly to pioneers of Art Nouveau.

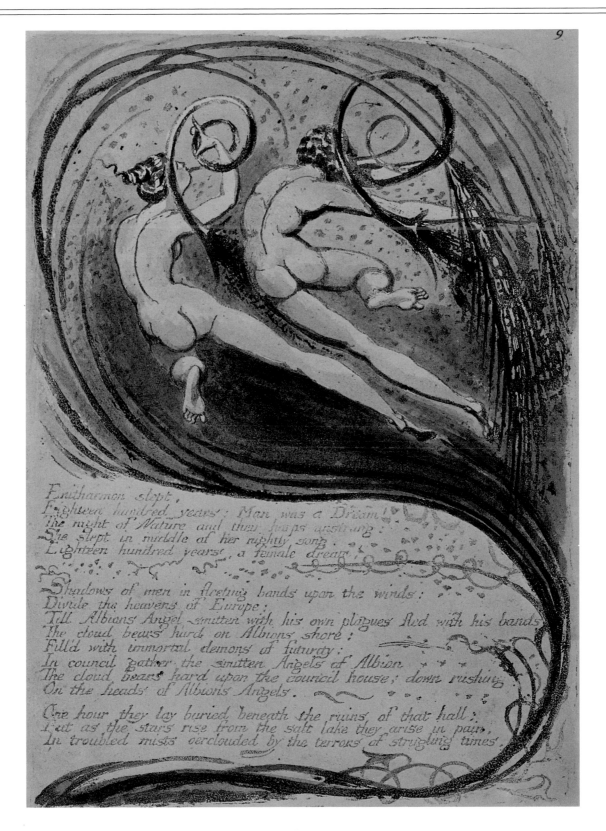

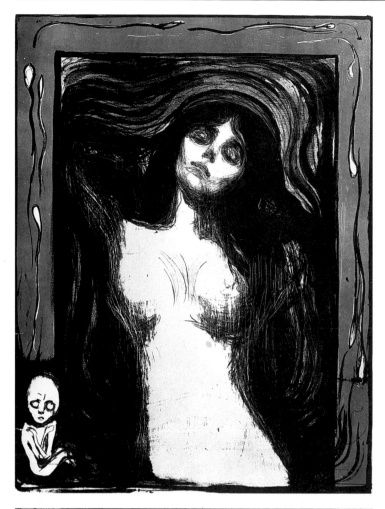

In his lithograph *Madonna* (1895), the Norwegian painter Edvard Munch reveals an almost morbid preoccupation with human desire (*left*). He expresses this feeling in the same imagery as Jan Toorop, whose painting *The Three Brides* (1892) makes prominent use of the sexual connotations of thick flowing hair (*lower left*).

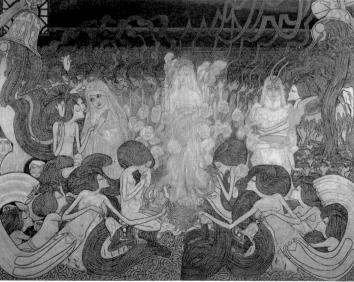

The American artist Elihu Vedder was influenced by William Blake in this design (*opposite*) for the *Rubáiyát of Omar Khayyám* (1884). The typography matches the illustrative style in a way which was to become common in Art Nouveau book illustration. Vedder's painting *The Cumaean Sybil* (1876) incorporates an example of the early use of the 'whiplash' curve (*above*).

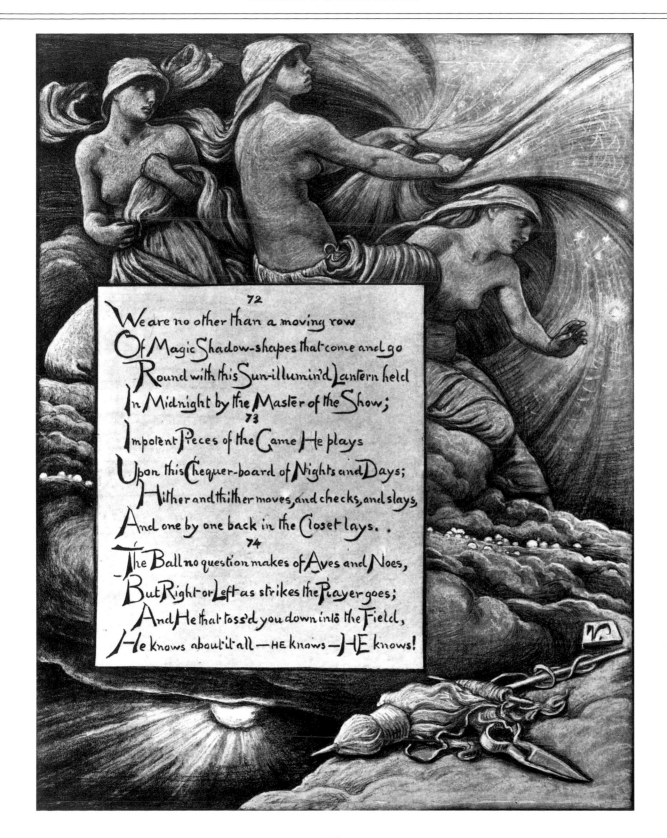

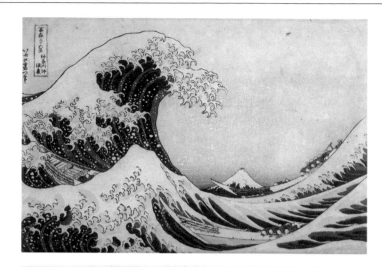

These Japanese silk embroideries, one eighteenth-century (*left*) and one nineteenth-century (*below*) belonged to Siegfried Bing, a Hamburg merchant who dealt in Japanese *objets d'art* in Paris before opening his Maison de l'Art Nouveau gallery there in 1895.

Few of the features in this nineteenth-century Japanese silk painting are to be found in western classical art. The figures exist in an unreal world where there is no perspective and no symmetry (*opposite right*).

This coloured woodcut by Hokusai from his series *One Hundred Views of Mount Fuji* inspired many Art Nouveau designers to exploit the curving form of the wave (*opposite upper left*).

J.M. Whistler's painting *Symphony in White No.2: Little White Girl* (1864) shows the distinct Japanese influence which began to affect western artists from the middle of the nineteenth century (*opposite lower left*).

These two pieces of furniture, designed
by A.H. Mackmurdo in the 1880s,
prefigure respectively the geometrical
and curvilinear modes of the Art
Nouveau style.

Sketches by Eugène Grasset (c. 1885) for a clock, a lantern and a candlestick intended for the Montmartre café Le Chat Noir. Their style shows a transition from the Gothic Revival to Art Nouveau.

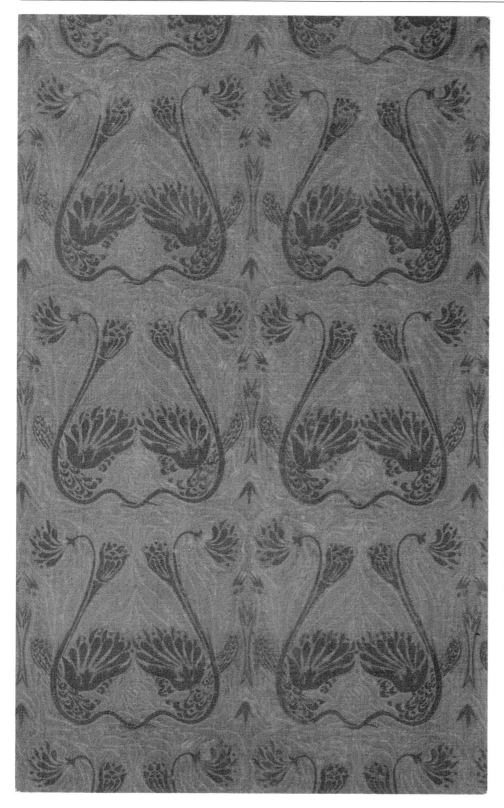

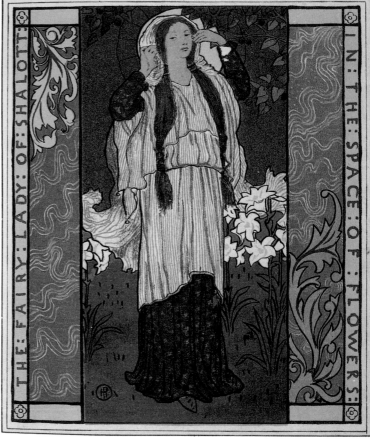

The American artist Howard Pyle worked in a style derived from English Pre-Raphaelitism. This 1888 illustration to Tennyson's *The Lady of Shalott* (*above*) also incorporates decorative elements, such as the borders, derived from Japanese art.

This printed fabric (*left*) designed by A.H. Mackmurdo in 1884 combines the peacock's plumage with the swirling vegetation forms.

The elements that D.G. Rossetti, the Pre-Raphaelite painter, contributed to the Art Nouveau style were an intense sexuality in his potrayal of the female form, and a method of flat and crowded composition, both very much in evidence in this painting, *Astarte Syriaca* of 1877 (*opposite left*). Edward Burne-Jones, an admirer of Rossetti's work, brought to his own painting a delight in sinuous figures and decorative floral motifs, seen here in his 1874 painting, *The Beguiling of Merlin* (*opposite right*).

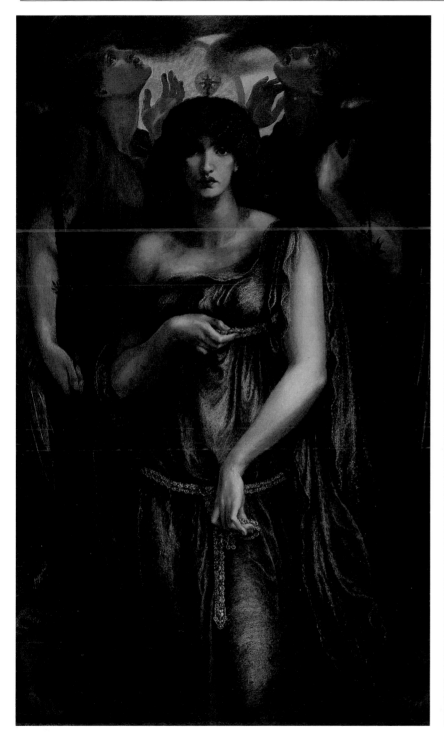

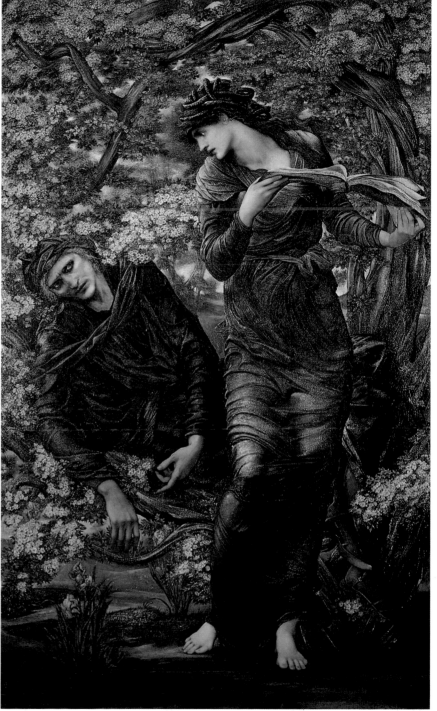

This silver candelabrum made in Amsterdam in 1770 shows how the rococo style, revived in several European countries during the second half of the nineteenth century, is related to Art Nouveau; the two styles both feature natural forms, asymmetry and a flamboyant sinuosity of line.

A ceramic *tazza* modelled by Paul Gauguin in 1888 reveals the links between avant-garde painting and early Art Nouveau; it is also an early example of how Art Nouveau artists incorporated the female nude even into functional objects.

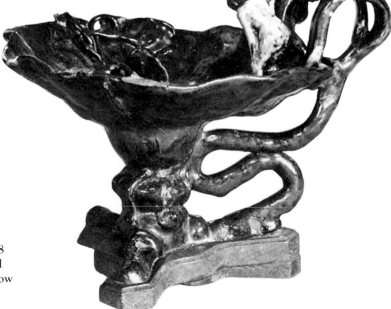

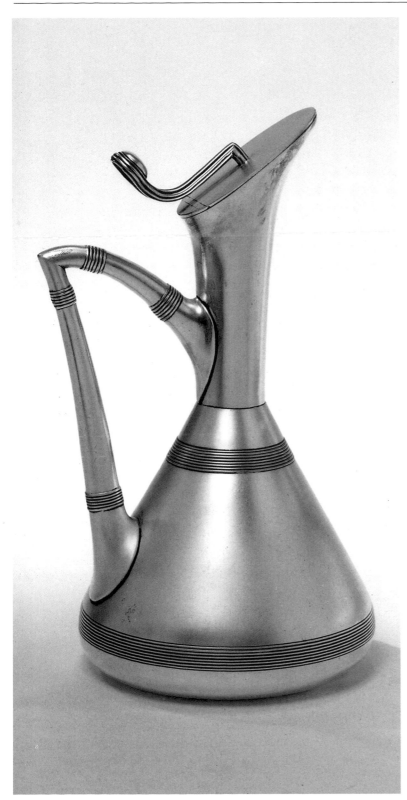

This silver-plated teapot (*above*) demonstrates the radical approach to design taken by Christopher Dresser. Its stark geometry contrasts with the biological form of the silver claret jug (*left*); these two apparently contrasting styles were both to be developed by Art Nouveau designers.

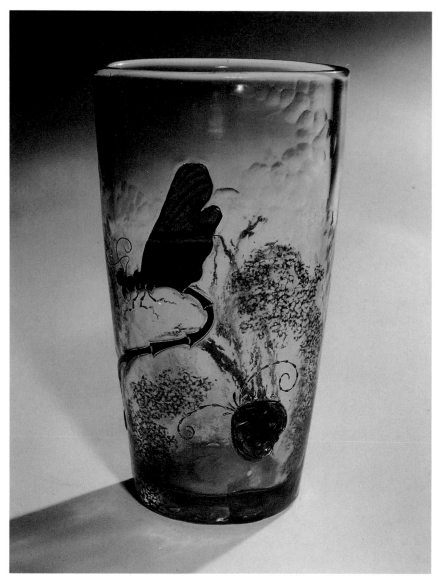

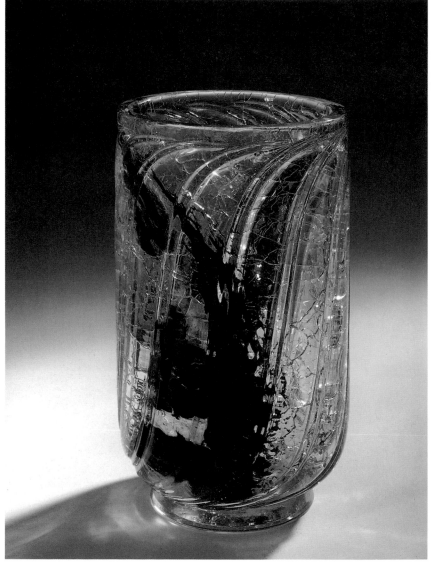

In this glass goblet of *c.* 1889 (*above*) Ernest
Leveillé has exploited the decorative value of
accidental effects, a distinctive feature of much Art
Nouveau pottery and glass.
An enamelled glass vase made by Emile Gallé in
1887; an early example of the incorporation of
Japanese motifs into the visual vocabulary of
curvilinear Art Nouveau (*above right*).

Raoul Larche made this gilt-bronze lamp *c.* 1896
(*opposite*) in celebration of the American dancer,
Loïe Fuller, whose colourful performances at the
Folies Bergère from 1893 were a source of
inspiration to many writers, artists and designers.

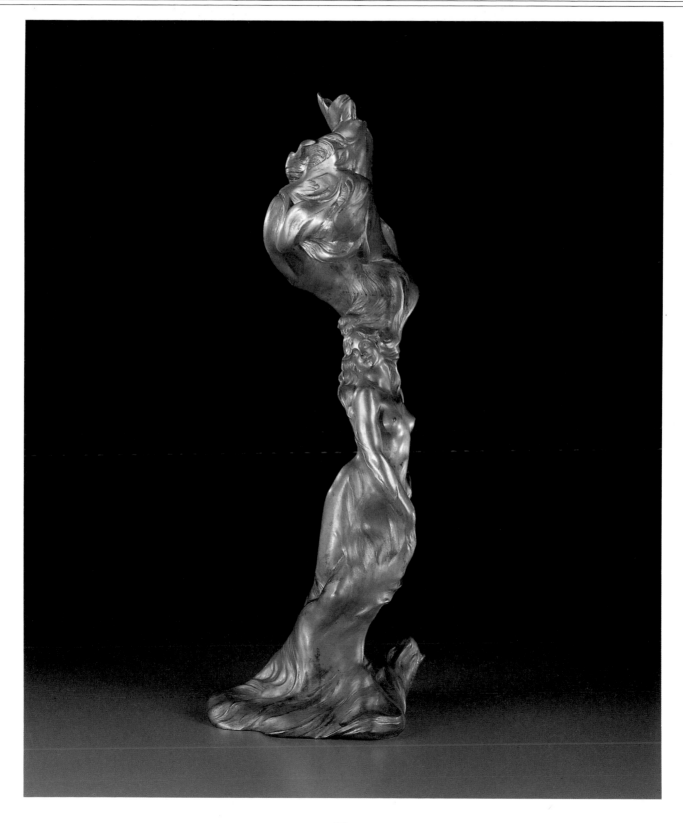

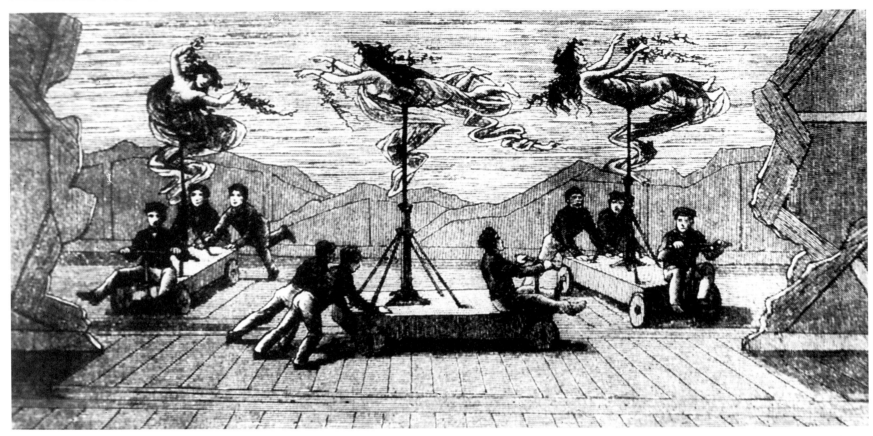

This stage machinery was used for the 1876 production of *Das Rheingold* at Bayreuth (*above*) to give the audience the impression that the Rhine maidens were swimming under water. This presentation of the female form prefigures a multitude of treatments of the subject by Art Nouveau artists and designers.

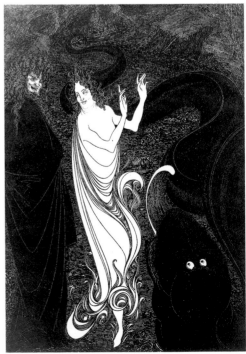

This pen and ink drawing by Aubrey Beardsley illustrating *Das Rheingold* (*right*), with its writhing dragon and flamelike draperies, expresses the Wagnerian spirit in *fin-de-siècle* terms. An illustration by Aubrey Beardsley to Wagner's *Siegfried* (*opposite*); it contains the overt sexual imagery which was to reappear time and time again in the work of Art Nouveau designers.

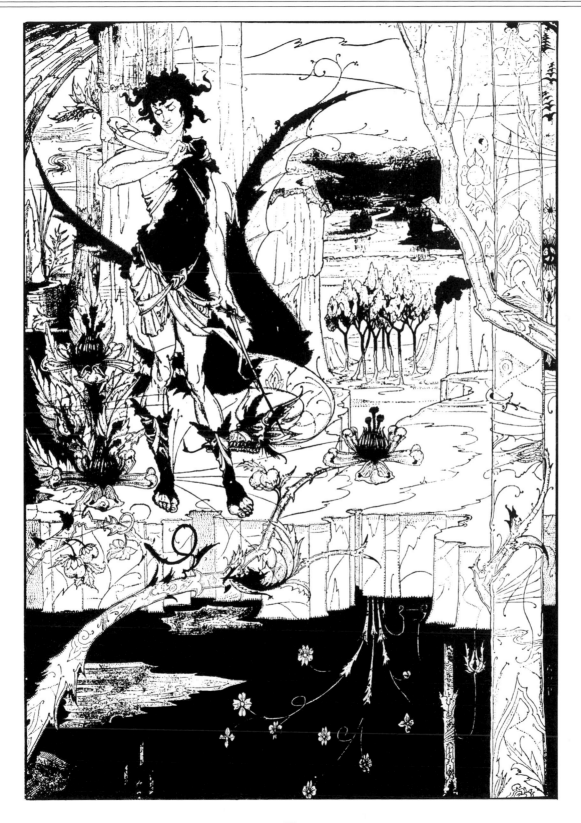

This coloured woodcut, *The Kiss* (1897), by Peter Behrens (*above*), combines Japanese technique with Pre-Raphaelite imagery to produce a quintessential Art Nouveau design.

This tapestry, *The Advent of Spring* (*left*), designed by the Munich artist Otto Eckmann and woven between 1896 and 1897, bears a quotation from Wagner's *Die Meistersinger von Nürnberg*.

François Rupert Carabin's figural furniture, most of which he made between *c.* 1890 and *c.* 1895, indicates a fetishistic attitude to women which is found frequently among Art Nouveau designers. The detail (*below*) is from a chest designed in 1892; the armchair (*right*) was made the following year.

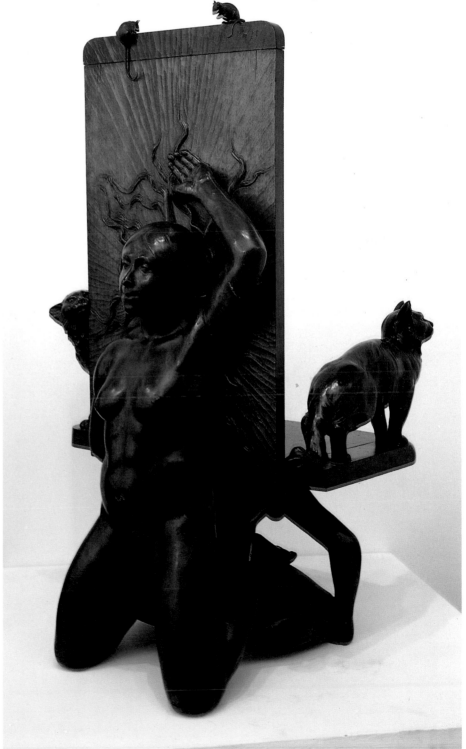

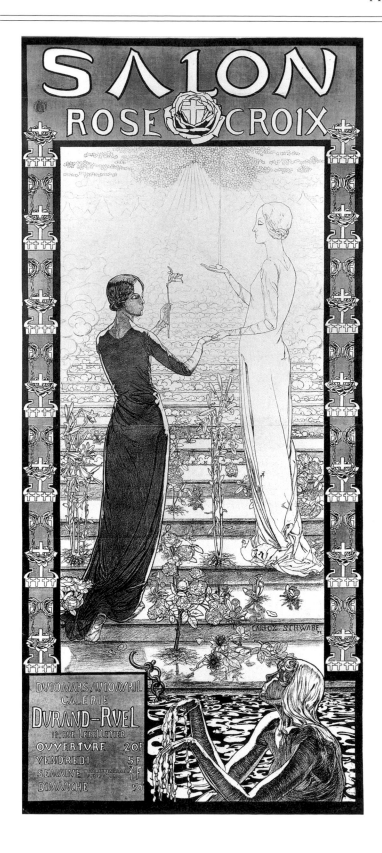

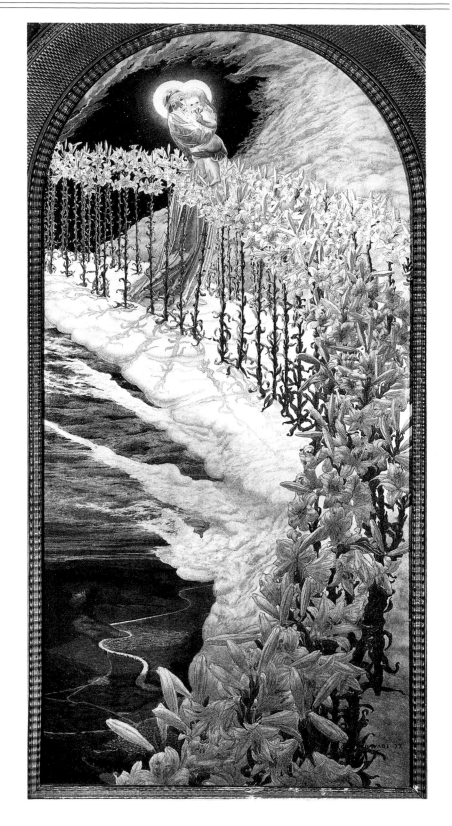

This watercolour by Eugène Grasset (1892) (*right*) displays several elements of Art Nouveau imagery: for instance, the decorative treatment of the tree trunks, the 'whiplash' line of the central figure's hair. But the whole atmosphere of fear and desire evoked by the main image is more representative of Art Nouveau than any single visual feature.

The Swiss artist Carlos Schwabe painted the *Virgin with Lilacs* (*opposite right*) in 1897 for the Salon Rose + Croix, for which he also designed a poster (*opposite left*) in 1892. The Salon was organized by Sâr Péladan (1859-1916), an ardent admirer of Wagner's work, who wanted to restore a spiritual dimension to the arts

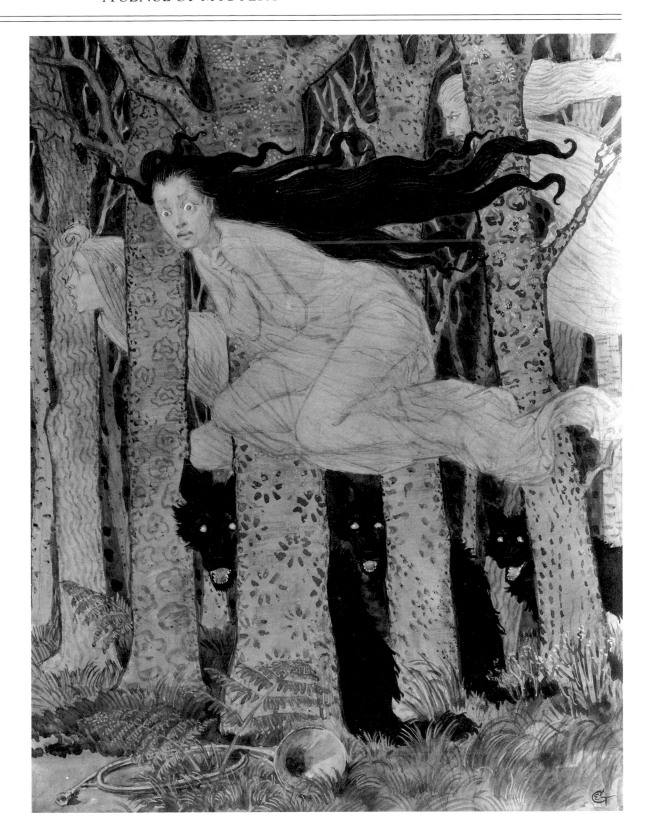

HIGH ART NOUVEAU

Art Nouveau burst on the scene, with scarcely a preamble, in the early 1890s. The few examples of the style which had appeared previously had not drawn much attention or acclaim. In the United States neither the swirling curves that Elihu Vedder had introduced into his paintings and designs nor the writhing neo-Gothic ornament with which Louis Sullivan in 1888 had bedecked the Auditorium Building in Chicago had been full-blown Art Nouveau. The dynamic, curving line that was to characterize the style had appeared in A.H. Mackmurdo's work in England, but only as a passing phase, to be superseded by a much more traditional manner in his later designs. Other designers, such as Christopher Dresser in England, Eugène Grasset in France and Antoni Gaudí in Spain, had all shown remarkable originality, but their work before about 1890 can hardly be described as pure Art Nouveau.

One of the most salient reasons for the explosion of the Art Nouveau style during the 1890s was the rapid growth in the quantity of periodical literature concerned with architecture and applied art. Some of the magazines were compiled and designed by the artists themselves, and copies of *The Century Guild Hobby Horse*, for example, published by Mackmurdo from 1884, were widely circulated in Europe and America and made an impact wherever they were seen. Such journals helped to disseminate new styles of typography and graphic art. Others were valuable for their illustrations of modern architecture and decorative art. It was not until the 1890s that illustrated art magazines began to exploit the new, cheap technique of photomechanical half-tone reproduction which quickly superseded line engravings. New objects demanded the graduated tones of photography to reproduce the subtle effects of their three-dimensional modulations, which would often have been lost in the traditional plates made from line drawings. *The Studio*, launched in 1893, was the first magazine in the field of the applied arts to be illustrated almost entirely with photographs, and its influence was enormous throughout Europe and the United States. It spawned imitations in many countries, which further assisted in the dissemination of the new style.

Another reason why the Art Nouveau style established itself so quickly during the 1890s was the advent of a more liberal consciousness, a phenomenon again promoted by new periodicals. Magazines such as *Arena*, launched in the United States in 1888, *New Review*, published in London from 1889, *La Plume* which first appeared in Paris the same year, and *Moderne Rundschau*, the German equivalent, expressed intellectual attitudes favourable to Wagner, Tolstoy,

Ibsen, Zola and the Symbolist poets, and acclaimed Pre-Raphaelitism, Impressionism, neo-Impressionism and the sculpture of Rodin. In short, they honoured modernity. The progressive intellectuals admired everything that Max Nordau despised as degenerate, and they would have endorsed Oscar Wilde's comment on the German critic: 'I quite agree with Dr Nordau's assertion that all men of genius are insane, but Dr Nordau forgets that all sane people are idiots.' Atheism and Darwinism were the only advanced ideas to which Nordau subscribed.

This body of progressive opinion adopted a catalogue of political causes. In Britain, for instance, it was shocked by Bulgarian atrocities and disapproved of the war in South Africa; in France, it sympathized with anarchists and supported the cause of Alfred Dreyfuss; in Germany it despised the Kaiser and derided Prussian militarism; in the United States, it protested about the brutal suppression by Spain of the 1895 revolt in Cuba and wanted to preserve the cultural identities of the Indian nations. Everywhere, it urged a mild feminism and shunned established religion.

In Belgium, where Art Nouveau first flourished, a section of the bourgeoisie had early adopted socialist ideals. It was not pure coincidence that Les Vingt (The Twenty), a society formed in Brussels for the promotion of modern art, held its first exhibition during the same year, 1884, that a Catholic majority was returned in the elections for the first time in the nation's fifty-four year history. A group of liberal lawyers whose enthusiasm for art and literature had already found expression in the magazine *L'Art Moderne* (Modern Art) formed the nucleus of Les Vingt. They were horrified at the brutality with which the army suppressed workers' riots at Charleroi in 1886, and some of them joined the Belgian Workers' Party. At the same time that they were forging links with the political left, Les Vingt, through the untiring efforts of their secretary Octave Maus, himself a lawyer, were also establishing relations with artists in France and England, also of leftish political persuasions.

In 1889, the Belgian delegates to a conference, held at the Salle Petrelle in Paris, which turned out to be the inaugural meeting of the Second International, must have been struck by the presence there, among the British delegates, of William Morris. At least, it is noticeable how, after that date, the decorative arts began to feature among the activities of Les Vingt and how greater attention was now paid to artistic and literary matters in the counsels of the Belgian Workers' Party. In 1891 two ceramic vases by Paul Gauguin were included in the annual exhibition of Les Vingt, and their 1892 show featured

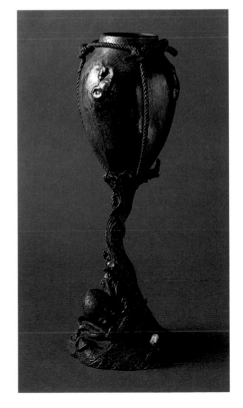

This pottery vase with metal mount was made *c.* 1900 by Maria Longworth Nichols Storer at the Rookwood Pottery Company, which she had founded in Cincinnati, Ohio, in 1880. It is inspired by similar objects made by Japanese craftsmen.

work by the French potter Auguste Delaherche and, from England, embroideries, book-covers and designs for stained glass. Meanwhile, the Belgian Workers' Party organized an Art Section at its Maison du Peuple (The People's House) in Brussels. The Section was run by the Symbolist poet Emile Verhaeren and the lawyer Edmond Picard, and among others who served on the guiding committee were Octave Maus and the painter Fernand Khnopff.

The first expression of such an art, at least in the realm of architecture, was emerging in Brussels during the winter of 1892-93. The house that Victor Horta was building at that time for the engineer Emile Tassel was the earliest manifestation anywhere of the full-blown Art Nouveau style. Throughout the house, the whiplash line of Horta's ornament enlivened the iron and brick structure. 'I leave the leaf and the flower,' said Horta, 'and take the stem.' Tendrils writhed over walls and ceilings; here they sprouted from iron pillars, there they grew across a stained glass window. Some of the rooms were decorated with English wallpapers, and Liberty silks adorned some of the interiors. The Tassel house was not Horta's first building but his earlier work had been mainly academic. The dramatic originality of the house was probably due in part to Tassel's enlightened attitude to the use of iron and glass. At the end of the 1870s Horta had worked in Paris, and he had developed an admiration for the ideas of the French architect Viollet-le-Duc who advocated the use of exposed iron, and in whose books there were illustrations of its ornamental treatment.

Horta's revolutionary ornament was the result of his study of plants and his assimilation of Japanese art. One of his close friends was the sculptor François Dubois who had studied the natural sciences at Brussels University, and who would, no doubt, have drawn Horta's attention to new discoveries in botany. Horta later built a house in Brussels and a villa at Sosoye for Dubois who himself adopted the Art Nouveau style; he made caskets, centrepieces and candelabra, often combining female figures carved in ivory with twisting plant forms in silver or silvered metal. Horta's knowledge of Japanese art came from the magazines *Le Japon Artistique* (Artistic Japan), edited by Siegfried Bing, and *Kokkwa*, an illustrated monthly survey of the fine arts published in Tokyo, to both of which he subscribed. Interest in Japanese art was particularly strong at that time among artists and architects in Belgium. The painter and poster artist Théo van Rysselberghe, a close friend of Octave Maus and a regular exhibitor with Les Vingt, was under its spell to such an extent that he took a Japanese mistress, the beautiful Omijo.

Two other Belgian architects who adopted the Art Nouveau style were Gustave Serrurier-Bovy and Paul Hankar. Like Horta, they had been influenced by Viollet-le-Duc and Japanese art. In 1884 Serrurier-Bovy had opened a shop in Liège selling Japanese goods as well as furniture, wallpapers and fabrics from England and America. Octave Maus invited him to exhibit in 1894 at La Libre Esthétique (The Free Aesthetic) which was the new name given that year to Les Vingt. He showed furniture in a style strongly influenced by the English Arts and Crafts movement, but he soon abandoned this for a more curvilinear, Art Nouveau manner. In addition to furniture, Serrurier-Bovy designed stained glass, wallpaper and ironwork. Hankar built several Art Nouveau houses in Brussels during the 1890s. He shared with Serrurier-Bovy a liking for motifs from Japanese architecture and joinery, such as the horseshoe-shaped arch, which they used on both the exteriors and interiors of their buildings.

From about 1895 to 1900 Hankar built a villa at La Hulpe for Philippe Wolfers, one of Belgium's leading Art Nouveau designers. The son of a goldsmith, Wolfers designed silver from 1880, at first in a neo-rococo style. During the 1880s he introduced Japanese motifs into his work which became progressively more naturalistic. In 1893 he started working in ivory, carving it into figures and flowers treated in an Art Nouveau manner; he sometimes gave these objects Symbolist titles. The jewellery which he made from about 1895 has a beauty and a technical mastery almost on a par with Lalique's. Like the French artist, Wolfers often incorporated in his jewellery insects, serpents, peacock feathers and flowers in gems and enamel.

Henry van de Velde was a painter before he became an architect and designer, and his work was based on aesthetic theories which he picked up when he was under the influence of the French neo-Impressionist artists Seurat and Signac. Although analytical in his approach to design, he was paradoxically emotional about the social role of art. 'Art is beginning anew,' he wrote in 1895, 'because society is beginning anew.' He had abandoned painting after seeing Van Gogh's pictures of working-class life, and he had readily accepted William Morris's gospel of salvation through the applied arts. Among his intimate friends was the Belgian Symbolist poet Max Elskamp, and around 1890 he and Elskamp had been taking hashish. The ornaments that van de Velde had engraved for two books of Elskamp's poetry have a psychedelic look, as does his cover for the magazine *Van Nu en Straks* (On the New in Art) which Elskamp launched in 1893.

In 1895 van de Velde built his own house, Bloemenwerf, at Uccle, not far from Brussels. He intended his home to be a complete artistic environment and designed all the furniture, light-fittings, cutlery – even his wife's dresses. Siegfried Bing and Julius Meier-Graefe, two of the great entrepreneurs of Art Nouveau, visited Bloemenwerf, and soon van de Velde's work was much in demand, particularly in Germany. In 1898 he established workshops at Ixelles where furniture was manufactured to his designs. His abstract, curvilinear style, which he called 'dynamographique', was an original and individual version of Art Nouveau. It was a style which could be adapted to any material, in any situation and on any scale, and yet retain consistent integrity. This helps to explain its success, which was also partly due to its energetic promotion by the designer himself through the books and magazine articles that he wrote.

There have been few episodes in the history of art and architecture when the development of a new style occurred in Belgium before it was taken up in France, but this is what happened in the case of Art Nouveau. Although the style was slowly emerging in France from the mid 1880s onwards, it only struggled free of its chrysalis when it was observed just how beautiful the butterfly was that fluttered in Belgium. The architect Hector Guimard, having seen and admired the buildings of Victor Horta, changed the direction of French Art Nouveau.

In François Rupert Carabin's opinion, Horta 'introduced the macaroni style which, when Guimard brought it to Paris, arrested the French movement launched by a few artists four or five years earlier'. The style which had developed in Paris at the end of the 1880s was derived from, on the one hand, Viollet-le-Duc's advocacy of Gothic art and, on the other, a growing appreciation of Japanese design. There was usually a strong figural element in this early Parisian Art Nouveau, whether in the posters and illustrations of Jules Chéret and Eugène Grasset, or in the three-dimensional work of Joseph Chéret (Jules's younger brother) and Rupert Carabin. Regretting the lack of any style which expressed the spirit of the age, Max Nordau wrote in 1891: 'An approach is, perhaps, made to one in the furniture of Carabin. . . . But these balusters, down which naked furies and possessed creatures are tumbling in mad riot, these bookcases where base and pilaster consist of a pile of guillotined heads, and even this table representing a gigantic open book borne by gnomes, make up a style which is feverish and infernal.' Nordau had seen Carabin's furniture at the 1891 salon of the Société Nationale des Beaux-Arts in Paris, and shown at the same exhibition were

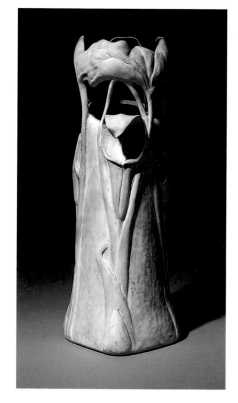

Vase using a Jack-in-the-pulpit flower motif, made by Tiffany Studios.

porcelain vases with relief decoration by Joseph Chéret which also featured tumbling nude figures and masks. The Société Nationale had been founded in 1889 by Rodin and the painters Eugène Carrière and Pierre Puvis de Chavannes. It admitted works of applied art, banned from the official salon, to its annual exhibitions.

A masterpiece of this early phase of Art Nouveau in Paris was the monumental doorway to the shrine commissioned by the Princesse de Scey-Monbéliard, which was to house the manuscript of Wagner's *Parsifal*. Made in stoneware by the potter Jean Carriès to the designs of Eugène Grasset, the doorway was composed of tiles modelled with human masks, and a frightening menagerie of grotesque hybrids. Both Carriès and Grasset had been deeply influenced by Japanese art; Grasset designed posters and illustrations which reflect his close study of Japanese prints and Carriès made stoneware vessels in the style of Japanese country pottery, often shaped as gourds or pumpkins. Stoneware influenced by Oriental ceramics was also made in France at this time by Ernest Chaplet, Auguste Delaherche and Adrien-Pierre Dalpayrat. They covered their pots with high-temperature glazes giving deep, mysterious colours that were admired by the Symbolist poets.

The works of applied art produced by the painters and sculptors known as Les Nabis also had strong Symbolist associations, and usually featured human or animal figures. Their leader, Paul Gauguin, made ceramic vessels, with painted or modelled decoration, which Chaplet fired for him. These, and his carved wooden reliefs, were inspired by Japanese and Indonesian works of art. Another Nabi, Georges Lacombe, took up wood carving in 1893 and made furniture and relief panels in a style related to Gauguin's. The sculptor Aristide Maillol and the painter Paul-Elie Ranson designed tapestries which generally featured female figures in landscape settings. Ranson's tapestries were woven by his wife, but Maillol wove his himself, even dyeing his own wools. The work of the Nabis was usually figural and often composed of curvilinear elements; both its style and its Symbolist content link it to Art Nouveau.

The figural element in Parisian Art Nouveau persisted into the period when the floral, more abstract Belgian version of the style had captured the French capital. The bronze foundries of Paris employed some 25,000 men at this time, and sculptors such as Raoul Larche, Charles Korschann and Maurice Bouval modelled utilitarian items for casting in bronze. Candelabra, centrepieces, inkwells, pen trays, seals, door handles and many other objects were adorned with female figures and flowers.

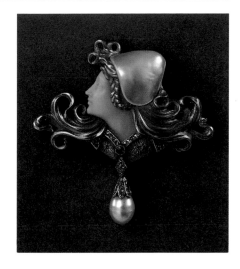

In this gold brooch by an unknown French jeweller, the woman's face is carved from coral and her hat is a piece of mother-of-pearl.

The work of Alphonse Mucha registers a transition from the earlier to the later versions of Art Nouveau in Paris. From his first important success in 1894, a poster for Sarah Bernhardt, Mucha hardly varied his style. His work nearly always featured seductive female figures, their long, swirling tresses treated as abstract ornament, posed in settings of exotic architecture, luxuriant blooms or interlace borders. He used the same formula, or elements from it, whatever the medium for which he was designing, whether it was textiles, stained glass, bronze or jewellery.

The style of the jewellery that Mucha designed for Georges Fouquet the Paris jeweller was also much influenced by the work of René Lalique. From the beginning of the 1890s Lalique created jewels which incorporated flowers, insects, animals, female figures and even landscapes in a wide range of materials, including gold, silver, gemstones, glass, horn and enamels. He experimented with enamels of unusual colours, producing subdued tints typical of the Art Nouveau palette and a contrast to the bright hues used previously by enamellers in the nineteenth century. Lalique's version of Art Nouveau was original and individual; his work owed much to Japanese art and Renaissance jewellery and his themes were those of the Symbolist poets. So great was his international success that many followers and imitators appeared – Philippe Wolfers in Belgium and, in France, Lucien Gaillard, Vever Frères and Georges Fouquet.

Like so many Belgian designers who worked in the Art Nouveau style, Hector Guimard had been fundamentally affected by the ideas of Viollet-le-Duc. So it is not surprising that he was influenced by the buildings of Horta and Hankar when he visited Belgium in 1895. Not only did they endorse his opinion that it was the architect's job to design the total building, inside and out, from rooftop to cellar, including all the furniture and fittings, but they also provided him with specific architectural motifs such as the horseshoe-shaped arch. The Belgian example also helped to form his own style of Art Nouveau ornament which was much more abstract than had previously been seen in Paris. Writing in *Le Figaro* in 1899 he expressed the opinion that the representation of leaves, flowers, fruit and animals should be banned from the decorative arts.

The first evidence of Guimard's more abstract Art Nouveau was the Castel Béranger, a block of flats, where the whiplash line of the ornament was carried through from the decorative details of the façade to the stained glass and ironwork of the interior. In 1898 he published an album of his designs for this building, and the volume was subtitled *L'Art dans l'habitation* by which Guimard expressed the

notion of the artistic life-style advocated by William Morris and transmitted by the Belgian Art Nouveau designers. As a result of Guimard's proselytizing zeal, the Belgian version of Art Nouveau gained currency in Paris with several French architects and designers imitating aspects of it. The first issue of *Art et Décoration* had appeared in 1897 containing a well-illustrated article on Horta's architecture, and the first issue of *L'Art Décoratif* (the French edition of *Dekorative Kunst*), published in 1898, was devoted to the work of Henry van de Velde.

The career of the French sculptor Alexandre Charpentier illustrates the progress of Art Nouveau in Paris. He was friendly with Carabin and, during the early 1890s, designed furniture in a figural style derived from the posters of Jules Chéret. At the same time he was exhibiting in Brussels with Les Vingt, and in 1897 he made a commemorative medal for an international conference of lawyers held that year in the Belgian capital. The effect of his links with Brussels became apparent in his designs for rooms in houses belonging to the banker Adrien Bénard (who had commissioned Guimard to design the entrances to the Paris Métro) and Baron Vitta, where much of the ornament was abstract and there were features such as the horseshoe-shaped arch.

Charpentier was involved in the decoration of a house built in Nancy in 1901 for the cabinet-maker and decorative artist Louis Majorelle. Two years earlier Majorelle had collaborated in the decoration of a restaurant in Paris. Such intercourse between Nancy and Paris only became feasible at the turn of the century because artists in both cities were responding to Belgian influence. Previously Nancy had developed its own version of Art Nouveau which had displayed features of the rococo. Nancy was the centre of an area where many factories and workshops producing glass, ceramics, metalwork and furniture were located, and during the second half of the nineteenth century their output was largely in a neo-rococo style. Most of the decorative artists who practised Art Nouveau in Nancy came from this background: Emile Gallé's father owned workshops making glassware and ceramics; Majorelle took over his father's Nancy cabinet-making firm in 1879; the painter and decorative artist Victor Prouvé was the son of an embroidery designer and ceramic modeller who had worked for Gallé's father; the cabinet-maker Eugène Vallin served his apprenticeship with his uncle, a Nancy manufacturer of ecclesiastical furnishings.

Gallé introduced into the traditional Nancy fare a new blend of *japonisme* and Symbolism which gave his glassware and furniture an

Art Nouveau appearance. Floral ornament was an essential ingredient of the Nancy version of Art Nouveau, and Gallé made use of his profound knowledge of botany in his decorative designs. Majorelle sometimes embellished his furniture with ormolu mounts in the form of flowers, a type of decoration derived from rococo models. Gallé, when he turned to the design of furniture, transferred the motifs of his glass decoration to marquetry and carving on forms which were basically rococo in style. But Majorelle created many original shapes for furniture which were closer to contemporary Belgian designs than to any historical precedents.

The Daum family acquired its glassworks in Nancy in lieu of an unpaid debt. They hired craftsmen who had gained their skills in Gallé's workshops and commissioned decorative designs from, among others, the Nancy artist Jacques Gruber. Between 1894 and 1897 he created a range of decorations including some that were inspired by Wagner's operas. Both the glassware and the furniture produced in Nancy were often decorated with scenes of woodland and water, another indication of the strength of Symbolist influence on this school of decorative artists.

In Germany, Art Nouveau was largely concentrated in Munich. There were smatterings of activity in Berlin, Hamburg and elsewhere, and in Darmstadt a geometrical version of the style was cultivated, but only in Munich did a coherent group of artists develop their own style of curvilinear Art Nouveau. A significant factor which undoubtedly contributed to this was the enormous number of artists working in the Bavarian capital. In 1893 the critic Leopold Gmelin claimed that there were more artists *per capita* in Munich than in any other city in the world. Among so many there were bound to be some who were discontented with the institutions of the Munich art world and the prevailing historicism practised by its artists. In 1892 a group had broken away from the Munich Academy and founded a new organization, known as the Secession. New ideas began to circulate among these painters and sculptors, one of which was equality between the fine and applied arts.

Graphic art provided a way of transition from painting to the decorative arts. Many of the artists who were later to become designers contributed drawings and graphic ornament to the magazine *Jugend* (Youth) which gave its name to the Munich version of Art Nouveau, Jugendstil (Youth Style). Youth, with all its innocence and aspiration, was a concept uppermost in the minds and imaginations of German writers and artists at the time. The period during which Art Nouveau flourished in Munich fell between the

production in 1893 of Max Halbe's play about the psychology of adolescent love, itself entitled *Jugend*, and the publication in 1904 of Hermann Hesse's *Peter Camenzind*, the story of a young, visionary artist's struggle to comprehend the forces within himself and within nature, and his failure to overcome the dead hand of a conventional education. The magazine *Jugend*, launched in 1896 and edited by Georg Hirth, was a literary and artistic review which lashed bourgeois conformity with its acerbic wit and often roused the ire of the Bavarian authorities. It featured covers and illustrations drawn by several artists, such as Otto Eckmann, Bernhard Pankok, Julius Diez, Fritz Erler and Bruno Paul, who later designed for the applied arts.

In 1896 an exhibition of tapestries designed by Hermann Obrist was held at Littauer's Salon in Munich. Obrist had studied the natural sciences at the University of Heidelberg and had travelled in Britain, where he had been enthused by the Arts and Crafts movement. Having tried ceramics, painting and sculpture, he had opened an embroidery studio in Florence. In 1894 he had moved to Munich. The embroideries that he exhibited in 1896 illustrated his theory that spiral movement gave designs life, beauty and significance. The subject matter of his work – usually more or less identifiable plants – was, he maintained, unimportant; the point was the aesthetic effect.

In the spring of 1896 Obrist met August Endell, a student of philosophy, psychology and aesthetics. Endell immediately gave up his academic career and learnt to draw and paint. Later the same year he published a pamphlet entitled *Um die Schönheit* (About Beauty), in which he outlined an aesthetic theory based on Obrist's ideas and the teaching of the psychologist-philosopher Theodor Lipps. Setting out from forms found in nature, the artist's task, asserted Endell, was to make the motif unrecognizable – abstract – so that no associations obstructed the beholder's purely emotional response to the image. He wrote in his pamphlet: 'He who has once learned to give himself over completely to his visual impressions, without associations and without reflections, who has once really felt the effect of forms and colours, will discover a never failing source of extraordinary and unimagined pleasure. . . . He who has not undergone such an experience will never comprehend art.' The front of *Um die Schönheit* was decorated with a design which could just be recognized as the flower of an orchid. A photographic studio, the Atelier Elvira, that Endell designed in 1896 was decorated inside and out with applied plaster reliefs based on forms of marine life which, however, were effectively non-representational. Both Obrist and Endell used such

abstract motifs for the metal mounts and carved decorative details on some pieces of furniture that they designed in 1899 for the poet Henry von Heiseler.

Japanese influence was strong on the Jugendstil artists of Munich. Hans Eduard von Berlepsch, who was a generation older than most of the Munich designers and played a key role in the development of Jugendstil, had admired Japanese craftsmanship and design since 1885 when he had been a jury member at an international exhibition of metalwork in Nuremberg. He designed metalwork, furniture and ceramics, and his work often reflected his enthusiasm for Japanese art which, he wrote, 'demonstrates what a people can achieve when they are intimately familiar with the beauty of their environment, its flora and fauna'. The coloured woodcuts of Otto Eckmann, and the wrought-iron candlestick that he designed in the form of a narcissus, testify to his assimilation of Japanese arts and crafts. Peter Behrens who, like Eckmann, had been introduced to Japanese prints by the Hamburg museum director Justus Brinckmann, made coloured woodcuts which reveal an understanding of both the technique and the formal devices employed by Japanese print-makers.

Jakob Julius Scharvogel, who moved to Munich in 1898 and set up a workshop in Obersendling, made stoneware in the style of Japanese peasant pottery, covered in strongly coloured high-temperature glazes. Some of his vases were given wooden stands, carved and decorated in the Japanese manner, and the device with which he marked his wares was closely modelled on a Japanese seal. Surprisingly, his first customer was the Prince-Regent Luitpold, not usually a patron of the Jugendstil artists; the Bavarian monarch generally favoured a neo-classical style for architecture and applied art.

The work of Richard Riemerschmid contained several elements characteristic of Munich Jugendstil. Like many of the artists involved in the movement, he had started out as a painter. He turned to the decorative arts in 1895 and at the International Art Exhibition held in Munich in 1897 he exhibited both paintings and furniture. Metal candlesticks and table lamps that he designed between 1897 and 1898 were in the form of plants, some of them suggesting Japanese influence, others – more abstract – reflecting the theories of Obrist and Endell. He designed furniture for a music room exhibited at Dresden by the Bavarian court piano manufacturers. The association of music with the decorative arts, a common characteristic of Art Nouveau elsewhere, was particularly strong in Germany. The Munich designer Fritz Erler created a music room for a house in Breslau in 1898, the year that Riemerschmid's room was exhibited in

Dresden. Endell, writing the same year, described 'an entirely new art': 'The art of using forms that, although they mean nothing and recall nothing, can move the human soul as profoundly as only the sounds of music have been able to do.'

Another respect in which Riemerschmid's work was typical of Jugendstil was the impact on it of Henry van de Velde's designs. Furniture by van de Velde was installed in the Munich home of Otto Meier in 1898, and the following year a selection of the Belgian designer's work was shown at an exhibition of the Munich Secession. Nowhere was the influence of van de Velde felt more strongly than in Germany, and hints of his style may be seen in the work done around 1900 by Richard Riemerschmid and other Munich designers including Peter Behrens and Bruno Paul.

The Art Nouveau usually associated with Austria was of the geometrical variety, to be discussed in the next chapter. However, the painters and sculptors of the Vienna Secession, when they turned to the applied arts, adopted a figural style not unlike the Art Nouveau that flourished in Paris. In 1899, for example, the painter Josef Engelhart who had stayed for a time in Paris in 1890 and had been a founder member of the Secession in 1897, designed a mantelpiece in wood and copper. Either side of the fireplace stood a naked Adam and Eve carved in high relief, while over the arch between them writhed the serpent, its coils intertwined with the branches of a tree which spread upwards into the overmantel. At about the same time the sculptor Gustav Gurschner modelled a series of candlesticks, candelabra and lamps in the form of female figures, which were cast in bronze. These related to Parisian Art Nouveau, not only as a type of object that had originated in Paris, but also as representing the dancer Ida Fuller; her real name was Ida Pinckney but she passed herself off as Loïe Fuller's sister-in-law and performed successfully in Paris and other European capitals. Her programme included a dance in which she appeared holding out in front of her a vessel containing some burning substance, and it was this image which Gurschner translated into a bronze candlestick, the vessel becoming the candle-holder.

In 1894 the architect Otto Wagner was appointed professor of architecture at the Academy of Fine Art in Vienna. Among his students were designers such as Olbrich, Hoffmann and Moser who developed the geometrical style later identified with the Wiener Werkstätte. Wagner himself designed several buildings in a more flamboyant, curvilinear version of the Art Nouveau style. The most notable was the Majolikahaus, so named because its façade was

covered with ceramic tiles arranged in a composition of twisting floral ornament. The interior and exterior ironwork was designed by Wagner in a more abstract style related to Belgian Art Nouveau. The Majolikahaus was built in 1898 and 1899, the years when the work of Horta and van de Velde was being copied all over Europe. The house Wagner built for himself in 1900 had stained glass windows designed by Adolf Böhm, a painter who had been among the founders of the Vienna Secession. Böhm designed book-covers and embroideries, as well as stained glass, and most of his decorations feature wooded landscapes with twisted tree-trunks.

Elsewhere in the Austro-Hungarian Empire, Art Nouveau flourished. In Budapest, the architect Odon Lechner designed several buildings in an Art Nouveau style inspired by the buildings of Otto Wagner. The Hungarian painter Josef Rippl-Rónai, who had been associated with the Nabis painters when he had lived in France, had designed tapestries and had exhibited his paintings at Siegfried Bing's Maison de l'Art Nouveau, designed decoration for ceramics made by Vilmos Zsolnay in Fünfkirchen, about eighty miles south of Budapest. The firm of Johann Loetz-Witwe of Klöstermühle in South Bohemia manufactured iridescent glass vessels in contorted Art Nouveau shapes decorated internally with swirling trails of glass thread.

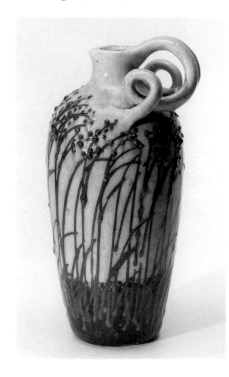

A small pitcher in glazed earthenware by Max Laüger (c. 1900).

Spanish Art Nouveau was dominated by the figure of Antoni Gaudí. He was the son of a coppersmith and had great respect for, and considerable knowledge of, the applied arts. He studied architecture at Barcelona University from 1873 to 1878 and was influenced by the writings of Viollet-le-Duc. His earliest jobs were designing furniture and metalwork and it was only after his first few architectural commissions that he began to use a style which looked forward to full-blown Art Nouveau. Wrought-iron whiplash scrolls above the entrance to the Güell palace built between 1885 and 1890 were an early instance of his highly individual and original version of the style. He often designed furniture for his buildings and it was usually asymmetrical to the point of eccentricity and organic to the point of sculpture (it has been described as 'osteomorphic'). His knowledge and love of nature were reflected in these designs, as they are in the architecture of the Casa Milá, built between 1906 and 1910, where the irregular corrugations in the stone walls seem to have been worn by the motion of the sea, and the twisted ironwork of the balconies resembles strands of seaweed.

Louis Sullivan occupies a similar position in relation to Art Nouveau in America to that of Gaudí in Spain. He was a pioneer,

developing his own individual style which had many of the characteristics of Art Nouveau half a dozen years before it emerged as an international style. Unlike Gaudí, however, Sullivan never designed three-dimensional objects in an Art Nouveau style. His swirling, vegetal ornament was applied in low-relief panels to the walls of his buildings. While a student at the Ecole des Beaux-Arts in Paris, he had been interested in the positivist philosophy of Hippolyte Taine, and he was also impressed by Herbert Spencer's positivist analysis of the natural sciences.

Louis Comfort Tiffany was the son of the founder of the famous New York firm of silversmiths and jewellers. He studied painting in Paris and turned to the decorative arts towards the end of the 1870s. The interiors he designed during the 1880s were in the eclectic manner of the Aesthetic Movement. But in 1889, at the Universal Exhibition in Paris, he met Siegfried Bing from whom he bought many Japanese works of art, and who began promoting his work in Europe and encouraged him to cultivate a more modern style. When Bing opened his Maison de l'Art Nouveau in 1895, he displayed stained-glass windows made by Tiffany and designed by the Nabis painters Pierre Bonnard, Edouard Vuillard, Ker-Xavier Roussel, Paul Ranson and Maurice Denis. By this time Tiffany was making his Favrile glass. He created vessels in organic shapes, often decorated with iridescence and sometimes with abstract Art Nouveau patterns in different coloured glass. His leaded glass lampshades featured flowers and insects. Tiffany Studios also made metalwork (including bronze bases for the lampshades), jewellery, ceramics and textiles.

Maria Longworth Nichols Storer started the Rookwood Pottery in Cincinnati, Ohio, in 1880, and the ceramics produced there were mostly decorated in a style derived from Japanese art. In the 1890s, however, the firm adopted a policy of sending its most talented artists on trips to Paris in order to study the latest developments in the decorative arts. Artus van Briggle, Albert and Anna Marie Valentien returned to the United States and created vases decorated with female figures modelled in high relief. These pots were Symbolist in feeling, and van Briggle gave some of his work titles such as 'Despondency' and 'Lorelei'. Anna Marie Valentien modelled a china tray in the form of the dancer Loïe Fuller. The work of the Valentiens and van Briggle has close affinities with the sculptural Art Nouveau developed in Paris during the early 1890s.

The Art Nouveau style adopted by the cabinet-maker Charles Rohlfs seems to have originated as much in his imagination as anywhere else. A New Yorker, Rohlfs designed cast-iron stoves during

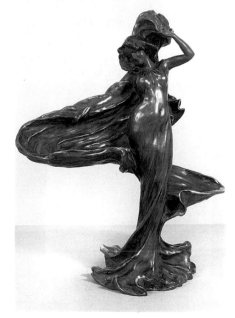

An earthenware figure of the dancer Loïe Fuller, manufactured by the Austrian firm of Riessner, Stellmacher & Kessel (c. 1900).

the 1870s. From 1877 to the early 1890s he was an actor, but by 1890 he had started to make oak furniture at his workshop in Buffalo. He decorated his work with carved curvilinear designs in an Art Nouveau style which was usually abstract and may have been inspired by Sullivan's ornament.

In 1904 the English architect Reginald Blomfield, writing about Art Nouveau, recalled: 'It started in England some twenty years ago, with the ingenious experiments of two young architects with an uncommon share of eccentric ability, who for the first time revealed the numerous possibilities of the "swirl" and the "blob".' Blomfield was referring to A.H. Mackmurdo and his assistant Herbert Horne, whose adventurous designs of the early 1880s had heralded the triumph of Art Nouveau during the following decade. English artists, however, hardly shared in this success. Mackmurdo and Horne soon adopted styles which reflected their growing obsession with the Italian Renaissance.

During the 1890s Aubrey Beardsley created a style of two-dimensional Art Nouveau which achieved instant international renown, both for its graphic elegance and its risqué wit. Artists such as Charles Ricketts and Laurence Housman used a style inspired by Beardsley's mixture of Burne-Jones and Utamaro, and their book covers and illustrations were accomplished exercises in Art Nouveau. Some of the metalwork and jewellery made by Alexander Fisher can be classed with Continental Art Nouveau. But the trials and conviction of Oscar Wilde in 1895 coincided unhappily with the publication in London of the English translation of Max Nordau's *Degeneration*. The intellectual bourgeoisie, always eager to strike a pose of pious dismay, put a stop to any artistic movement that challenged conventional standards, whether moral or aesthetic. It became important for English artists and designers to project an image of robust probity in the years following the Wilde débâcle. People who had contributed to the formation of Art Nouveau attacked the style in language which might almost have come from the pages of Dr Nordau's diatribe. Lewis F. Day declared in 1900 that Art Nouveau showed 'symptoms not of too exuberant life, but of pronounced disease', and Walter Crane described the style as the 'strange decorative disease known as "l'Art Nouveau".' This rejection of the style by the worthy but intolerant stalwarts of the English Arts and Crafts movement, if it has any value at all as a critical statement, tends to confirm rather than deny the validity and integrity of Art Nouveau.

August Endell designed the Elvira photographic studio (now demolished) in Munich in 1896. The ornament of the reception hall (*below*), based on forms of submarine life, is repeated on the façade (*opposite*) which is starkly devoid of any other ornament. The close attention to the proportions of the door and window openings reflects Endell's interest in the psychology of aesthetics.

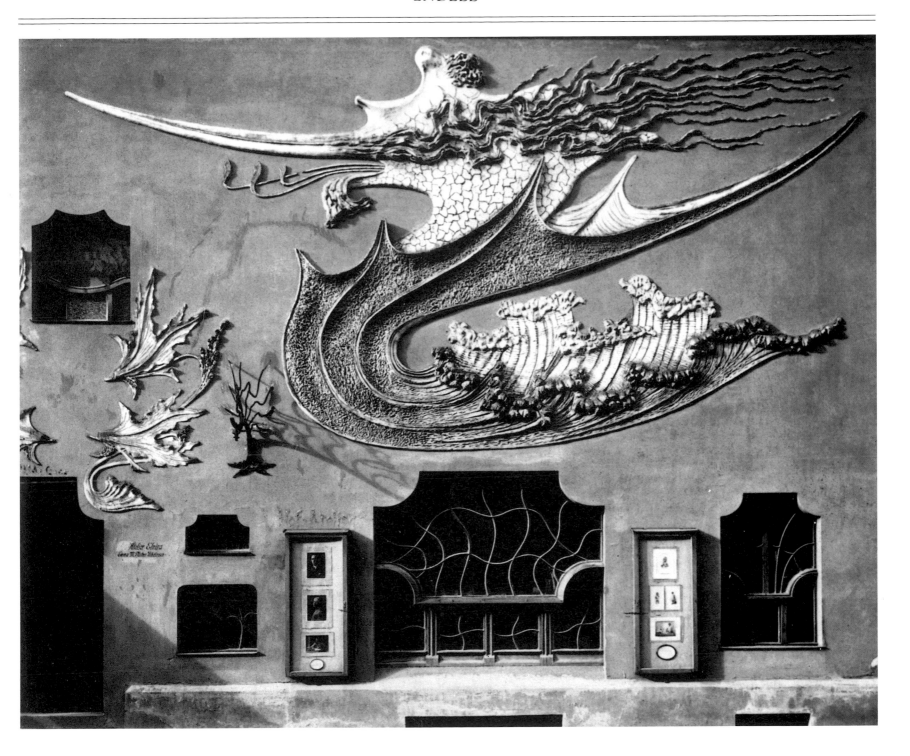

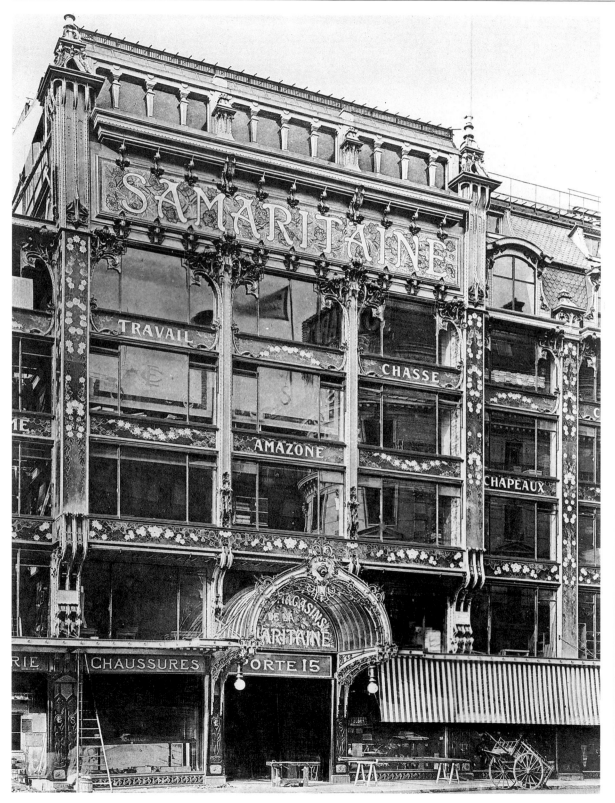

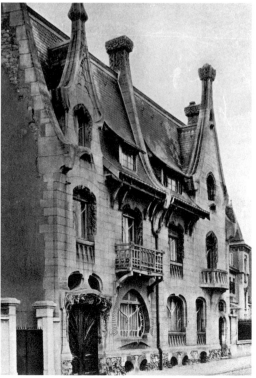

The Samaritaine department store (*left*) in Paris, designed by Frantz Jourdain and built 1905-7, contrasts with the house (*below*) in Nancy, designed by Emile André and built in 1903. Jourdain's Beaux-Arts training has resulted in a rational concept, while André's design is much more individual and romantic.

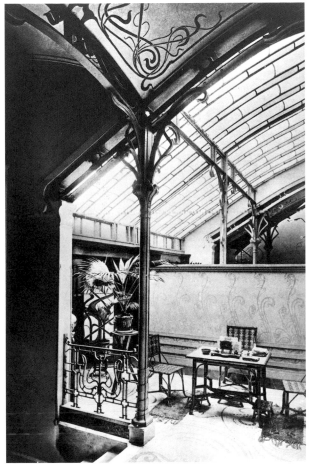

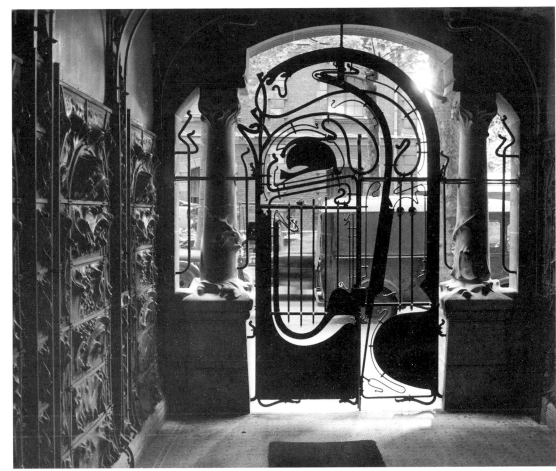

The interior of Victor Horta's Hôtel Tassel (1893) in Brussels was one of the earliest examples of full-blown Art Nouveau design (*above*). Hector Guimard, strongly influenced by Horta, built the Castel Béranger apartments between 1894 and 1898 (*above right*). The Humbert de Romans concert hall (*right*), designed by Guimard in 1899, shows the architect using plant forms structurally as well as ornamentally.

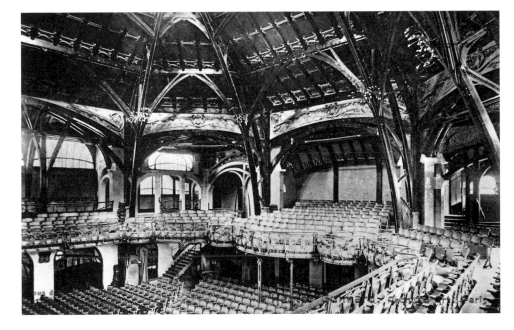

At his home Bloemenwerf, outside Brussels, Henry van de Velde sought to create a complete environment, even including dress, designed in his own abstract style of Art Nouveau (*left and above*). These gowns fall loosely around the wearer in the fashion adopted by women in the 'artistic' circles of the era.

The Italian architect Giovanni Michelazzi built the Villino Giulio Lampredi (*right*) and the Villino Broggi-Caraceni (*below*) in Florence around 1910. Art Nouveau reached Italy late, but Italian designers brought their own flair to the style.

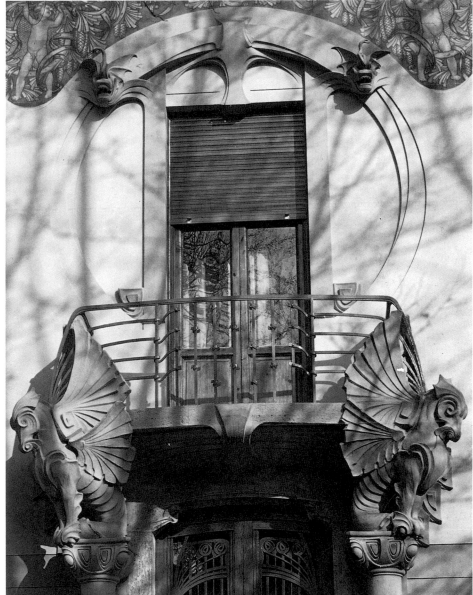

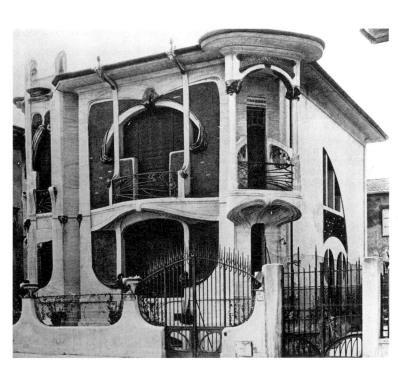

Eugène Vallin of Nancy designed the furniture and lamp fitting for this interior exhibited at the Salon d'Automne of 1910. This is the Nancy style in its dying moments.

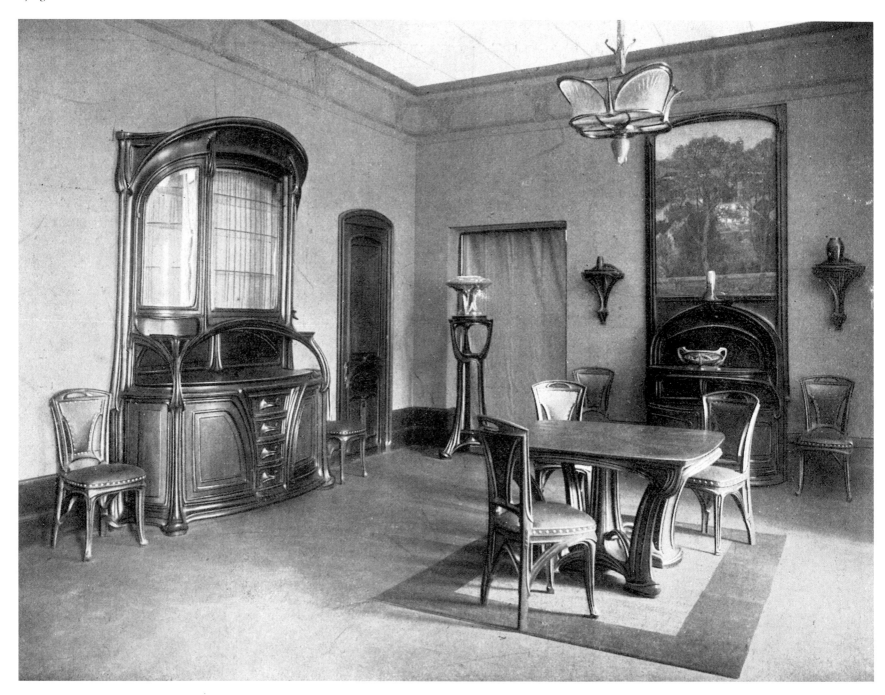

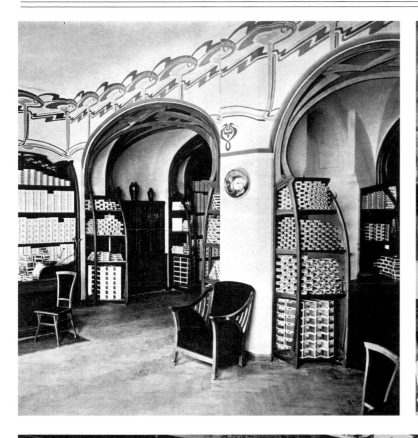

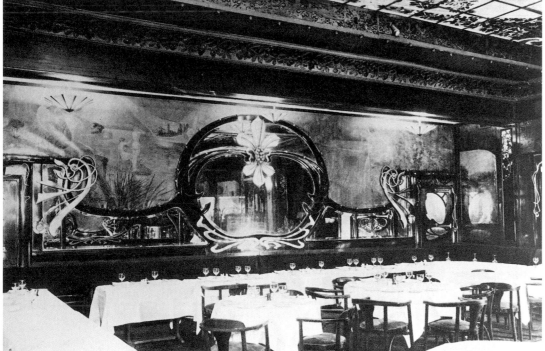

This study photographed *c.* 1900 (*above*) has been furnished with chairs by Eugène Gaillard and a writing table by Edward Colonna. The potted palm and the oriental screen were typical adjuncts to an Art Nouveau ensemble.

Henry van de Velde's version of Art Nouveau became widely popular in Germany around the turn of the century. He designed this interior in 1899 for the Havana Cigar Store in Berlin (*above left*).

The interiors of Maxim's restaurant (1899) were designed by Louis Marnez (*left*); the design borrowed elements from the work of both Grasset and Guimard.

The façade of the Casa Milá (*below and above right*) resembles a beach marked by a receding tide, with the iron balconies representing seaweed. Designed by Antoni Gaudí and built between 1906 and 1910, the building was, however, nicknamed by the citizens of Barcelona 'La Pedrera' (the Quarry). The Casa Battló (*below right and opposite*) for which Gaudí designed this façade in 1904, testifies not only to the architect's fondness for biological forms but also to his devotion to the structural principles of Gothic architecture.

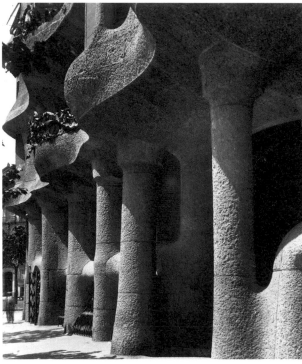

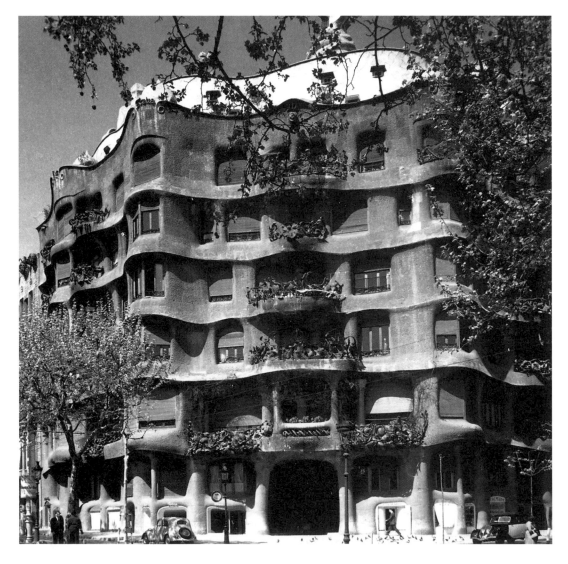

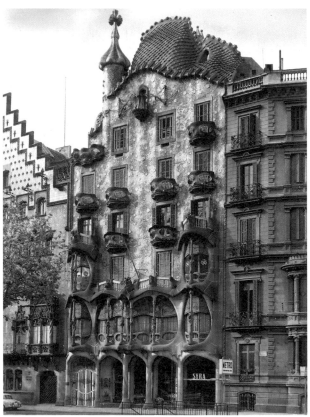

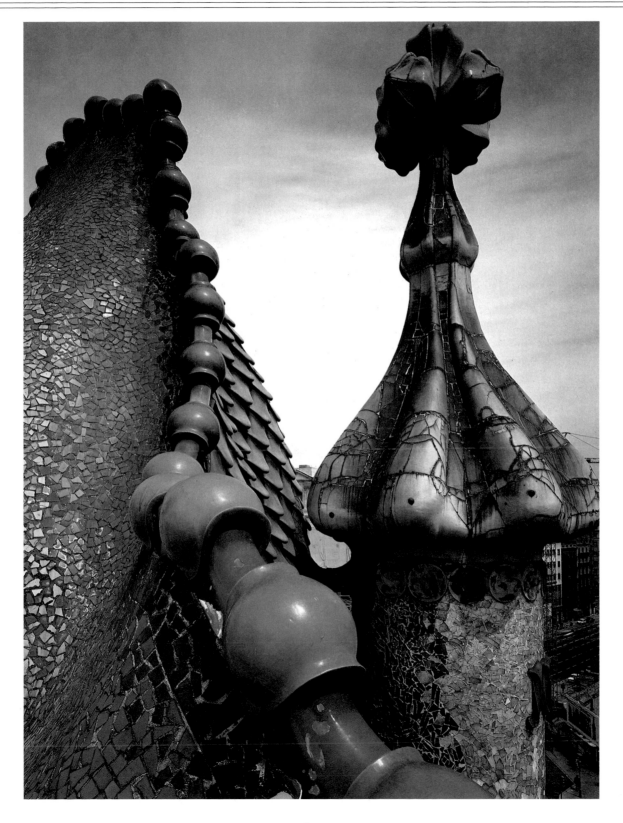

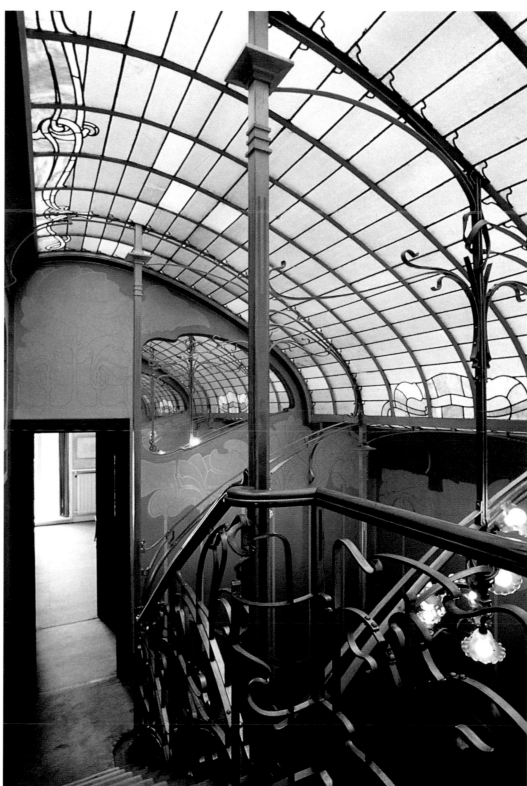

The façade (*above*) and dining room (*opposite*) of the house which Victor Horta designed for himself in Brussels (1898) display the architect's confident handling of both the Art Nouveau style and unusual materials, such as wrought iron and glazed bricks. The decoration of the staircase (*right*) is a particularly good example of the Art Nouveau style which flourished in Brussels during the 1890s. Horta was its leading exponent, his influence spreading especially to France and Germany.

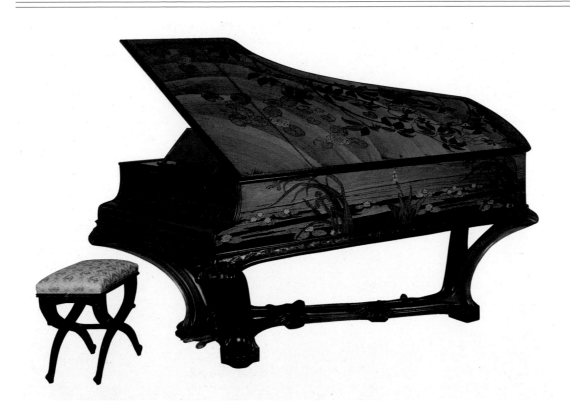

Three pieces of furniture all designed by Nancy artists: the grand piano and stool (*left above*, c. 1905) are the work of Louis Majorelle and are decorated with marquetry designed by the painter Victor Prouvé. The dressing table (*left below*) was exhibited at the 1900 Universal Exhibition in Paris. The *étagère* (*below*), designed by Emile Gallé c. 1900, incorporates carved dragonflies, one of his favourite motifs.

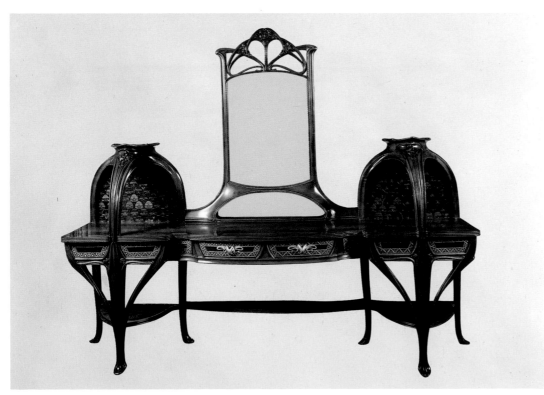

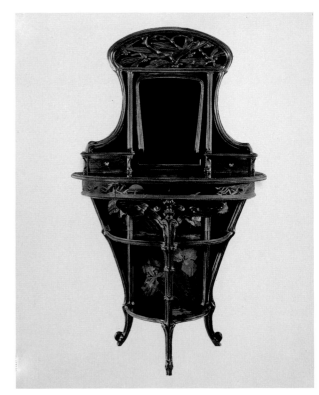

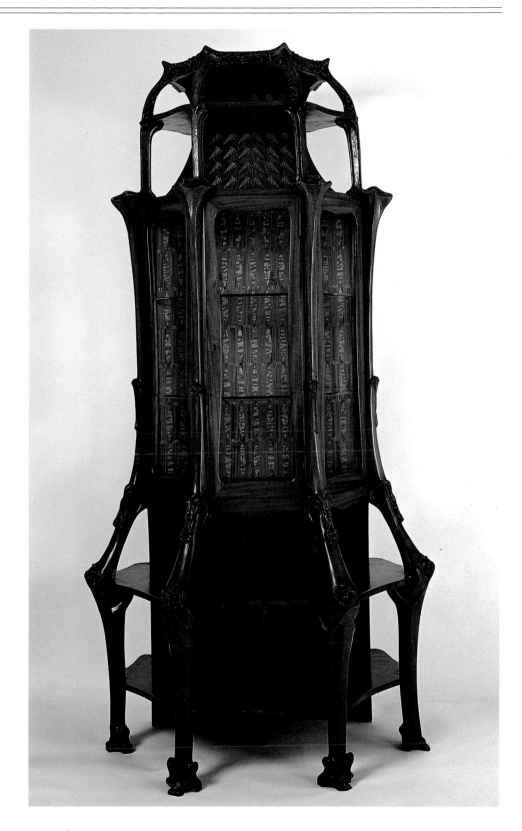

Oak *vitrine* (*c.* 1899) by Bernhard Pankok; it was
made by Vereinigte Werkstätten für Kunst im
Handwerk and is almost identical to one that
Hermann Obrist commissioned from Pankok for his
own house. The skeletal form is typical of the
Munich designers who were inspired by Haeckel's
biological illustrations which were being published
at the time. (K. Barlow Ltd, London)

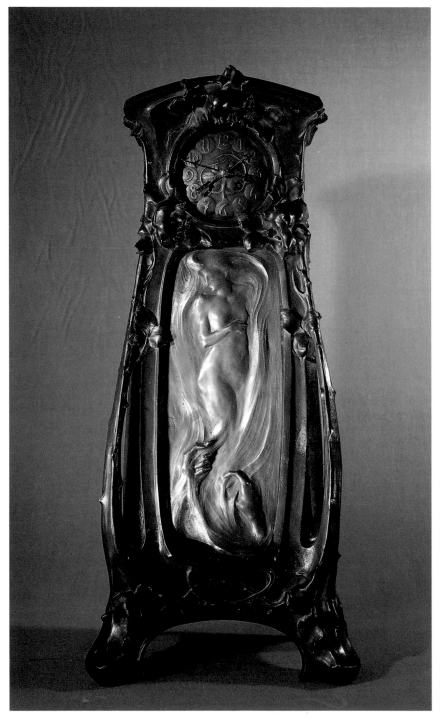

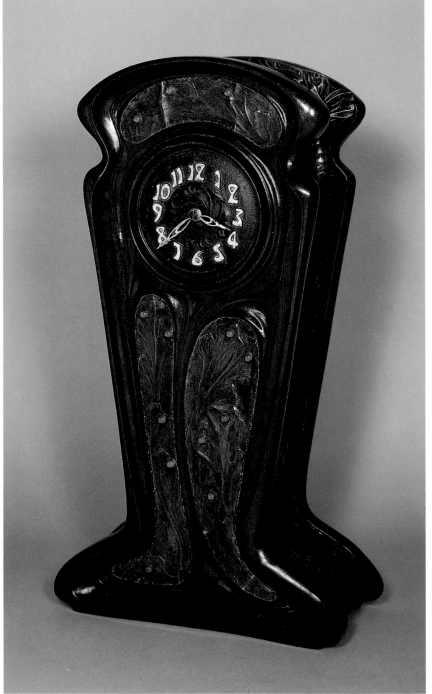

This partly gilded bronze mantel clock (*opposite left*) was cast from a model by Alexandre Charpentier (*c.* 1900). The juxtaposition of floral forms to a very sensual female nude is often found in Parisian Art Nouveau, imagery which the decorative style shared with Symbolist painting. The mahogany clock designed by Louis Majorelle (*opposite right*) is in the simpler style of the Nancy school.

The stoneware vases by Adrien Dalpayrat (*below right*) and Jean Carriès (*below left*) are both derived from Japanese peasant pottery. Carriès, a sculptor who turned to pottery in his mid thirties, worked at Saint-Amand-en-Puisaye, a traditional pottery area near Nevers. Dalpayrat specialized in the *rouge flambé* glazes seen on the piece illustrated.

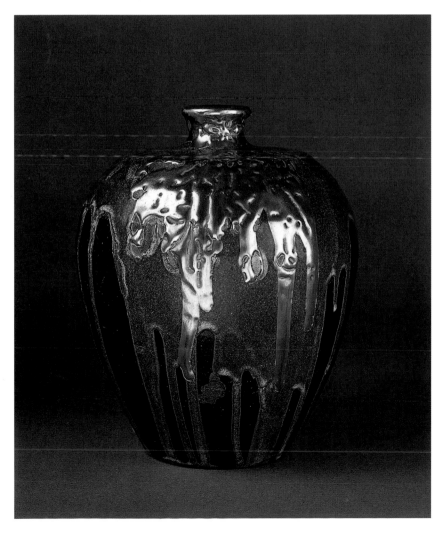

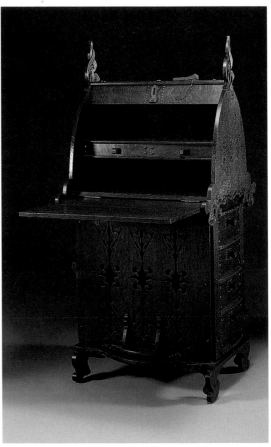

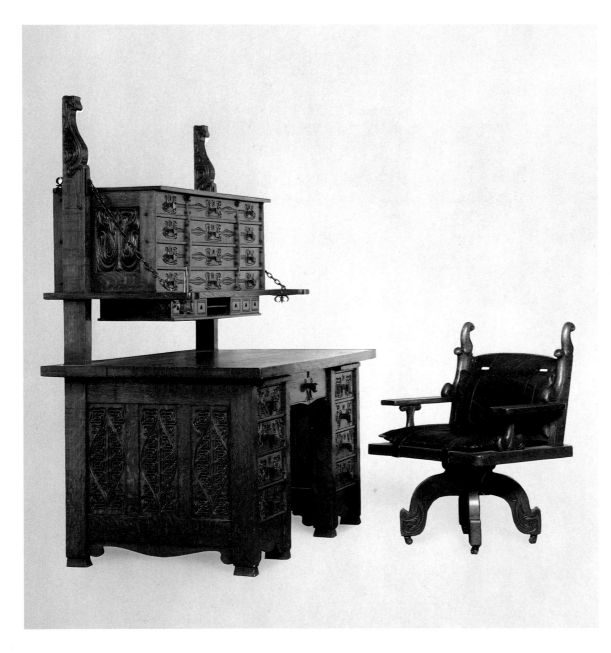

Charles Rohlfs carved his furniture (*left and above*) with spiralling motifs which, he said, were suggested by cigarette smoke, but which perhaps owe a more direct debt to the work of Louis Sullivan and Edward Colonna.

A brooch (*below right*) of gold and opals and a
pendant (*below left*) of gold, opals and topaz made by
A. Fogliata for Frances M. Glessner, the wife of a
Chicago millionaire; little is known of Fogliata who
worked in Chicago during the first decade of this
century. The style of his jewellery is related to both
French Art Nouveau and the English Arts and
Crafts movement.

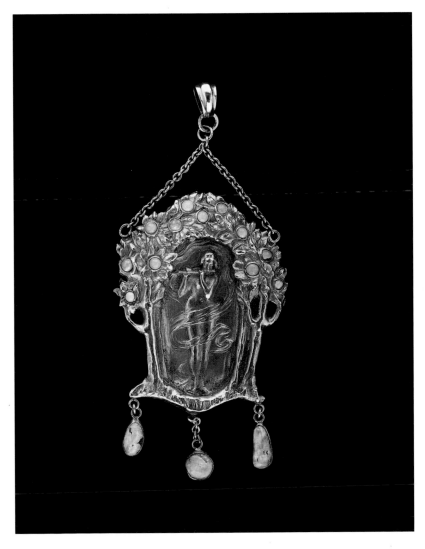

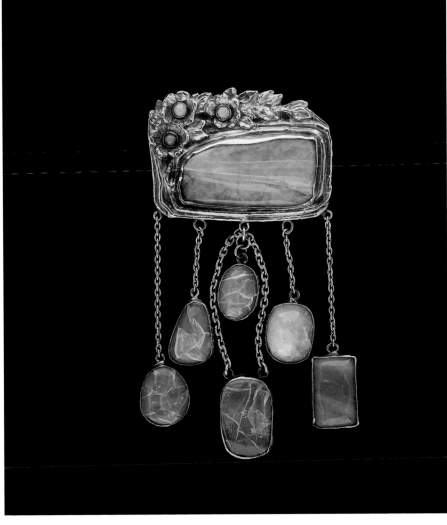

Tiffany lampshades were usually mounted on bronze stands which were also made by the Tiffany Studios (*opposite left*). This lamp is much less distinctively Art Nouveau than the example (*opposite right*) with a ceramic base made by the French potter Clément Massier.

Tiffany Studios made ceramics (*below left*) as well as glass (*below right*). Their porcelain vases were made in the forms of plants, here a fern frond. The 'lava' technique of this glass vase was one of Tiffany's finest achievements.

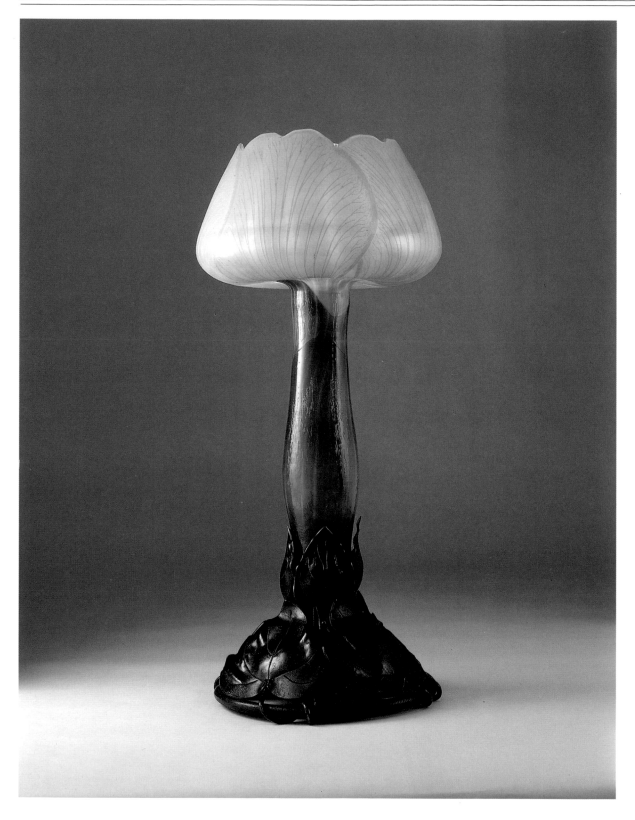

Emile Gallé displayed his mastery of the glass medium in this bronze-mounted table lamp called *Corolla* (*c.* 1900). It is made of blown glass which has been cameo carved and etched.

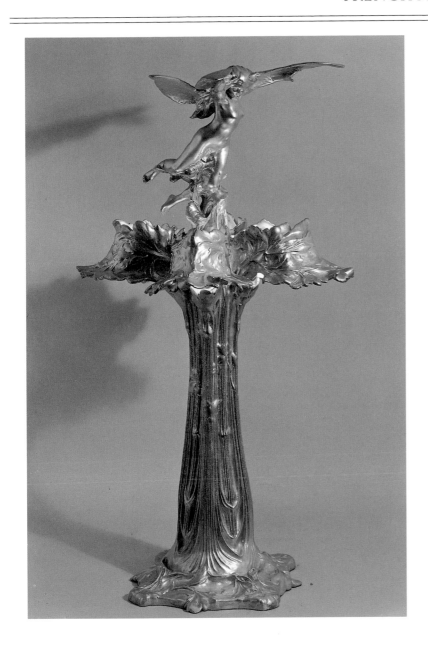

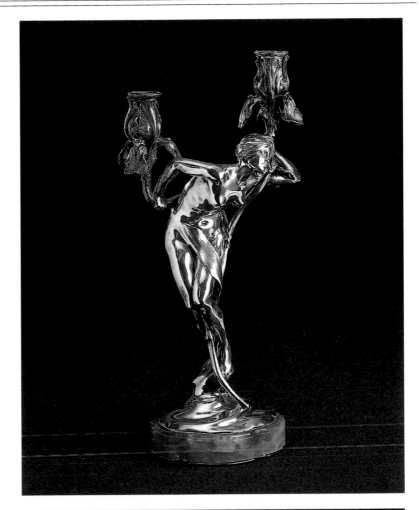

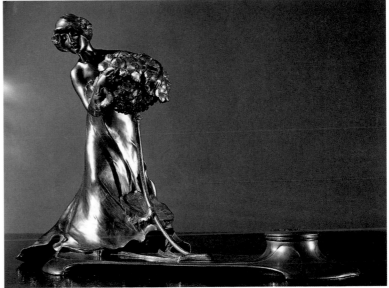

French Art Nouveau designers often incorporated female figures in functional objects. The silver candelabrum (*above right*) was cast from a model by Maurice Bouval, entitled *Dream*. Raoul Larche's gilt-bronze table lamp *Dragonfly* (*above*) is a fine example of the Art Nouveau designer's obsession with the metamorphosis of woman into plant or animal form. The gilt-bronze desk lamp (*right*) was modelled by Charles Korschann.

Philippe Wolfers, a Belgian sculptor who designed pottery and glass as well as jewellery, created this pendant (*right*) of enamelled gold, pearl, mother-of-pearl, garnets and carved cornelian.

René Lalique created this corsage ornament *c.* 1898. Made of gold, enamel, chrysoprase, moonstone and diamonds, it depicts a monster dragonfly, with griffin's claws, disgorging a female figure bedecked with the insect's wings – macabre sexual imagery characteristic of much high Art Nouveau (*opposite*).

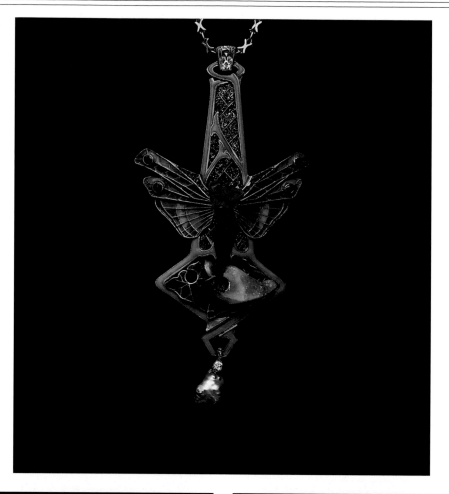

The influence of Lalique is plainly discernible in this gold brooch by the Parisian jeweller Georges Fouquet which incorporates enamelling, diamonds, engraved glass and a pearl (*below right*).

The Danish jeweller and metalworker Georg Jensen made this silver belt buckle set with opals (*below left*).

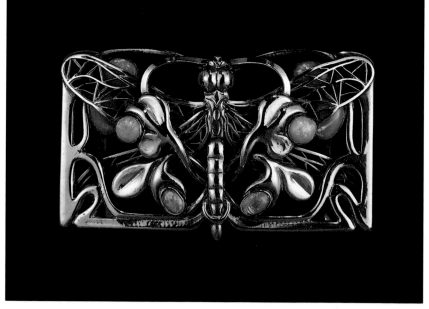

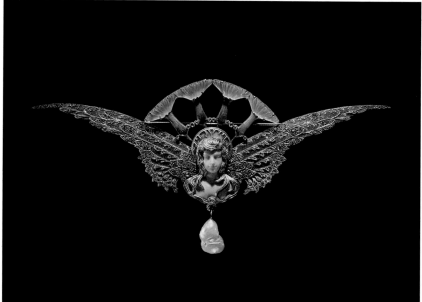

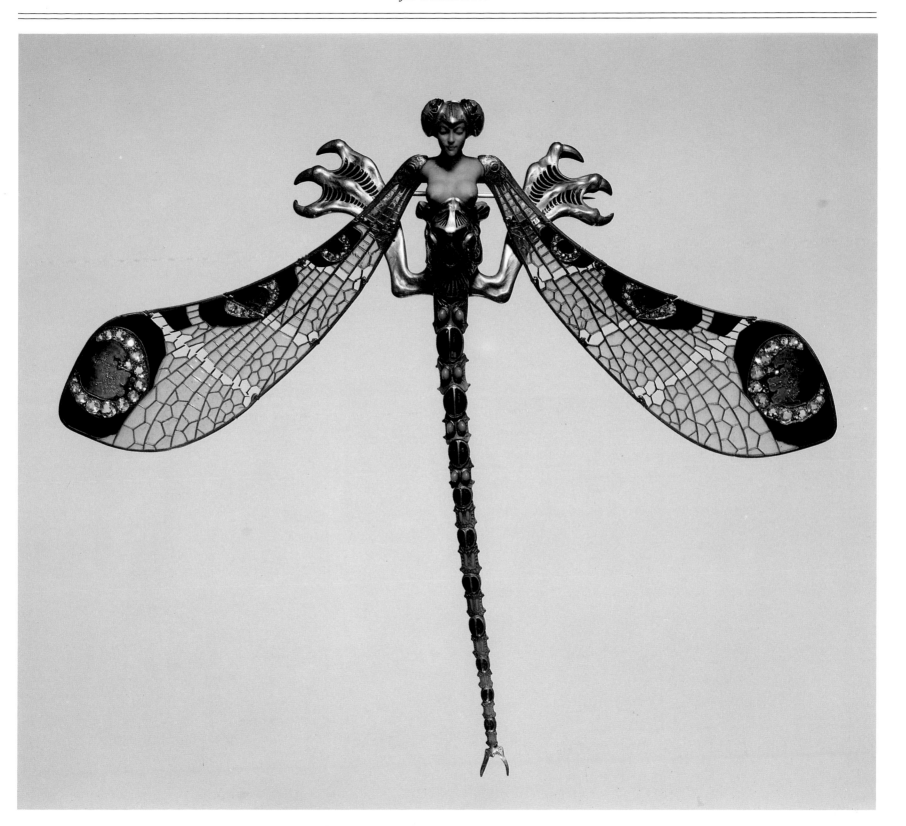

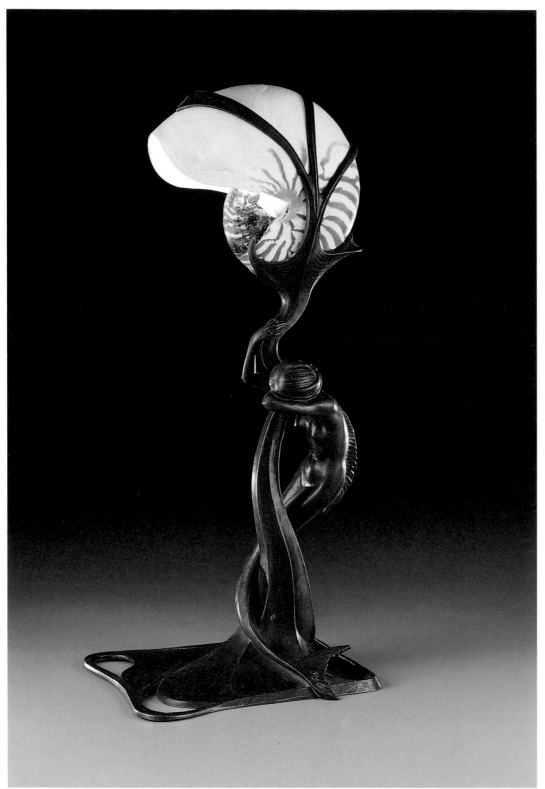

This bronze table lamp (*left*) was cast from a model by the Viennese sculptor Gustav Gurschner; the shade is an actual nautilus shell.

The Johann Loetz-Witwe glassworks at Klostermühle, Austria, made iridescent glassware from the 1880s onwards, sometimes like this vase (*below*), decorated with applied metal.

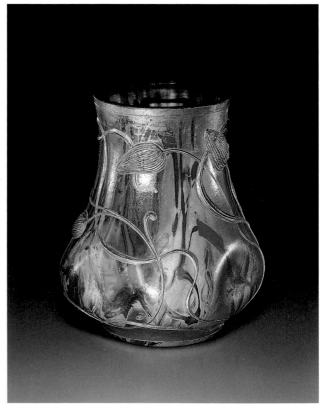

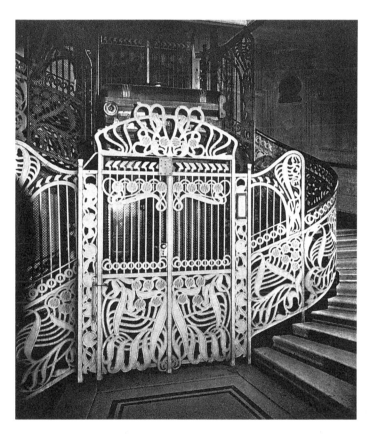

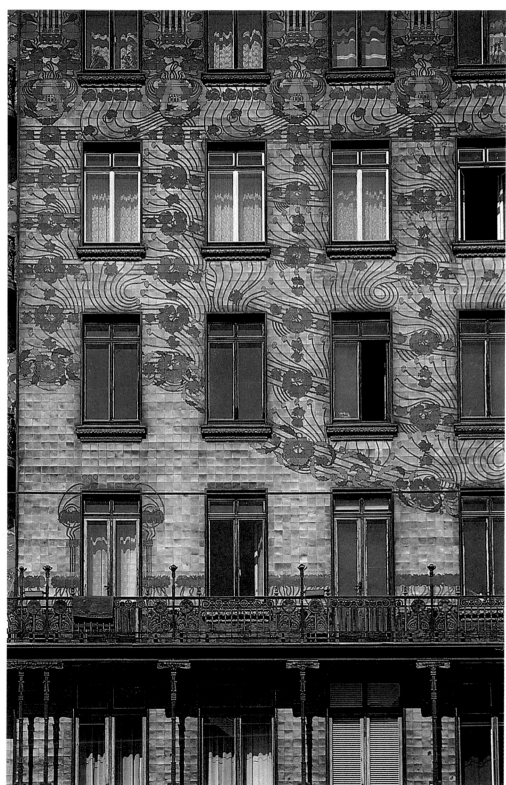

The Majolikahaus (*right*), so called because of the tiled façade, was built in Vienna by Otto Wagner in 1898. The curvilinear decoration corresponds to French and Belgian Art Nouveau of the same era. Later, Austrian designers developed their own geometrical version of Art Nouveau. Wagner also designed the lift gates (*above*) for a neighbouring house on Linke Wienzeile, Vienna.

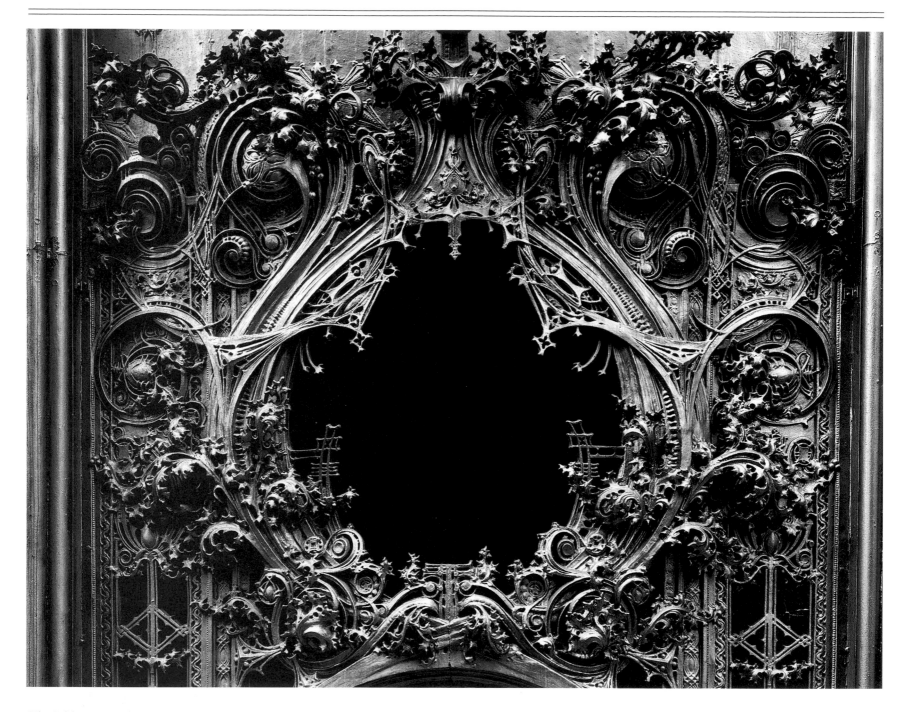

The Schlesinger and Mayer Store (now Carson Pirie Scott) in Chicago was designed by Louis Sullivan and built between 1899 and 1904. This cast iron decoration over the entrance reveals Sullivan's debt to Gothic ornament, the revival of which in the nineteenth century presaged the more revolutionary style of curvilinear Art Nouveau.

Charles Ricketts' book covers and illustrations were among the few instances of high Art Nouveau to appear in English design.

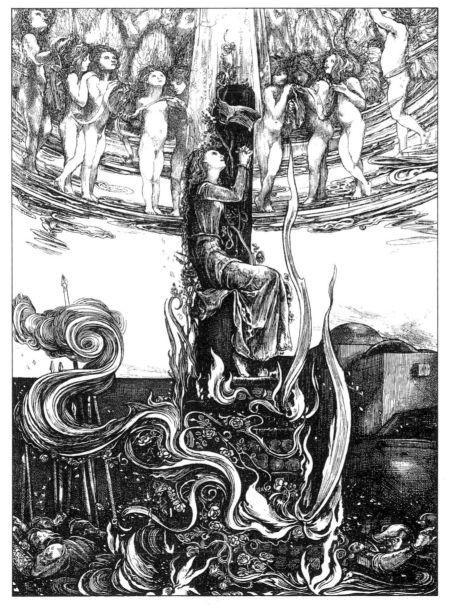

THE NEW GEOMETRIC STYLE

Art Nouveau offers some stark contrasts. Take, for example, two side chairs, one designed by the French architect Hector Guimard, and the other by Josef Hoffmann, also an architect, but working in Vienna. Made within a few years of each other, the chairs are as different as they posssibly could be, given that they were both built to fulfil the same function, and from the same material – wood. There is not a single straight line in Guimard's chair, in Hoffmann's not a curved one. Whereas the legs on the chair designed by Guimard gracefully swell and taper, those on Hoffmann's have a uniformly square section. The back rest on Guimard's chair is sensuously curved; on Hoffmann's it is rigidly rectilinear. There is some floral ornament carved in low relief on Guimard's chair, but the one designed by Hoffmann is completely unadorned.

The geometrical version of Art Nouveau which developed in Glasgow, Vienna, Darmstadt and Chicago, although visually so remote from the curvilinear, floral style, was nevertheless an outcome of the same cultural climate. The phenomenon arose as a result of there being in those cities, just as there was in Paris or Brussels, a progressive intelligentsia with sufficient wealth to pay artists and designers to create an environment which expressed the modern outlook and ignored traditional styles. A successful young doctor in Vienna would probably have shared with his counterpart in Brussels a strong belief in science, some sympathy with feminism, a mild form of socialism and a love of Wagner's music and Ibsen's plays, but he would almost certainly have bought his wife jewellery designed by Hoffmann in a geometrical style rather than a curvilinear, figural piece created by Philippe Wolfers. Similarly, the designs of C.R. Mackintosh or Frank Lloyd Wright fulfilled the same cultural aspirations and satisfied the same artistic appetite as the work of Louis Majorelle or Antoni Gaudí, but the forms of their work are markedly different. The Austrian painter Carl Moll, whose house in Vienna had been built and furnished by Hoffmann, gave a prominent place in his studio to a statuette by the Belgian Art Nouveau sculptor Georges Minne: the geometrical and curvilinear styles of Art Nouveau could easily share a similar clientele.

Glasgow was an ideal seedbed for Art Nouveau. Business in the city was thriving at the end of the nineteenth century as a result of rising demand for the ships which were built in the yards along the river Clyde. Remoteness from London and a lingering nationalist resentment against English government caused a large measure of discontent with established authority. Equally, the strong presence in the city of both the Presbyterian and Catholic churches ensured an

aversion to organized religion among those who felt that salvation lay in an unprejudiced belief in scientific progress. Feeling powerless and frustrated, intellectuals turned to art for solace. The artist and author Joseph Pennell, writing in 1900, commented: 'Art never has been, is not now, and never will be an affair for the multitude. But I do think that the few who care in Glasgow care more intelligently than the few who care in London, or Liverpool, Manchester or Birmingham.'

In 1885 Mackintosh had enrolled as a student at the Glasgow School of Art where Francis Newbery was the newly appointed principal. He had remained as a part-time student during his apprenticeship to a Glasgow architect, and in the autumn of 1893 he had attended a series of lectures on the applied arts which Newbery had organized at the School of Art. Mackintosh and his friend Herbert MacNair had been introduced by Newbery to the Macdonald sisters, Margaret and Frances, their respective brides to be. MacNair designed some furniture, and the Macdonald sisters designed and made metalwork. Margaret collaborated with Mackintosh on many of his decorative schemes, making several gesso panels and stained glass windows. The two couples became known as the Glasgow Four, and they exhibited as a group at Liège (1895), Vienna (1900), Turin (1902) and elsewhere. The decorative style they developed, apart from being influenced by the art of the Glasgow Boys and Japanese prints, owed something to the current revival of interest in Celtic ornament. In addition, their work was influenced by the prints of Aubrey Beardsley, paintings by the Dutch artist Jan Toorop and the furniture of C.F.A. Voysey. Illustrations of these three artists' work were published in early issues of *The Studio.*

The first decorative scheme commissioned from Mackintosh was for Miss Cranston's Tea Room in Buchanan Street, Glasgow, and he subsequently designed furniture, metalwork and mural decorations for her other tea rooms. His *chef d'œuvre,* however, was undoubtedly the new Glasgow School of Art, which was built in two stages, the first lasting from 1897 to 1899 and the second from 1907 to 1909. Mackintosh designed not only the building but also the furniture, light-fittings, and metalwork such as iron railings, finials and weather-vane.

Mackintosh's style ranges from a diagrammatic version of full-blown Art Nouveau, complete with mysterious females and spiralling plants, at one end of the scale, to unadorned arrangements of geometrical shapes at the other; in between, every degree of formalization and abstraction is to be found. Much of his work has for its main feature the swelling curve that characterizes Art Nouveau at

This decorative motif designed by Peter Behrens indicates the trend towards geometrical Art Nouveau which characterized the work of the Darmstadt artists' colony founded in 1899.

the turn of the century, and his ornament often has some symbolic meaning, another feature of most Art Nouveau. Although Mackintosh and his wife disliked the writhing forms of French and Belgian Art Nouveau, their work was usually put in the same category by their contemporaries in Britain. Their genius and originality were better appreciated on the Continent, particularly in Austria.

In Vienna during the 1890s, conditions similar to those in Glasgow prevailed. As in the Scottish city, there emerged during the last quarter of the nineteenth century a group of wealthy and intellectual people who held advanced views, but who were denied any influence or authority in the extreme conservatism of the Austro-Hungarian Empire. It was administered by an awesome bureaucracy, supervised by a hereditary nobility which also provided the army with its officers and the church with its prelates. This aristocratic clique devoted much of its attention and energy to the functions and intrigues of the Imperial Court. At the head of this archaic machinery of state sat His Imperial and Royal Apostolic Majesty the Emperor Franz Joseph, whose chief preoccupations were the preservation of his power and the ruthless suppression of anything or anyone remotely threatening it. In 1898 he celebrated the fiftieth anniversary of his accession to the throne. There were parades, banquets, balls and tributes from his loyal subjects. The Social Democratic Party, however, did not hit quite the right note when they issued a medal commemorating the fiftieth anniversary of the 1848 revolt, when revolutionaries had come close to ending the young monarch's life.

The Social Democrats' medal was a reflection of the beam of light which had shone in the general gloom of political and cultural life since the previous year when the Christian-Socialist Dr Karl Lueger had been elected mayor of Vienna. Only when the populace had taken to the streets had the Emperor grudgingly ratified the election. In the arts, too, the year 1897 had seen inroads made into the hidebound conservatism which dominated the official institutions. In spite of opposition from the highest quarters, Gustav Mahler had been appointed director of the Imperial and Royal Court Opera. He had made his debut there conducting a performance of Wagner's *Lohengrin*. Among the painters, sculptors and architects of the Kunstlerhaus (House of Artists), the official institution which controlled artistic life in Vienna and throughout the Empire, dissension had been rumbling, and on 24 May 1897 seventeen of its members had resigned. They had been led by the painter Gustav Klimt, and their number had included the painter Koloman (Kolo) Moser and the architect-designer Joseph Maria Olbrich. The group was called the

Vienna Secession, and on 2 July another architect had joined them, Josef Hoffmann.

Like so many of the groups involved in the development of Art Nouveau, the Secessionists were quick to launch their own magazine. They called it *Ver Sacrum*, 'Sacred Spring' in Latin, and its pages were filled with the latest in art and literature from Austria and abroad. From its first issue in 1898 the magazine had its own distinctive graphic style which was, however, derived from several sources, not the least conspicuous of which was the work of the Glasgow Four. Soon, Vienna had its own journals devoted specifically to the decorative arts: *Kunst und Kunsthandwerk* (Art and Art Handicraft) from 1898 and *Das Interieur* (The Interior) from 1900.

In the first issue of *Ver Sacrum* the artists of the Secession declared: 'We recognize no distinction between "high art" and "minor art" . . . ', and their first exhibition, held in 1898 at the Vienna Horticultural Society's hall, included pieces of furniture designed by Hoffmann in a simple, geometrical style which owed much to the aesthetic philosophy of his mentor, the architect Otto Wagner. Olbrich who worked in Wagner's office adopted a similar manner when he built, later the same year, the Secession House where the group held all its future exhibitions. A suitable site had been secured by the Secession through its friends on the new city council, and the funds required for erecting the building had been provided partly by donations from wealthy backers such as the iron and steel magnate Karl Wittgenstein. An arrangement of flat-faced blocks was surmounted by a large sphere covered with gilt-bronze laurel leaves. Any building composed of such simple elements was bound to be conspicuous among the dramatic, ornate edifices – Gothic, baroque and rococo – that filled central Vienna.

Exhibitions organized by the Secession followed each other with amazing rapidity. They all showed members' work and in addition usually featured contributions from foreign artists. In 1899 at the third exhibition there was a room devoted to Walter Crane and another to Eugène Grasset. At the next show, paintings by the Glasgow Boys were displayed, including works by David Gauld and Edward Hornel. In the same exhibition Hoffmann arranged a 'Grey Room', with furniture and a decorated ceiling in a style which could be described as part Mackintosh and part van de Velde. The fifth Secession exhibition, still in 1899, featured the graphic art of Aubrey Beardsley, who had died the year before. Fritz Waerndorfer, an industrialist and the friend and patron of several Secessionist painters and designers, owned an extensive collection of Beardsley's prints

The Austrian architect Joseph Maria Olbrich designed this clock about 1900. Although the form of the case is curvilinear, the numerals on the dial are severely geometrical and look forward to the style of the Wiener Werkstätte. (K. Barlow Ltd, London)

which he was always glad to show to his visitors. Kolo Moser designed a bookplate for him in 1903 which is almost a pastiche of a Beardsley print. The subject of the Secession's sixth exhibition (early 1900) was Japanese art; it is a measure of Vienna's artistic isolation during the second half of the nineteenth century that most of the exhibits had to be borrowed from a collector in Cologne.

The decorative arts were the primary concern of the eighth Secession exhibition (late 1900). Hoffmann, Moser and other Viennese designers were represented, and from abroad there were displays sent by La Maison Moderne (the Paris shop run by Julius Meier-Graefe), C.R. Ashbee's Guild of Handicraft and the Glasgow Four. The room decorated by Mackintosh and his wife and furnished by them and the MacNairs was particularly well received. The style of this room was very much that of the Tea Rooms in Glasgow; indeed, the dominant feature was two large gesso panels which had been commissioned by Miss Cranston for her Tea Rooms in Ingram Street. One Viennese critic, Ludwig Hevesi, described it as 'a white room with scattered white squares of decoration', and he noted the 'black, stiff-necked furniture' and 'a predilection for spectral and grotesque human forms whose excessive thinness gradually leads into thread-like linear curves'. Another critic, Richard Muther, wrote in similar vein: 'You stand perhaps in the room of Mr and Mrs Mackintosh, you see thin, tall candles, chairs and cupboards which thrust upwards in pure verticals, panels with slender elliptical figures whose outlines are determined by the linear play of the unifying thread.'

Neither critic was particularly enthusiastic about the geometrical features of Mackintosh's work, although both suggested that they contributed to the unity of the whole ensemble. The rectilinearity of Ashbee's furniture designs, however, was noted by Hevesi, who derisively observed that they might have come 'from a rectangular planet inhabited by four-square peasants'. By 1900 both Hoffmann and Olbrich, as well as Mackintosh, had produced designs which consisted exclusively of geometrical shapes. Their work was acclaimed by the critics, while Ashbee's was greeted with less than polite approval, because it was elegant and stylish. Hevesi apostrophized Ashbee's furniture as 'simple, worthy and clumsy', and added: 'Ashbee himself is a rough and ready workshop man, even in his decorative objects, which might be taken for domestic folk art The furniture displayed here leaves the Viennese (with a few exceptions) fairly cool.'

The concept of style was a key factor in the development of geometrical Art Nouveau in Austria. The Viennese art historian

Alois Riegl had published a book in 1893 entitled *Stilfragen* (Questions of Style) in which he had argued the cultural validity of conventionalized and abstract geometrical ornament. In a later publication he had shown how central European tribes of the fifth and sixth centuries AD, previously considered benighted and uncultured, had created a consistent and refined decorative style from a combination of abstract geometrical shapes and diagrammatic representation of human and animal figures. The art of these migrant tribes (incidentally the bane of late Roman civilization) was closely related to the Celtic ornament which had inspired the Glasgow Four, a factor which – consciously or unconsciously – may have prompted the Viennese designers' admiration for their work. Riegl had written a book about middle-eastern carpets, explaining the sophisticated symbolism of their geometrical patterns.

The greatest success of the eighth Secession exhibition was the contribution from the Viennese designers themselves. The work of Hoffmann, Moser and Leopold Bauer was matched against the best of foreign design, and it proved itself at least comparable. In 1903 Fritz Waerndorfer provided the capital required to establish the Wiener Werkstätte (Vienna Workshops) which were run by Hoffmann and Moser. An extensive range of furniture, jewellery, metalwork and leather was produced at the workshops, and glass and ceramics were manufactured by outside firms to designs by the Werkstätte artists. From 1905 to 1911, the Wiener Werkstätte created the Palais Stoclet in Brussels, designed by Hoffmann for the Belgian coal magnate Adolphe Stoclet. Here, the emphasis was on a refined geometry of stark simplicity relieved only by the richness of the materials and a mosaic mural designed by Gustav Klimt which consisted of abstract ornament and scenes symbolizing carnal love, a favourite Art Nouveau theme.

A striking difference between the evolution of Art Nouveau in Darmstadt and the development of the style in Glasgow or Vienna was that, whereas in the Scottish and Austrian cities, the impetus had come from liberal groups disenchanted with established authority, in the German town the new style was fostered by a hereditary monarch and his elected government. However, the Grand Duke Ernst Ludwig, one of Queen Victoria's grandsons, was no ordinary ruler. He was nicknamed 'the red Grand Duke', and from his accession in 1892 he was eager to implement new social policies and promote new artistic activity. In 1897 he employed the English architects M.H. Baillie Scott and C.R. Ashbee to decorate a drawing-room and dining-room in his palace, and the Munich artist

Otto Eckmann was asked to design the Grand Duke's study-workroom. Ernst Ludwig sponsored the Freien Vereinigung Darmstädter Künstler (Free Union of Darmstadt Artists) and its first exhibition, held in 1898, included an applied arts section organized by a local carpet manufacturer Alexander Koch. The previous year Koch had launched a magazine, *Deutsche Kunst und Dekoration* (German Art and Decoration), which was modelled on *The Studio.*

In December 1898 Koch suggested that an artists' colony should be built in Darmstadt. Ernst Ludwig was enthusiastic and offered a hill on the outskirts of the town, the Mathildenhöhe, as a site. Parliament voted the necessary funds, and invitations were sent to six German artists, including the Munich painter and designer Peter Behrens, and one Austrian, the architect Joseph Maria Olbrich who had just built the Secession House in Vienna. The houses which Olbrich designed for the other members of the colony on the Mathildenhöhe, as well as the Ernst Ludwig House where their studios were situated, reflected the current Viennese version of Art Nouveau – simple shapes decorated with patterns based on floral motifs, full of squares, circles and triangles. Behrens, who designed his own house, also employed a geometrical style, although his was derived from the work of Henry van de Velde and C.R. Mackintosh, and ancient Egyptian decoration.

The artists of the Mathildenhöhe established a distinctive geometrical style which persisted despite frequent changes in the colony's personnel. Behrens left in 1903 and Olbrich died in 1906. But Paul Haustein who joined in 1903, and Albin Müller, who replaced Olbrich, as well as Hans Christiansen and Patriz Huber who had been among the original seven artists, all adopted a recognizably Darmstadt style while they were working at the colony.

In 1897, the Chicago Arts and Crafts Society was founded at Hull House on South Halsted Street. The venue is significant, for Hull House, which had been founded in 1889, had become one of America's leading social settlements, where welfare of the poor was combined with the promotion of craft activities. Among the founding members of the Chicago Arts and Crafts Society was the architect Frank Lloyd Wright who, recalling the 1890s, wrote: 'Good William Morris and John Ruskin were much in evidence in Chicago intellectual circles at the time.'

Wright had worked as a draughtsman for Louis Sullivan from 1888 to 1893. From the mid 1890s he often designed furniture, stained glass and decorative metalwork for the houses that he built. He was influenced by the ideas of the Viennese architect Otto Wagner and

tended towards a plain geometrical style. He had been impressed by the Japanese Pavilion at the Chicago World Columbian Exposition of 1893, and he always tried to achieve the elegant, uncluttered simplicity of Oriental design in his architecture and decoration. His stained glass sometimes reflects his knowledge of American Indian art, and the Tree of Life motif which he often incorporated in the designs probably derived from the middle-eastern carpets he collected. In 1897 he designed *The House Beautiful,* a book written by William C. Gannett and produced by the Auvergne Press in River Forest, Illinois. This private press had been started the year before by Chauncey L. Williams, a publisher, and William Herman Winslow, a manufacturer of ornamental iron and bronze, both of whose houses Wright had designed. Gannett edited a magazine called *House Beautiful,* which he had launched in 1896 and which carried articles on modern decorative art from both sides of the Atlantic. The title page which Wright designed for Gannett's book is reminiscent of Mackintosh's Buchanan Street Tea Room frieze decoration, combining enigmatic figures with a geometrical framework of plant forms.

The style of many American Arts and Crafts designers was geometrical, at first in imitation of work by English artists such as C.F.A. Voysey and M.H. Baillie Scott, and later as a result of influences from Germany and Austria. In 1904 the Louisiana Purchase Exposition at St Louis, Missouri, featured six rooms in the German section designed by Olbrich, and photographs of them were reproduced in American journals. At about the same time the young Chicago architect William Purcell visited Europe where he was deeply impressed by the architecture of the Vienna Secessionists, an admiration which is evident in his designs for furniture. Another prominent American designer, Dard Hunter, visited Vienna in 1908 and the metalwork and stained glass that he designed after his return owe much to the work of the Wiener Werkstätte.

The geometrical versions of Art Nouveau that had been established in Glasgow, Vienna, Darmstadt and Chicago by the end of the nineteenth century provided the source of many subsequent decorative styles in places as far apart as Budapest and San Francisco. The hot-house intensity of the full-blown Art Nouveau style could not be maintained over a period of any length, and as the flowers withered and the female figures visibly flagged, the leaping curves tended to straighten as designers turned to a more reposeful – but equally modern – style of abstract geometry. Unfortunately, it was but a short step from this to the neo-Classicism in which, even before World War I, designers such as Behrens and Hoffmann were indulging.

Interiors designed by Charles Rennie Mackintosh
are characterized by strong vertical accents. Forms
such as flowers and female figures, typical examples
of Art Nouveau symbolism, were translated by the
Scottish designer into geometrical diagrams, deftly
fitted into a rectilinear grid. The lithograph
(*opposite*) is a perspective view of a music room for
the House of an Art Lover, part of Mackintosh's
entry for a competition organized in 1901 by
Alexander Koch, editor of a Darmstadt decorative
arts journal. The doors (*right*) and the mirrors lining
a wall (*below*) are in the Willow Tea Rooms, which
Mackintosh began decorating in 1901.

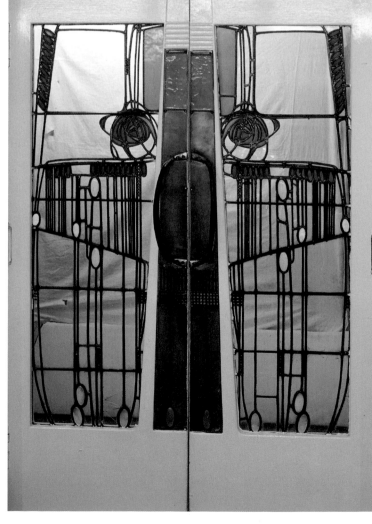

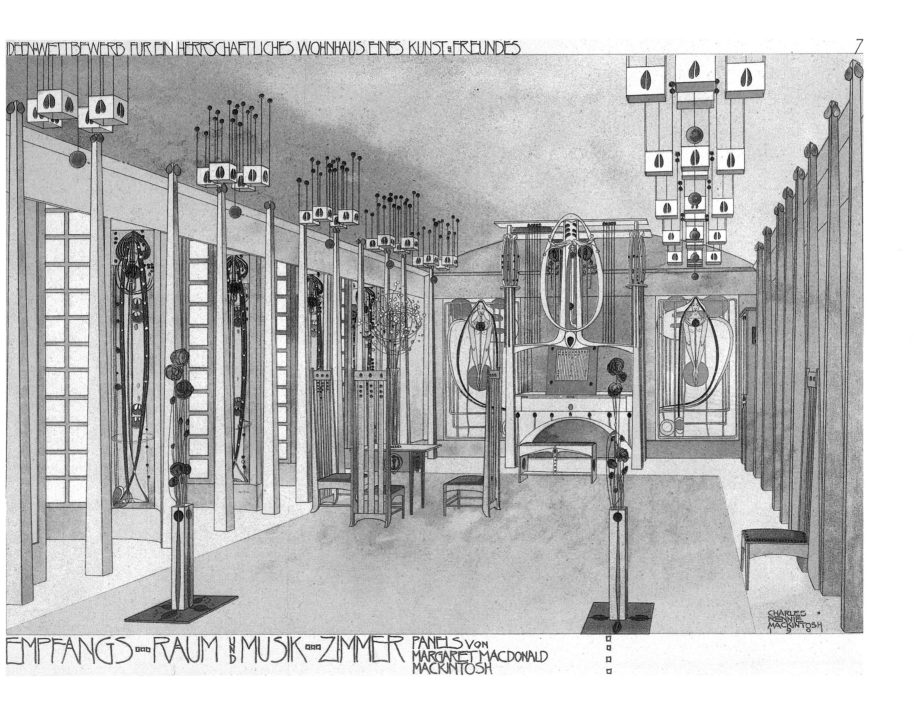

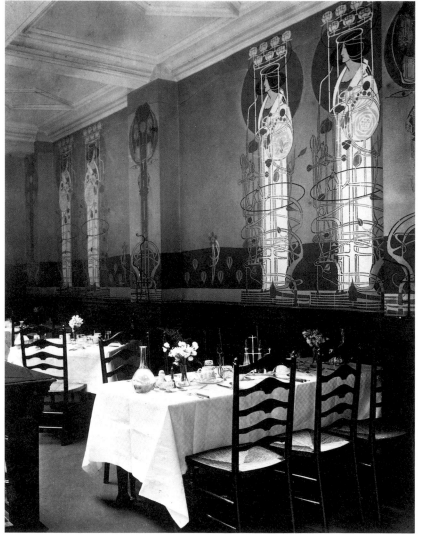

The high back chair seen in this early photograph of the dining room of the Willits house in Highland Park, Chicago, was one of Frank Lloyd Wright's boldest designs. The house was built about 1902. Compared to Mackintosh's work, Wright's style was heavier with greater emphasis on the horizontal. The severity of his forms and the lack of any ornament shocked middle-class Chicagoans.

This contemporary photograph of the sitting room in Mackintosh's Glasgow home (*left above*) shows characteristic precision and clarity. The bold geometrical forms were entirely innovative and must have seemed revolutionary to Mackintosh's contemporaries.
The wall decorations of the Buchanan Street Tea Rooms in Glasgow (*left*), designed by Mackintosh in 1898, show his style evolving from a swirling linearity to a more static geometry. It can be seen from this interior why the Glasgow designers were at first dubbed 'the Spook School' by critics.

The décor in the hall of Hill House is a clever arrangement by Mackintosh of squares and circles, light and dark, solids and voids. Mackintosh's furniture was usually either painted white or stained black, giving his rooms a striking monochrome uniformity (*right*).

Mackintosh designed Hill House at Helensburgh for the publisher J.M. Blackie; this is the main bedroom (*below*). Blackie also used members of the Glasgow school to design books which his firm published.

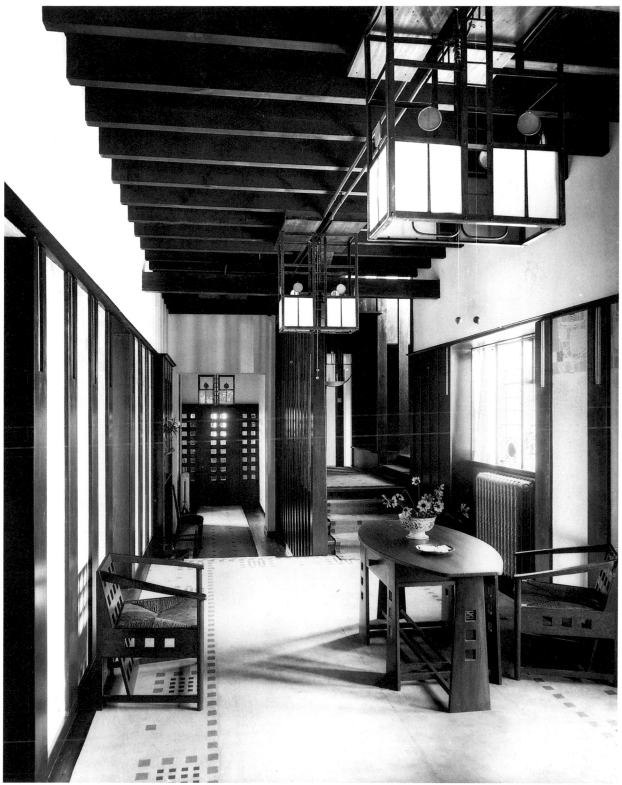

The fascination felt by Frank Lloyd Wright for geometrical shapes and patterns is clearly shown by these designs. The window (*right*) from the Avery Coonley Playhouse, Riverside, Illinois, was designed by Wright in 1912; the oak side chair (*below*) dates from about 1901, and the copper urn (*below right*) was made for the Dana House, Springfield, Illinois, which Wright designed about 1903. The glass ceiling panel (*opposite*), which Wright designed about 1900 for the B. Harley Bradley House, Kankakee, Illinois, has a central motif based on American Indian ornament.

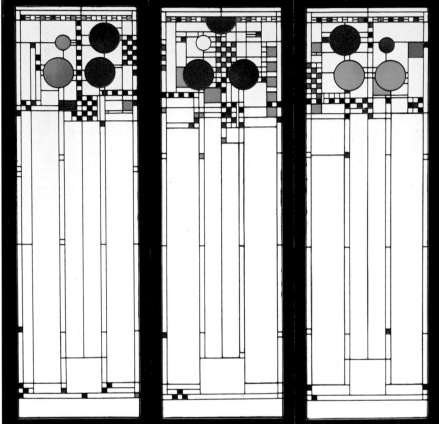

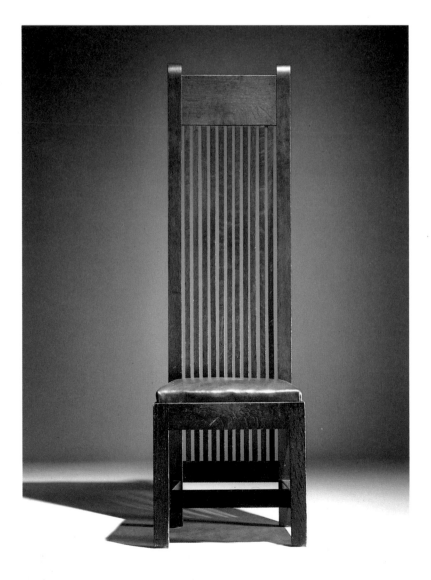

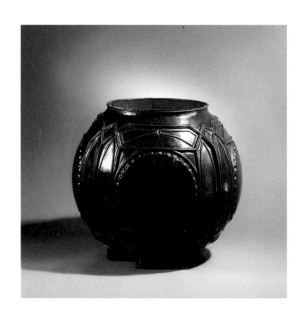

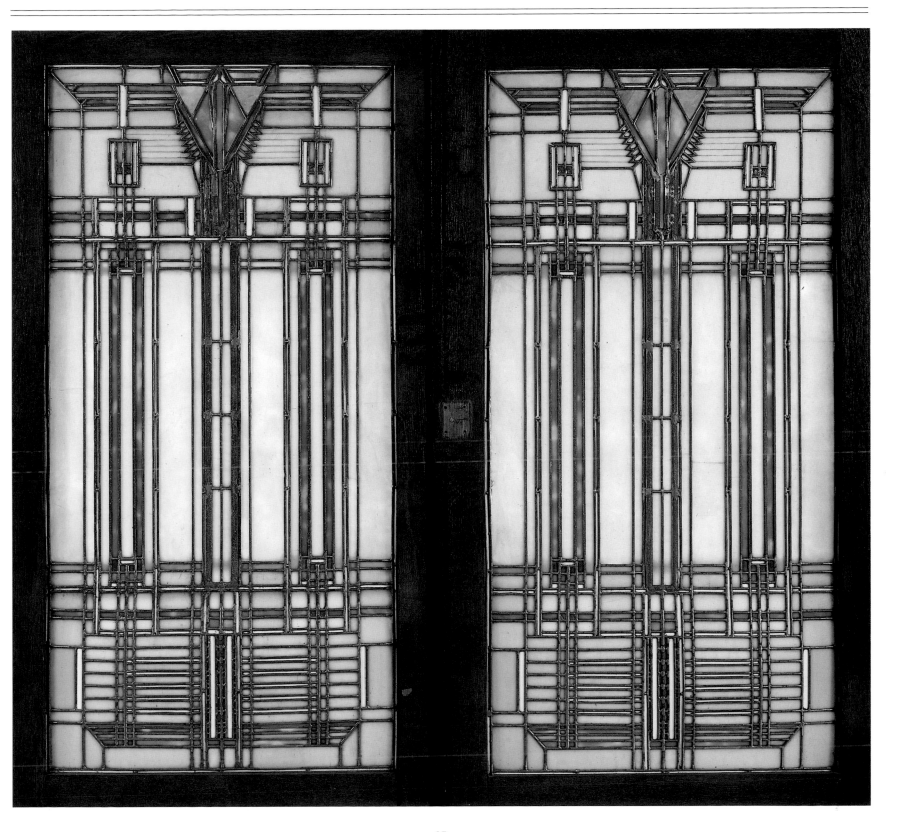

These cast iron fire-dogs (*left above*) were designed about 1910 by George M. Niedecken, who sometimes collaborated with Frank Lloyd Wright. Their cubic form is a striking example of the geometric decoration which flourished in Chicago.
This fall-front desk designed by Harvey Ellis for Gustav Stickley's Craftsman Workshops in 1903-4 (*above*) has the severe rectilinearity which typifies the designs of the American Arts and Crafts movement.
William Gray Purcell, who designed this oak and fir table about 1912 (*left*), was a Chicago architect of the Prairie School. He became much influenced by the architecture of the Viennese Secession after a trip to Europe.

Kolo Moser, co-founder with Josef Hoffmann of the Wiener Werkstätte in 1903, designed for several different media in a style which became increasingly geometrical. The furnishing fabric (*right below*) which features recognizably floral forms, and the design for a necklace (*below*), with its staring female face, demonstrate the stylistic affinities which existed between Glasgow and Vienna. The swirling, abstract pattern (*right above*) was reproduced in the Viennese design periodical *Ver Sacrum* in 1899.

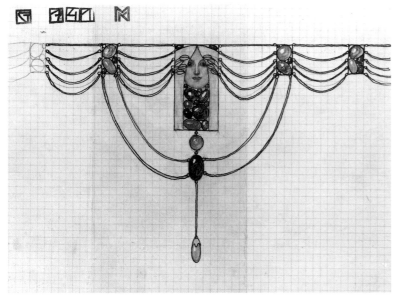

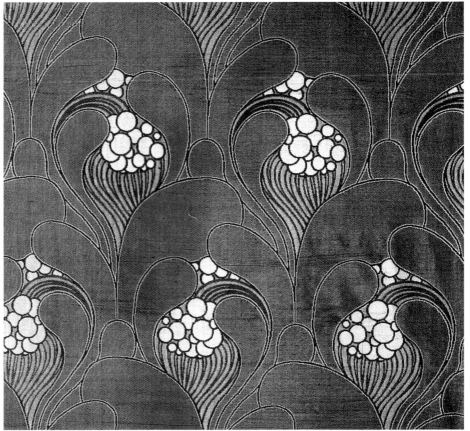

Gustav Klimt painted *The Kiss* (*right*) in
1908. It shows how even the eroticism
which pervades much Austrian art of the
era could be expressed in a style related
to geometrical abstraction.

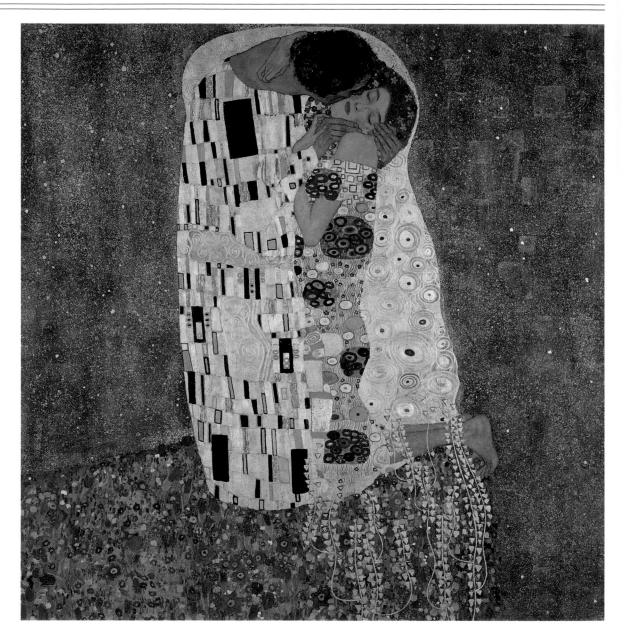

A silver-gilt buckle (*below*) designed by
Kolo Moser; it was made by the Wiener
Werkstätte *c.* 1904.

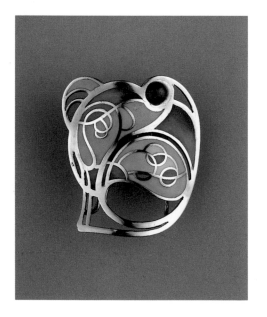

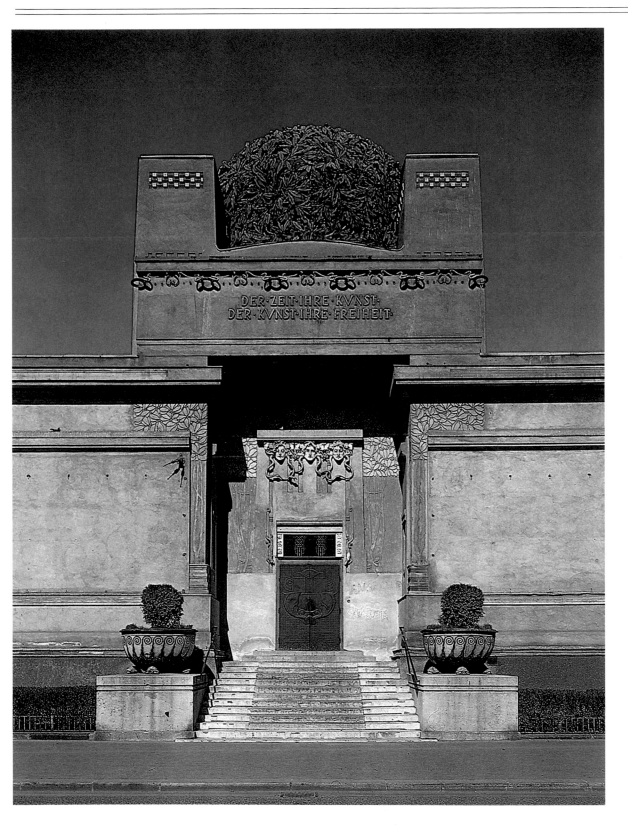

The Secession House, Vienna (*left*), designed by Joseph Maria Olbrich and built in 1898, was a bold gesture of defiance towards the Viennese art establishment. Its imposing geometry was a beacon of the new style in the midst of overwhelming rococo whimsy.

This elegant silver chalice (*below*) designed by Josef Hoffmann about 1905, reveals a concern with natural forms, in spite of the predominantly geometrical style of Viennese Art Nouveau.

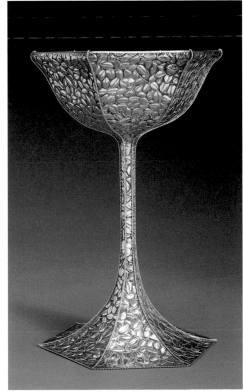

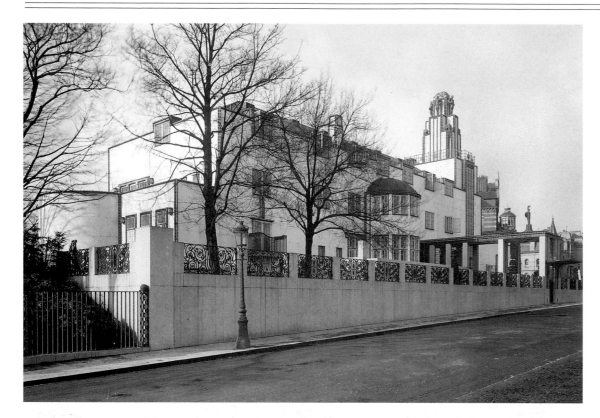

The Palais Stoclet (*left above and below*) was built in Brussels for the coal magnate Adolphe Stoclet. Started in 1905, the mansion took six years to complete. It was designed by Josef Hoffmann and all the furniture and decoration were executed by the Wiener Werkstätte in a geometrical style carried throughout the house and its garden. The dining room featured murals designed by Gustav Klimt.

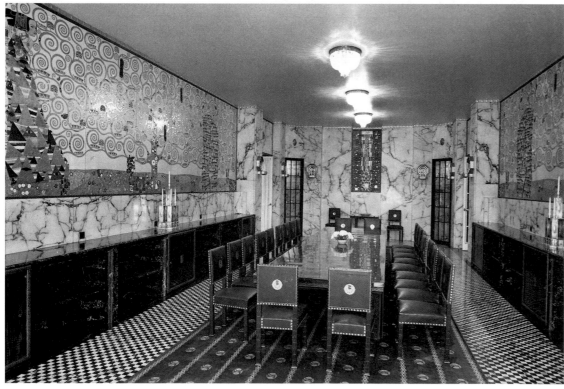

This house was built by Peter Behrens for himself in 1901 (*right*). It is on the Mathildenhöhe in Darmstadt and formed part of the artists' colony established there by the Grand Duke Ernst Ludwig. The geometrical style which evolved in Darmstadt was clearly derived from Vienna and Glasgow.

This room in the Spitzer house, Vienna (*below*), designed by Joseph Maria Olbrich about 1900, shows the emergence of the Austrian version of the geometrical style. Although many of the forms are still built up from flowing curves, rectangles and circles are beginning to impose an order on the room as a whole. (K. Barlow Ltd, London)

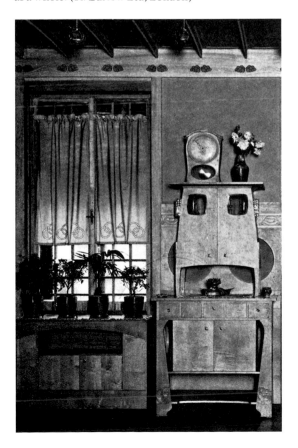

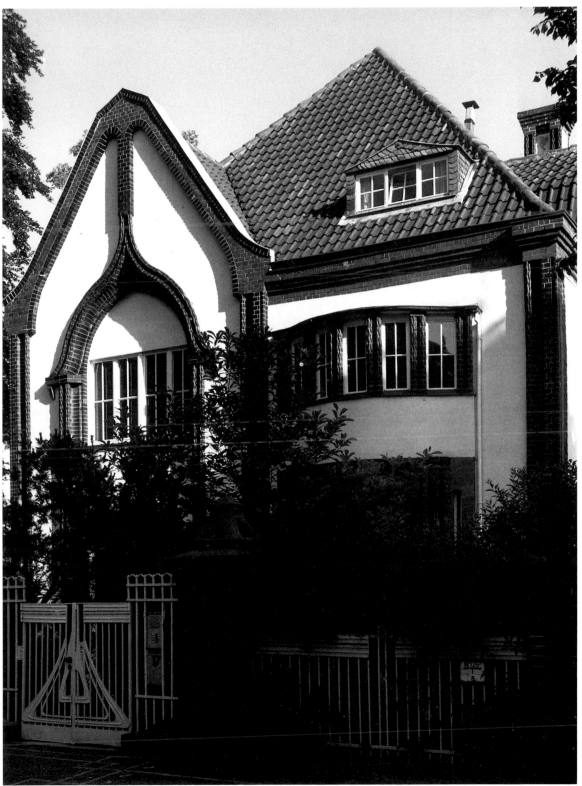

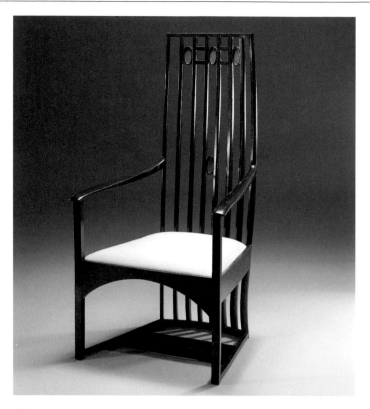

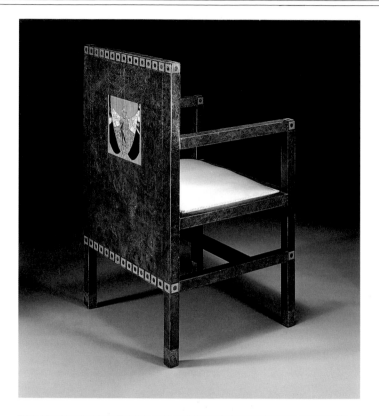

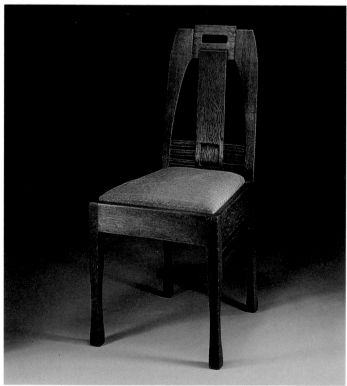

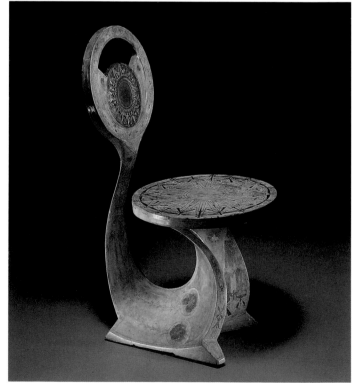

This chair was designed by Charles Rennie Mackintosh about 1904 (*opposite left above*). It represents the geometry of his style at its most refined. Peter Behrens designed this oak dining chair in 1902 (*opposite left below*). He developed an individual style based on a repertoire of dynamic, abstract forms. Carlo Bugatti's 1902 chair (*opposite right below*), covered with parchment and copper, shows the Italian designer adapting the geometry of his Moorish-inspired style to the Art Nouveau idiom. This chair was designed by Kolo Moser in 1904 (*opposite right above*). The fine materials and the quality of craftsmanship were features that often appeared in the work of the Wiener Werkstätte.

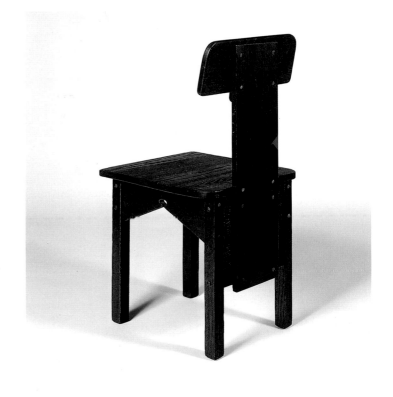

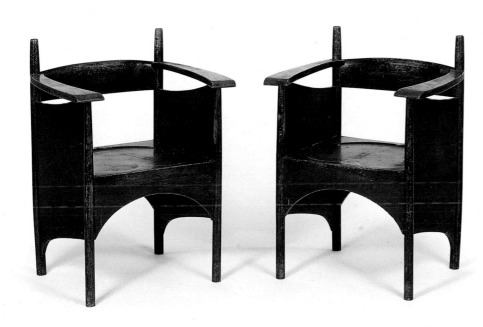

These armchairs were designed by C.R. Mackintosh for the Argyle Street Tea Rooms, Glasgow, in 1897 (*above*). An early design by the Glasgow architect, they do not have the geometrical severity of his work after 1900.

Charles Rohlfs designed this stained ash chair between 1900 and 1905 (*right above*). Its geometrical forms show Rohlfs responding to the taste for simple, unadorned furniture which prevailed in the United States during the first decade of the twentieth century. The Chicago partnership of Purcell, Feick & Elmslie designed this armchair for the Merchants Bank of Winona, Minnesota, *c.* 1912 (*right below*). It is a late example of the Prairie School style which had been introduced by Wright in the 1890s.

The 'Craftsman' furniture created by Gustav Stickley and manufactured in Eastwood, New York, from about 1900, was plain and solidly constructed. This library table is constructed from regularly shaped elements and the decoration is limited to the stretcher joints and the hemispherical studs securing the leather top.

Richard Riemerschmid designed this octagonal table in 1903 for the Munich banker Karl Thieme. The inlay on the top is related to the natural forms which characterized Art Nouveau in Munich. The mother-of-pearl insets in the legs, however, and the overall shape of the table, show Riemerschmid moving towards a more geometrical interpretation of the style, a trend which prevailed in Germany during the first decade of the twentieth century. (K. Barlow Ltd, London)

The Finnish pavilion at the Paris Universal Exhibition of 1900, designed by Hermann Gesellius, Arman Windgren and Eliel Saarinen, was a controlled exercise in the disposition of simple, geometrical elements. The stylized rising sun motif featured on the tower helps to give the whole building an exciting vitality.

ART NOUVEAU FOR ALL

One aspect of Art Nouveau that makes it very much a style of the twentieth century, although it developed during the nineteenth, was its application to a wide range of mass-produced goods. Lamp-posts and lorgnettes, biscuit tins and boot scrapers – around 1900 practically every item of use or decoration was available in the Art Nouveau style. There were several factors which contributed to the style's universal appeal, some of which had little to do with aesthetics. Art Nouveau coincided with an era when the middle classes in Europe and America were sufficiently conscious of style to make it worth a manufacturer's trouble and expense to have his products designed in a style which would describe the consumer's status and outlook, as well as make the goods more attractive than those offered by the competition.

During the nineteenth century firms which manufactured household goods had offered their customers a variety of styles. British and American cabinet-makers, for instance, had produced furniture in the 1870s and 1880s which might have been called 'Chippendale', 'Louis Quinze', 'Queen Anne' or 'Medieval'. At the turn of the century, some version of Art Nouveau was generally added to the range. One example is 'Secession Ware', a line of decorative and domestic china by the British manufacturer Minton of about 1905. The shapes and decoration were supposedly related to the version of Art Nouveau then emerging from Vienna, and the name 'Secession' expressed a feeling of revolt against the restraints of Victorian morality, a feeling shared by many of the young middle class in western Europe at the time.

Art Nouveau was the first style in the decorative arts to receive widespread publicity. Not only was there a host of magazines devoted to applied art, but the advertisements which appeared in the new popular newspapers were often designed in the Art Nouveau style or illustrated Art Nouveau products. Likewise, hoardings everywhere were covered in posters that displayed the beauty of Art Nouveau just as prominently as the product being advertised. It was probably the first style ever to turn its leading artists into public celebrities. A 1907 catalogue issued by the Saint-Dizier Foundries in France showed a wide range of cast-iron goods designed by Hector Guimard, and its cover proudly bore the legend 'Style Guimard'. The designer Alphonse Mucha was so overwhelmed with demands for his services that he published an album of motifs and patterns. 'Of course,' he wrote many years later, 'I imagined quite wrongly that now I would be left in peace. Not at all. I started getting even more requests . . . I became the victim of my own stratagem.'

Throughout the second half of the nineteenth century there had been mounting pressure from various quarters to improve the taste of consumers and manufacturers alike. The initiative had been taken by governments which had begun to realize the significant part played by design in trade and industry. The Great Exhibition at the Crystal Palace in 1851 had been instigated to provide a shop-window for British goods, but it had revealed an appalling lack of artistic taste among manufacturers, not only in Britain but everywhere else as well. Comte Léon de Laborde, the French ambassador in London, who was ordered by his government to report on the exhibition, recognized that, as the craftsman had been superseded by the machine, a gap had opened up between the artist and the manufacturer. 'Where,' he asked, 'does art end and industry begin?' In order to close the gap, governments in most of the leading industrial nations had undertaken vigorous programmes of art education. Art schools had been founded in the capital cities and in areas where goods were manufactured. Public museums had been founded which displayed examples of the applied arts from the periods and cultures which were recognized as the best. The museums were often kept open in the evening so that the working classes could visit them. By decree from the top, taste would be improved from the bottom. This idea had become so fixed in the mind of the ruling classes that even Kaiser Wilhelm II, not noted for either good taste or philanthropy, endorsed it. Speaking in 1901 he asserted that 'art should help to educate a nation . . . we should give the working, the laborious classes, the opportunity to raise themselves up to what is beautiful and to escape from and overcome their other thoughts.'

Such 'other thoughts', of course, were assumed to be of revolution, or at least of higher pay and better working conditions. According to the Kaiser's notion, art was to be enlisted to support the flagging forces of religion as 'the opium of the masses'. Anyway, it was art, not Art Nouveau, that the Kaiser and other conservative leaders throughout Europe were eager to promote.

However, one of the principal reasons why Art Nouveau became such a popular style was that, while conservative governments were busy improving the taste of the working classes, many prominent socialists were also trying, though with directly opposite motives, to heighten the sensibilities of the proletariat, emphasizing the ideological superiority of Art Nouveau. Several Art Nouveau designers were socialists. They accepted the validity of William Morris's contention that art should not be the preserve of the rich and privileged. Many artists gave up careers as painters and sculptors for just that

reason, as indeed had Morris himself. Only by working in the applied arts could they hope to address a wider audience. Morris, however, had found to his disgust that because he refused to adopt the soul-destroying methods of machine production his goods were generally too expensive for any but the wealthy. The German designer Otto Eckmann, longing to escape from the same quandary, declared: 'We must use the snob, so that we may gradually reach the people.'

In France and Belgium reformers took a less compromising attitude. 'Make beautiful,' wrote the French socialist architect Frantz Jourdain, 'but make cheap.' Jourdain argued for 'art in the street', and he welcomed the new lithographic posters that were going up in Paris around 1890. He wanted to see building façades decorated with a new kind of art that would be intelligible to the masses. He urged architects to abandon the language of Classicism that was comprehensible only to a small élite, and to adorn their buildings with decorations inspired by nature. 'I believe,' William Morris had said, 'that art will make our streets as beautiful as the woods, as elevating as the mountain-sides.' Jourdain reproached Lalique for supplying the demands of so exclusive a clientele, and exhorted the jeweller to spread a sense of beauty 'even among the *petite bourgeoisie,* even among the people'. In 1898 he criticized Guimard for designing such expensive furniture and four years later commended Léon Bénouville for the simple furnishings he created for workers' housing. The most ardent disciple of William Morris in France was the writer Jean Lahor. In 1903 he founded the Société de l'Art Populaire. The aim of this society was to provide housing and decorative art at low prices, and even if its achievement was limited its membership was impressive: Charpentier, Chéret, Gallé, Grasset, Horta and Lalique were among its supporters.

Some of the activities of the Société de l'Art Populaire had been undertaken a dozen years before by the Club de l'Art Social which had numbered Jourdain and Rodin among its members. It had organized lectures on art and architecture which were given in the working-class quarters of Paris, and it had arranged visits after working hours to exhibitions in museums. The introduction of art to the workers was held to be an important part of the socialist programme. The Whitechapel Gallery, built by C.H. Townsend between 1899 and 1901 in London's East End, owed its origin to this notion, and at the Vienna Secession's first exhibition in 1898 artists escorted groups of workers round the show, explaining the works on display. It was stated in the Secession's own report of the exhibition that members had found this 'a tremendously onerous, but most successful attempt,

The magazine *Jugend* (Youth) was published in Munich from 1896. It was one of the many journals which transmitted the Art Nouveau style to a wider public. This cover was designed by the German artist Ludwig von Zumbusch.

to introduce an understanding of modern art among the broad strata of the population'. In Brussels, the Belgian Workers' Party set up an Art Section in 1891 to foster literary and artistic appreciation among the proletariat. Lectures were given on the principal movements in modern art, poetry, drama and music, and visits were arranged to museums and exhibitions of contemporary work. Art Nouveau designers were closely involved with the Belgian Workers' Party's cultural activities. When the party required new premises in Brussels, the building was designed by Victor Horta; the Maison du Peuple (the People's House) was erected in 1897 and contained lecture halls which were used for the Art Section's meetings. Henry van de Velde designed much of the printed material issued by the Section, such as the lecture programmes to which he gave exciting Art Nouveau borders.

Van de Velde also designed publicity material for various commercial enterprises, for instance the Cologne food-processing firm Tropon and the cigar importers Continental Havana Company of Berlin. The fact that large companies adopted Art Nouveau as their house style probably helped as much as – if not more than – all the lectures and exhibition visits arranged by the socialists to raise people's awareness of modern tendencies in the decorative arts. It is, however, immaterial which was more influential, the socialists' initiatives or commercial pressures; what was significant was the compound effect of the two, plus the additional propaganda emanating from governments. The designer had been contriving to draw the manufacturer's attention to style for at least as long as governments had been encouraging designers to work with industry. For example, from 1849 to 1852 the *Journal of Design and Manufactures* had appeared in London, and in 1861 the French designer Emile Auguste Reiber, in association with the ceramist Théodore Deck, had launched a magazine significantly entitled *L'Art Pour Tous* (Art for All) which was devoted to the application of art to industry. Although this periodical continued until 1906, it never really escaped from the historical eclecticism that had dominated style in the decorative arts during its first thirty years of publication. But the pages of the decorative arts press, both in Europe and America, were littered during the 1890s with exhortations to manufacturers to adopt the modern style and commendations of those who had.

The 1898 manifesto of the Vereinigte Werkstätten für Kunst im Handwerk (United Workshops for Art in Handicraft), signed by Hermann Obrist and Richard Riemerschmid among others, started with an appeal to manufacturers to recognize the plight of the desig-

ner: 'Experience over the last few years in Germany and abroad has shown that ever larger sections of the purchasing public would happily espouse the new, individual direction in the arts and crafts if . . . prices were not higher than those of the commonly available merchandise in well-known styles.' A response to this kind of plea from the designer came from across the Atlantic, from Illinois, where the ceramic manufacturer William D. Gates commissioned designs from several Chicago architects, including Frank Lloyd Wright, for his 'Teco' line. Gates acknowledged that there was 'a large element of the public . . . who cannot afford to indulge in the luxury of high-priced articles of a decorative nature', and claimed that 'in putting Teco ware on the market in artistic designs . . . we will meet a public want.' There was an element of genuine philanthropy in Gates's assertions, but he was no doubt aware of the commercial advantage of marketing Art Nouveau at affordable prices. A growing number of entrepreneurs in Europe and America were learning the same lesson.

One of the earliest and most popular ways for manufacturers to exploit the growing appeal of the Art Nouveau style was through the design of posters advertising their goods. The Art Nouveau poster became one of the most ubiquitous manifestations of the style and helped to beautify the streets of all the major cities in Europe and America. Connoisseurs began to collect posters designed by the best artists and a rash of magazines illustrating the latest examples burst upon the scene. *Les Maîtres de l'Affiche* (Masters of the Poster), a series of albums containing smaller versions of the posters themselves, was sold by subscription in Paris between 1895 and 1900. Clément Janin and André Mellerio produced the monthly *L'Estampe et l'Affiche* (Print and Poster) from 1897 to 1899, also in Paris. *The Poster* was published in London from 1898 to 1901, and *Poster* and *Poster Lore* appeared in New York.

Many Art Nouveau posters advertised exhibitions held by the various groups of artists and designers who worked in the style. They were also widely used for the promotion of theatrical productions and cabarets, particularly after the enormous success of Alphonse Mucha's posters for Sarah Bernhardt. The posters designed by Henri de Toulouse-Lautrec advertising *café-concerts*, Le Divan Japonais and Le Grillon, for example, were masterpieces of their kind, and Manuel Orazi's poster for Löie Fuller was another. In London, Aubrey Beardsley's 1894 poster for the Avenue Theatre broke new ground in the art of the hoardings, with its simple, decorative design. New books were advertised through posters, particularly in the United States. Will H. Bradley's poster for *When Hearts Are Trumps* by Tom

Hall, published in 1894, has become an Art Nouveau classic, and when, in 1897, Emile Zola's *Paris* was published in *Le Journal,* a poster designed by Théophile Steinlen appeared all over the French capital: 'Zola and the *Journal* and Steinlen's poster thereof,' wrote Arnold Bennett in his diary, 'seem just now to flame in the forehead of the city.'

The bicycle, as much a symbol of spiritual liberation as Art Nouveau itself, was widely advertised through posters designed in the style. Bradley did one for Victor in America; Mucha depicted a young nymph leaning alluringly over the handlebars of a Perfecta, and Grasset showed a more demure lady holding a Georges Richard. Jules Chéret, Jean Forain and Toulouse-Lautrec designed posters for cycles, and Pierre Bonnard drew one which advertised an aperitif called Bécane, a French colloquialism for 'bicycle'. Alcoholic beverages were another product often advertised through posters. Biscuits, oil-lamps, health resorts, cigarette papers – even a eucharistic congress – were all featured on Art Nouveau posters which, pasted up in city streets all over the western world, gave wide publicity to the style as well as to the product advertised.

As Art Nouveau became more popular, shops were established to supply the growing demand for household goods in the style. Siegfried Bing, a merchant from Hamburg who had settled in Paris about 1860, and who had dealt in Japanese art for many years, in 1895 opened La Maison de l'Art Nouveau on the corner of rue de Provence and rue Chauchat in Paris. Some of the objects on sale there were unique and expensive – and none were cheap or mass-produced. But Bing marketed the products of several Art Nouveau workshops, such as the English designer W.A.S. Benson's metalwork, Tiffany's glass, pottery by Alexandre Bigot and the German Max Läuger, porcelain by the Swedish firm of Rörstrand, and fabrics from Morris & Co. and Liberty's. Bing also commissioned designs for furniture, metalwork, rugs and porcelain from Georges de Feure, Eugène Gaillard and Edward Colonna, an American designer working in Paris. Workshops were opened for the manufacture of the furniture, and the porcelain was made by a firm in Limoges. In 1899 the German art critic Julius Meier-Graefe opened a similar establishment, also in Paris, called La Maison Moderne. The principal designers who worked for him were Henry van de Velde, Abel Landry, Paul Follot and Maurice Dufrêne; like Bing he sold a wide range of Art Nouveau products from France and abroad.

In Brussels, the sons of Edmond Picard, one of the organizers of the Art Section of the Belgian Workers' Party opened a store called La

Maison d'Art à la Toison d'Or in 1895. A wide range of Art Nouveau goods was sold there. In Amsterdam, 't Binnenhuis (The Interior), a shop selling furniture and other decorative arts, was opened in 1900 by the architect H.P. Berlage and the furniture and ceramics designer J.P. van de Bosch; two years later De Woning (The Dwelling) was established in the city, a shop directed by the metalworker Jan Eisenlöffel and the ceramics designer C.J. van der Hoef. The equivalent establishment in Berlin was the Hohenzollern-Kunstgewerbehaus (Hohenzollern Applied Art House). It had been opened by the businessman Hermann Hirschwald in 1879 as a gallery offering the best in contemporary German decorative arts and, since it was a venture in the national interest, the Crown Prince Wilhelm had allowed his family's name to be incorporated in the shop's title. In 1898, however, it must have seemed to Wilhelm, by then the Kaiser, rather worse than ironic when Hirschwald was won over to Art Nouveau; Hirschwald not only provided Eckmann with a workshop on his premises but also organized an exhibition that year which featured work by the English designers C.F.A. Voysey, W.A.S. Benson and C.R. Ashbee, and the French designers Charles Plumet and Tony Selmersheim. But an even worse insult to the Hohenzollern name and German honour came the following year when Henry van de Velde, a Belgian, was appointed to supervise the gallery's studios and workshops.

Many of the large department stores in Europe and America started selling Art Nouveau goods, and some of them had their premises designed in the Art Nouveau style. Liberty's of London, which had already established a name for dress and furnishing fabrics in modern styles, in the late 1890s commissioned designs for pewter, silver and jewellery in the Art Nouveau manner. The store also sold pewterware manufactured by several German companies such as J.P. Kayser & Son of Krefeld, Walter Scherf & Co. of Nuremberg, W.M.F. of Geislingen and Lichtinger of Munich. Another item from Munich which Liberty's stocked was a chair designed by Richard Riemerschmid. The London store was also in the forefront of making goods, especially textiles and furniture, from the Orient available to a wide public.

Tiffany's in New York sold not only Art Nouveau products of the Tiffany Studios but also a wide range of goods in the style from America and Europe. Marshall Field in Chicago and Wanamaker's in Philadelphia also offered furniture and other household items in the Art Nouveau style. La Samaritaine, a leading Paris department store, was housed from 1905 in an Art Nouveau building designed by Frantz

Jourdain and decorated by Eugène Grasset, and in 1901 Victor Horta built new premises for the Brussels shop À l'Innovation. The Antigua Casa Franch in Barcelona advertised carpets and textiles 'in various styles' on Art Nouveau posters by Alexandre de Riquer.

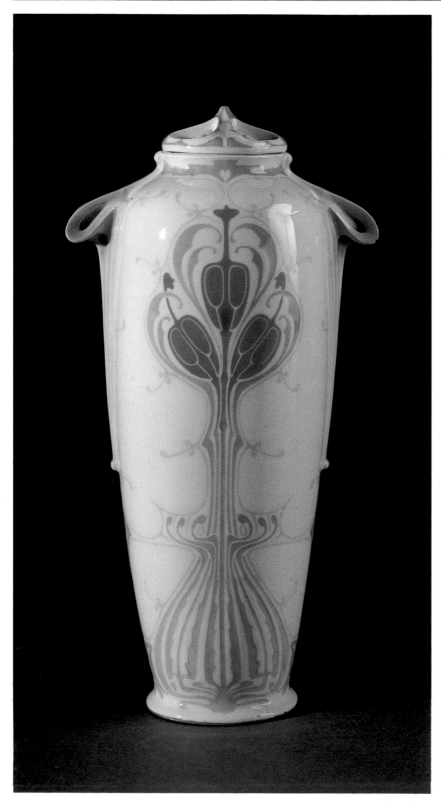

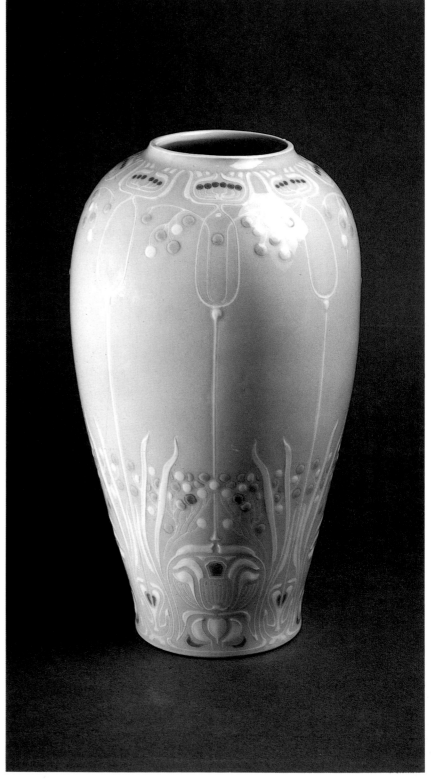

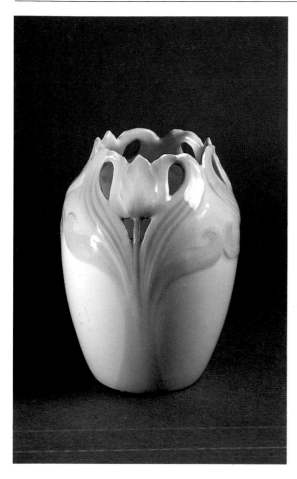

The Teco line of moulded earthenware vases (*below*) was manufactured by the Gates Potteries at Terra Cotta, Illinois. Distinguished designers, including Frank Lloyd Wright, provided designs for the Gates Potteries, thus bringing the best Art Nouveau to a wider public.

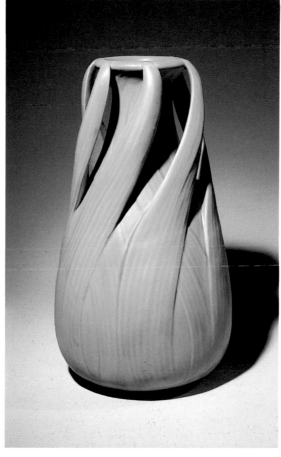

Jacques Sicard designed this vase (*below*) made at the Weller Pottery in Zanesville, Ohio. Sicard had previously worked at Clément Massier's pottery in Vallauris, France, which also produced ceramics decorated with the iridescent glazes so popular around 1900.

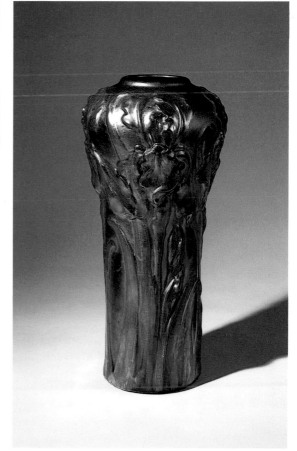

This porcelain vase (*above*) was made at the Rörstrand factory near Stockholm. The floral version of the Art Nouveau style soon found a wide popularity among the European and American bourgeoisie.

These porcelain vases (*opposite*), designed by Edward Colonna (*left*) and Georges de Feure (*right*) were manufactured in Limoges and sold at Siegfried Bing's Maison de l'Art Nouveau in Paris. Bing was among the first entrepreneurs to exploit the growing popularity of the Art Nouveau style.

Henry van de Velde designed these knives (*left*) for butter (*right*) and caviar (*left*); they were manufactured by Koch & Bergfeld of Bremen.

The Freiberg firm of F. Arno Bauer made this silver plated fork and spoon (*below*).

This silver plated carving set (*below*) was designed about 1900 by Joseph Maria Olbrich and manufactured by the Westphalian firm of Clarfeld & Springmeyer.

This silver fish slice and serving fork (*opposite left*), designed about 1904 by Peter Behrens, were manufactured by the Düsseldorf firm of Franz Bahner which had branches in Berlin, Brussels, Prague, Copenhagen and elsewhere. While the slice echoes Behrens's earlier Japanesque designs, the abstract, geometrical motif on the fork is an example of the style he developed after he had gone to Darmstadt.
Kaltenbach & Son of Altensteig in Württemberg made this silver fork and butter knife (*opposite right*). Although the decoration is Art Nouveau, the shapes are quite traditional. A notable feature of the Art Nouveau style was its application to every detail of domestic life. A distinctive ambience was created in the Art Nouveau home; the designed environment had emerged.

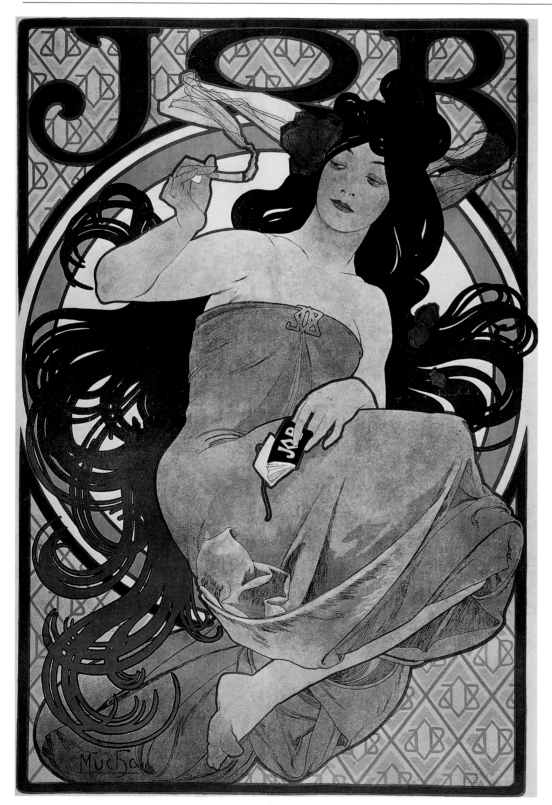

Alphonse Mucha's poster for Job cigarette papers (*left*) was designed in 1897, four years after Henri de Toulouse-Lautrec's for the Divan Japonais café-concert (*opposite left*). Mucha exploited the Art Nouveau style to produce an eye-catching design which was easy to comprehend; Lautrec's poster is still closely related to his earlier graphic work but is also an individual expression of the new style.

The Dutch artist Jan Toorop designed this poster (*below*) for salad dressing in 1895. Toorop had been born in Java and the exotic mysticism of his Symbolist paintings was a significant element in the formation of the Art Nouveau style.

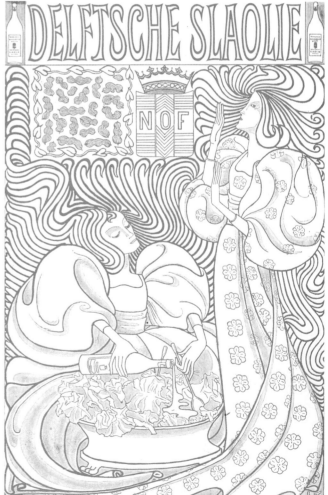

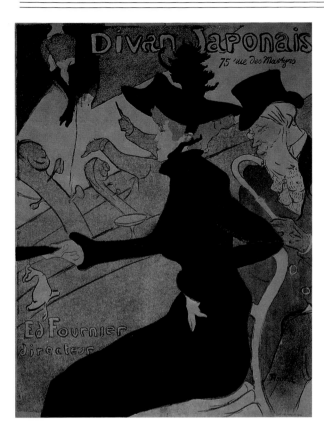

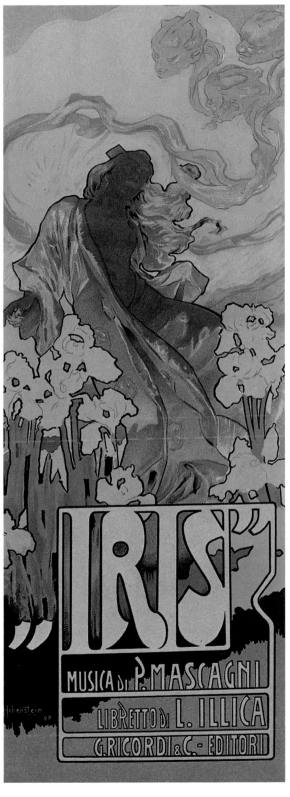

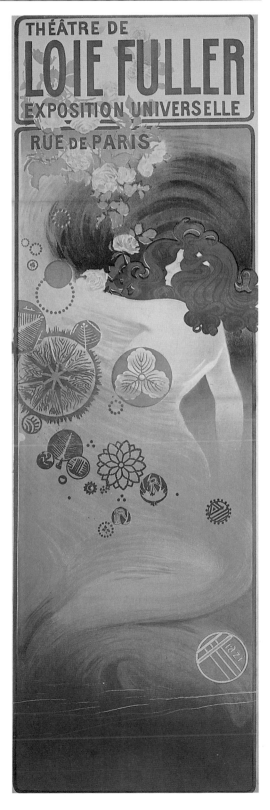

Manuel Orazi designed this poster (*far right*) advertising Loïe Fuller's theatre at the Paris Universal Exhibition of 1900. Orazi designed posters and jewellery for La Maison Moderne, the Paris store selling Art Nouveau furniture and accessories, which was run by the German art critic Julius Meier-Graefe. This poster (*right*) for the operetta *Iris* was designed in 1898 by the Italian artist Adolfo Hohenstein. His style was derived from the work of the French poster designer Paul Berthon, though it is more dramatic in both its composition and colour.

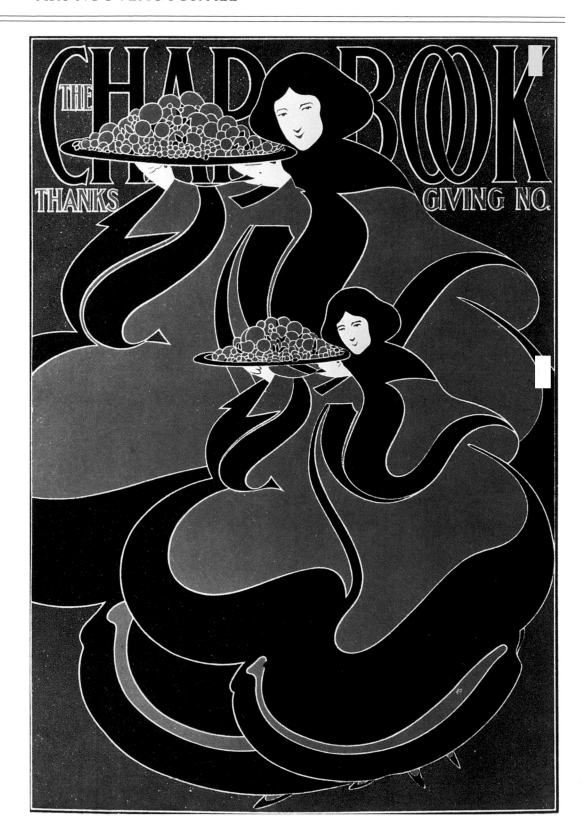

Ein Händeineinanderlegen,
Ein langer Kuss auf kühlen Mund,
Und dann: auf schimmerweissen Wegen
Durchwandern wir den Wiesengrund.

Durch leisen, weissen Blütenregen
Schickt uns der Tag den ersten Kuss —
Mir ist: Wir wandeln Gott entgegen,
Der durchs Gebreite kommen muss.
 RAINER MARIA RILKE.

The Yellow Book
An Illustrated Quarterly
Volume IV January 1895

Price $1.50 Net

London: John Lane
Boston: Copeland & Day

Price 5/- Net

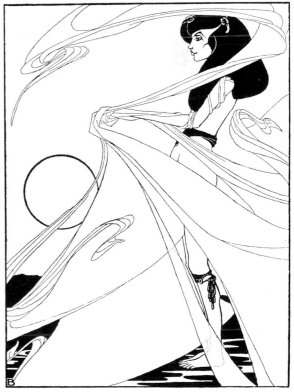

In America, periodicals such as
Harper's, Lippincott's and *The Chap
Book* adopted a graphic style strongly
influenced by Aubrey Beardsley's
illustrations (*opposite above*). Two of
the leading artists who contributed to the
magazines were Will Bradley (*The Chap
Book*) and Will Carqueville
(*Lippincott's*).
This poster for Tropon (*opposite left*), a
firm of food manufacturers, was designed
in 1897 by Henry van de Velde.

Josef Hoffmann designed this border for
a poem by R.M. Rilke (*above*) published
in the Austrian periodical *Ver Sacrum*.
This illustration by Markus Behmer
(*right*) appeared in a German edition of
Oscar Wilde's *Salome* published in
1906. It retains the spirit of Beardsley's
designs for the first edition of the play
and is indeed very much in the style of
the English artist (*right above*).

At their Regent Street store in London, Liberty &
Company sold their Cymric range of silverware
which was manufactured in Birmingham. These
frames, decorated with enamels, show two
variations of Art Nouveau embraced by the firm's
distinctive house style. The one on the right was
designed by Archibald Knox, and features the
interlacing curves derived from Celtic ornament
which characterize his work. The one on the left is
decorated with flowers which have been far less
formalized than on Knox's frame, and the different
motifs have not been so successfully welded into an
overall design. Both versions of the Liberty style
seem to have sold well, judging by the considerable
amount of each still existing today.

Liberty's printed cottons became popular during the 1890s throughout Europe and America. These two designs were supplied by the Silver Studio where the patterns for many Liberty fabrics were created. The fabrics were used both as dress material and for furnishings. The Silver Studio in London provided several manufacturers in Britain and on the Continent with designs for fabrics and wallpapers. Some of Liberty's metalwork was also designed by the studio.

This pair of china dishes made by Minton (*right*) are from the British firm's 'Secession' line of vases and tableware. The version of Art Nouveau which became most widely popular in Britain featured conventionalized flowers and swirling lines. Anything more exotic — and certainly any hint of eroticism — was generally frowned upon, particularly after the scandal of Oscar Wilde's trials in 1895.

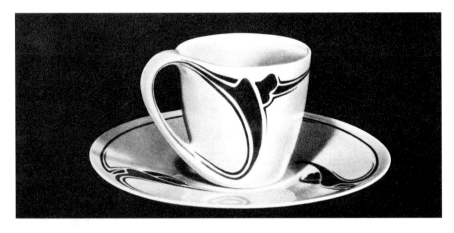

Although the Dresden porcelain factory of Meissen seldom employed outside designers, such was the standing of Henry van de Velde in Germany that he was invited to design a range of crockery for the firm; this cup and saucer (*left*) was made *c*. 1904.

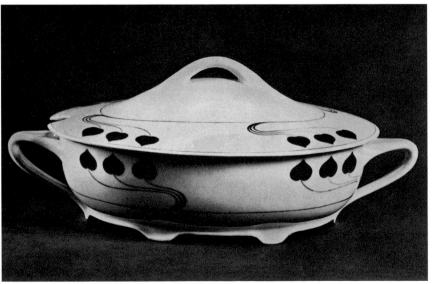

The Bavarian firm of Rosenthal made this porcelain tureen (*left*) *c*. 1900. The style of the decoration is well suited to the piece's shape.

Two contrasting items of ceramics, both designed by Richard Riemerschmid, demonstrate the Munich artist's versatility. The pewter lidded stoneware tankard (*left*) was made at the Reinhold Merkelbach potteries near Coblenz, and the porcelain tableware (*below*) was manufactured by Meissen from about 1904. (K. Barlow Ltd, London)

Lamps in the Art Nouveau style were sold in large numbers in Europe and America. They were made in a wide variety of materials, for example glass, ceramic, spelter, silver-plate and pewter, and in many different forms, such as flowers, sea monsters and females, draped or nude. The electric lamp (*below right*) was designed by Hans Christiansen and manufactured about 1900 by the Mainz firm of Louis Busch. The Tiffany oil lamp (*below left*) was made at about the same time and sold through Siegfried Bing's gallery Maison de l'Art Nouveau in Paris. Iridescent glass shades gave the soft light favoured by the devotees of Art Nouveau.

This silver and garnet buckle bears the mark of Murrle, Bennett & Co, a firm of jewellery manufacturers and importers. They supplied Liberty with pieces made at Pforzheim, a centre of the German jewellery industry.

Firms which produced jewellery in quantity used the Art Nouveau style for at least part of their output. This silver brooch was manufactured by William B. Kerr & Co of Newark, New Jersey.

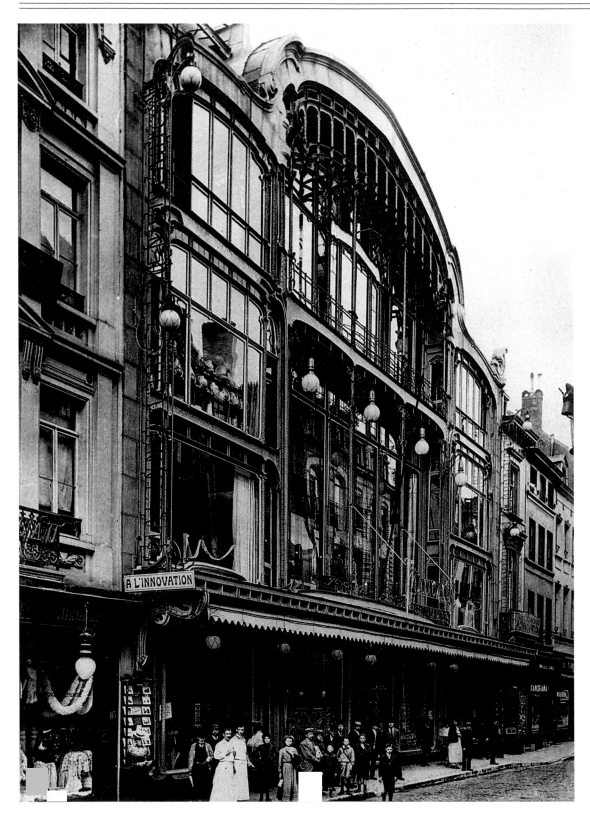

The department store, À l'Innovation in Brussels, was designed by Victor Horta in 1901; the first decade of the century saw the establishment of many such stores in the capitals of Europe and many of them reflect the stylistic preoccupations of the period.

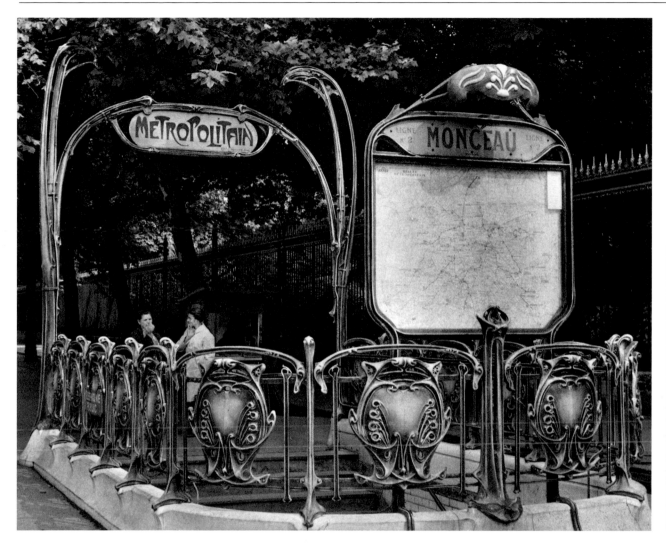

Hector Guimard, the architect responsible for some
of the most stylish Art Nouveau buildings in Paris,
was commissioned to design entrances to some of the
stations on the Métropolitain, the underground
railway system. If posters by Mucha and others filled
the streets of Paris with Art Nouveau pictures,
Guimard's cast iron Métro stations provided the
capital with pieces of Art Nouveau sculpture.

5

**TWENTIES
AND
THIRTIES
REVIVALS**

Although there is a strong tendency to consider Art Nouveau to have died by World War I and the twenties to belong to Art Deco and Modernism, there are very good reasons for searching out elements of continuity between the two periods. On the most simple level, for instance, high Art Nouveau and the French Art Deco are linked by their use of rich ornament and materials and their fine craftsmanship; the Modernism of the twenties and thirties, equally, owed a substantial debt to the rectilinear and geometrical Art Nouveau of Vienna, Darmstadt and Glasgow. Interestingly, the critical disfavour into which Art Nouveau fell after the first decade of the new century in France was partly due to its association with German culture, the *goût munichois*, after the exhibition of applied arts from Munich which formed part of the Salon d'Automne of 1910.

There was, however, some contemporary praise for the restraint and order in the German designs, even from writers who were later to criticize the style. In contrast to what was regarded as the anarchism of current French styles, the impact of the Munich work came from the promotion of ensembles of furniture and decoration, which was to be a major feature of both Art Deco and Modernism. The immediate post-war years took up this theme in a search for order and clarity in design which were to be expressed in geometrical forms. All important was the idea of 'construction', which was especially antithetical to high Art Nouveau, since it was in direct opposition to the principle of natural growth.

In general, then, these attitudes meant that high Art Nouveau was little discussed. However, the writers of the *Encyclopédie des Arts Décoratifs et Industriels Modernes au XXème Siècle*, a set of volumes put out to accompany the 1925 International Decorative Arts Exhibition, at which Art Deco reached its popular peak, had to come to terms with the pre-war movement. The preface said that Art Nouveau had borrowed forms from nature and in doing so had broken with the laws of construction and the traditions of history. Works by Emile Gallé, for instance, were said to have aligned themselves against good taste and good sense. Art Nouveau was thus consigned to a kind of prehistory as far as the 1925 show was concerned. The essay in the architecture volume of the *Encyclopédie* described the 1900 Paris Universal Exhibition as a time of degeneracy after the constructive heights of the mid 1880s and claimed that Art Nouveau architecture had forgotten the lessons of Viollet-le-Duc that forms must express structure and be determined by function and material. Art Nouveau had imposed its sinuous line regardless of its suitability to the material used, or so its critics claimed.

There were, however, some examples of Art Nouveau at the 1925 Exhibition, although they did not go under that name. Jacques Gruber exhibited a window from 1924 called *Exotisme* which illustrated a palm tree and monkeys above some native figures. Perhaps it was the subject-matter indicated by the title that gave the artist the freedom to use curving, almost whiplash-like lines, giving the whole a dynamic effect. G.R. Gianotti exhibited some linear *Sgraffiti Polychromes* designed for a restaurant at the 1923 Exhibition in Monza which included some detailed turkeys pecking among flowers under drooping willow trees.

Perhaps the most remarkable Art Nouveau feature at the 1925 Exhibition was the performance of the Loïe Fuller school at the opening gala, along with Mistinguett and the Tiller girls from the Folies Bergère.

Fuller's light and sound dance at the 1900 Universal Exhibition was one of the highlights of the event and her piece twenty-five years later was no less successful. The troupe danced to Debussy's *La Mer*: the staircase of the Grand Palais was covered in silk, beneath which the dancers moved and over which different coloured lights played in simulation of the movement of the sea. It is difficult to imagine a scene more evocative of Art Nouveau.

This was no isolated performance on the part of Fuller, who was also active in film. In 1919 she made *Le Lys de la Vie* a fairy tale in which her dancers starred and which employed slow motion and the innovatory technique of using the negative for projection. The film was largely shot in the open air and stressed the natural forms of trees and mist as elements of the unreal dream world it tried to evoke. In contrast to these elements of continuity with the pre-war era, the representation of dancers in the figurines of this period show a marked shift away from Art Nouveau. Those by Demetre Chiparus stress movement and femininity, but the limbs are far more sharply defined than in Nouveau pieces of the same subject; there are no flowing tresses or robes. Similar are Ferdinand Preiss's figurines of dancers with short hair and scanty costumes.

Other restrained Art Nouveau elements appeared in the designs exhibited at the 1925 Exhibition: for instance, in the metal grilles by H. Favier, with their spiralling plant-like forms. These elements tended to appear within a strict rectilinear setting and to exhibit their own internal symmetry: Art Nouveau forms had been tamed by Art Deco.

However, there were a number of exhibits which departed from the main stream. Süe et Mare exhibited a rococo room with heavily

patterned wallpaper and fabrics and archaic furniture. It had carvings representing fabrics hanging at the level of the picture rail and garlands of flowers painted on the ceiling. A Lalique dining room designed for the Sèvres company had engraved glass walls showing a hunt scene in a forest. The trunks of the trees are thick and the line rather stiff, but the overall effect the lines of the branches give to the room is reminiscent of Art Nouveau.

The botanical side of Art Nouveau was seen in France after the war increasingly in terms of a neo-rococo and Louis Quinze revival. There was a nationalist side to this return to traditional styles. Louis Süe and the painter André Mare established the Compagnie des Arts Français in 1919. They used rare and exotic materials as both Art Nouveau and Art Deco designers did, but their style owes much to the eighteenth century. The firm lasted until 1928 and was second only to Ruhlmann in size. Süe designed a villa at Saint-Cloud for the actress Jane Renouardt and the firm decorated and furnished it. Some of the furniture shows a distinct Art Nouveau spirit, such as an ebony cabinet, the legs of which arch up in leaf-like forms to merge with the body and which has a motif of flowers inlaid in mother of pearl on the door. There was undoubtedly a fairly strong current of anti-modern design in Paris which was run by older Art Nouveau designers. In some ways, though, the continuity of the twenties and thirties with the pre-war era in design can be most fruitfully examined in terms of attitude.

There were certain eccentric figures on the margins of the Modern Movement who practised or patronised Art Nouveau and rococo art forms. Carlos de Bestegui had Le Corbusier design an apartment for him in 1931. This Paris flat was exceptional, not only for its eccentric features but because of the involvement of the major figure of French architectural modernism. It was basically a modern white shell with a large window. An 'architectual promenade' took the occupant up a spiral staircase wound around a glass screw-shaped column on to a series of roof terraces with high walls. Here is found a false rococo fireplace and box hedges run by motors that slide along the ground. The roof terrace apes a room in which the sky is the ceiling and the lawn a carpet. Despite the large amounts of electrical gadgetry, the only lighting is by candle. The furnishings are rococo and Second Empire and include a life-sized statue of a blackamoor dressed in ostrich feathers.

Another way in which Art Nouveau designers accommodated themselves to the post-war environment was simply to temper and modify their old style. Hector Guimard refined his Art Nouveau

work into what he called 'Style Guimard' in the years following the 1900 Exhibition. This style was more restrained, symmetrical and unified but was also more ornamental. He used recognizable Art Nouveau elements in the details of his work well into the twenties. His apartment buildings in Paris feature rococo forms in the doors and windows and even his utilitarian 'Standard House' of 1921 has a 'Style Guimard' doorway.

The major Parisian department stores established interior design sections in the twenties and they used experienced decorators to run them. The Galeries Lafayette department was headed by Maurice Dufrêne, an Art Nouveau designer who had been involved in Julius Meier-Graefe's Maison Moderne. Au Bon Marché was headed by Paul Follot, also a noted Art Nouveau practitioner. Both became noted for putting together ensembles of their own and other designers' work. The market for this kind of very expensive and manifestly luxurious furniture was of a quite specific type: couturiers, public figures in theatre or politics and captains of industry. It was distinct from the kind of clients that a modernist architect and interior designer such as Le Corbusier was attracting in the twenties; these were often relatively young people involved in the art world and often expatriates. The extremely expensive materials used by Ruhlmann, for instance, were well beyond the means of most of these clients. One of his ebony desks made between 1925 and 1927 features fittings in snakeskin, ivory and silvered bronze. The latter makes protective mounts for the legs which swing out and back in a curve reminiscent of Art Nouveau.

In the United States Joseph Urban worked in an uncompromising Art Nouveau style throughout the inter-war period and his work varied little from the early pieces made in Vienna. Urban had enormous influence over the decorative arts in America, especially with displays like his Lady's Bedroom in black mirrored glass shown at the 1928 American Designers Gallery. He differs from the Parisian designers in concentrating on inexpensive materials from 1929, a move more often associated with modernist designers. Urban also built and decorated many theatres such as Ziegfeld's in New York, the interior of which was covered in a massive painting on paper called *The Joy of Life* by Lillian Gaertner, representing flowers, foliage, castles and music-making scenes in a crowded, swirling design.

Lalique maintained his success even through the Depression. He achieved wide acclaim for his work in moulded glass at the 1925 Exhibition and for his glass fountain at the Ideal Home Exhibition at Olympia in 1931. In 1933 a retrospective at the Pavillon Marsan

covered the whole range of his work including his early Art Nouveau pieces. He also made glass fittings for the liners *Paris, Ile de France* and *Normandie*. The continued success of Lalique was in contrast to the situation of Tiffany in the United States, whose unwavering continuation of the Art Nouveau style brought the company to bankruptcy in 1932.

An affinity with the artistic and stylistic preoccupations of the Art Nouveau period was certainly discernible in an exhibition of a group of neo-Romantic painters at the Galerie Druet in Paris in 1926. The group included Christian Bérard, Pavel Tchelitchev, and Eugène Berman. All had studied at the Académie Ranson and were influenced by Denis and Vuillard. Berman's interest in baroque architecture led him to paint melancholy ruins inhabited by beggars and gypsies. One purchaser of his works was Edward James. Berman also made a wardrobe painted to resemble a ruined building which was exhibited at the Galerie Drouin in 1939.

Christian Bérard came to have a dominating role in theatre fashion and decoration. His work included many ballet designs, magazine covers and fashion drawings, notably for *Vogue* in the thirties. He designed the sets for the Cocteau plays *La Vie Humaine* and *La Machine Infernale*. Art Nouveau forms could also be seen in the graphic work of 'Alastair' (the pseudonym of Baron Hans Henning Voigt) whose work was inspired by Poe and Beardsley and appeared in the fashion magazine *Die Dame*. Cocteau and the Vicomtesse Marie-Laure de Noailles painted Christofle plates in a Nouveau style, with women's heads featuring flowing drapery or hair. There is a disturbing aspect of these pieces which is perhaps closer to Surrealism than to Art Nouveau. What most of these artists just mentioned share is a stance which sets them apart from the major concerns of their time. To some extent, they can be seen as peripheral figures whose work was largely collected by enlightened eccentrics. Rex Whistler could be cited as a British example. It is almost as though preoccupations of a type not dissimilar to those of Art Nouveau were acceptable in the inter-war climate if they were seen to be separate from fully serious use or from the main stream of the fine arts.

An apparent exception to this are the complex connections between Art Nouveau and Surrealism. Although it is clear that the Surrealists used linear and organic forms in their work, the leading theorist of the movement, André Breton, was uninterested in the subject-matter of painting and never made reference to the significance of these natural forms. There was a very general association

made between curvilinear forms and free or unconscious expression of the kind which Surrealists like André Masson were practising. This was partly due to the contemporary debate in psychology, which in turn owed a good deal to the earlier theories underlying Art Nouveau.

In Britain the ideas of Worringer on the aesthetic response to curvilinear and geometric forms were publicized by Herbert Read and influenced Henry Moore. By the mid 1930s Moore had come to regard his sculpture as nature stripped down to its essence. Moore was probably influenced by the Surrealists from around 1928 and had works published in their journal *Minotaure*. His works at the 1936 International Surrealist Exhibition in London were fluidly biomorphic. However, our identification of these organic forms as being similar to stone or bones was not made until the late thirties. They can also be related, perhaps, to the microphotography of Karl Blossfeldt and Albert Renger-Patzsch, in whose work natural forms were treated as works of art. However, their photographs generally stressed the construction and order of their subject matter and it is probable that the Surrealists saw these pictures in a different way, although some of Blossfeldt's photographs are similar to Art Nouveau forms.

Microphotography revealed a new natural world: we can see the use of cell forms in painting for instance by Valmier as an updated form of Art Nouveau. The forms in Miró's work were seen by some critics as being bacteriological. However, it is significant that contemporary biology suggested that at a deep level organic and inorganic forms were similar, so that the whole distinction between the two could be seen to be breaking down. This sense of a shifting world was vividly expressed by Dali in the softening of hard forms like watches.

Dali was especially interested in the process of natural growth and read scientific texts such as those of Edouard Monod-Herzen on the subject. He was one of the few artists to write directly about Art Nouveau. In an article entitled 'L'Ane Pourri' of 1930 he deliberately picks out Art Nouveau as a style out of fashion, leaving neglected and misunderstood buildings scattered throughout Europe. Art Nouveau buildings have the quality of being simulacra or doubles, presumably because they are buildings which can resemble animals or plants. Such buildings, according to Dali, are on the margins of architecture, dreamlike and disturbing. Their double nature was made automatically without conscious control and showed a need to get away from reality to an ideal world: this tendency is like that of an infantile neurosis. It is interesting how much Dali's view coincides

with the detractors of Art Nouveau architecture who would no doubt agree that it was deranged. However, while the critics of Art Nouveau say that it copied the real too closely, Dali sees it as being a flight from the real.

Another illustrated article of 1933 was entitled 'On the Terrifying and Edible Beauty of Modern-Style Architecture'. Brassaï had photographed the Art Nouveau Métro entrances by Hector Guimard in Paris and Man Ray the Gaudí monuments in Barcelona. Both photographers stressed the fantastic animal nature of these works: one of Brassaï's photos of a light above a Métro entrance is contrasted with a picture of a praying mantis. In a way, these pictures which were published in the Surrealist magazine *Minotaure* can be seen as a foil to the Blossfeldt pictures of plants published in *Documents* four years earlier. In the same issue of *Minotaure* appeared some 'involunary sculptures' by Brassaï. These were ready-mades mostly composed of little pieces of paper such as bus tickets which had been rolled and worn in the pocket. The unconscious actions of the human hand are compared to the forces of nature and in some a spiralling and curving form emerges. Again forms related to the dominant idiom of Art Nouveau are linked to the actions of the automatic and the unconscious.

If we look at the drawings of mediums and of the insane which the Surrealists published there often seem to be fortuitous connections between them and Art Nouveau. The mediumistic drawings by Victorien Sardou for instance are crowded with lines representing flowers and tendrils, and the swirling forms of the pictures of the insane Comte de Tromelin contain bizarre animals. We can see that the Surrealists associated Art Nouveau with these kind of works on formal grounds, no doubt helped by the general ideology that surrounded the style. Occasional features of subject-matter were shared by the Surrealists and Art Nouveau. The underwater scene explored by Tanguy was one such theme which survived into the twenties in the decorative arts. For instance, at the 1925 Exhibition Fargue and Bastard exhibited an enamelled window with underwater flowers, fronds and fish set in swirling lines that represent water.

The collector Edward James purchased Surrealist works, including those of Magritte and Dali; in his mind and that of collectors like him there is a sympathy between Art Nouveau and rococo on the one hand and Surrealism on the other. This kind of association became less eccentric after the success of the 1938 Surrealist Exhibition in Paris. Kurt Seligmann's *Ultra-Meuble,* a stool which is composed of four naturalistic representations of stockinged and high-heeled

The French designer Jean Maillart drew this evening gown in 1932. The ruched shoulder piece and the elegantly curved train were reminiscent of Belle Epoque fashions, and indicate a revulsion from the straight-lined look of the 1920s.

women's legs was shown here. From this point Surrealism began to
have a strong influence in fashion and design. It opened the way for
such works as Dali's sofa in the guise of Mae West's lips, made in pink
satin. This had been derived from drawings of her face as a room in
which her eyes were pictures, her hair draperies.

In the period between the wars Art Nouveau had been forced into
a largely anonymous and marginal position despite its real influence
in the arts and design. The popularization of Surrealism at the end of
the period marked a point at which the values of the style had once
again become acceptable in significant areas of the fine and decora-
tive arts.

The Russian ballerina Alla Nazimova produced and took the title role in the 1922 Hollywood version of *Salome* (*above and above right*). The costumes and sets, based on Aubrey Beardsley's illustrations to Oscar Wilde's original play, were designed by Natasha Rambova. The fairies in Max Reinhardt's 1935 production of *Midsummer Night's Dream* (*right*), also made in Hollywood, recall the German artist's roots in the Jugendstil of turn-of-the-century Berlin with their tresses and seductive looks.

When, during the 1930s, interior designers reacted against the clinical plainness of modernism, they often turned to the forms and motifs of the baroque and rococo styles. The exoticism and voluptuous flamboyance of these revivals came close to Art Nouveau in feeling, typified in Rex Whistler's illustration to *Silver Collar Boy* by Constance Wright (*above*), published in 1934.

Osbert Lancaster's *Homes Sweet Homes*, a witty survey of interior decoration, was published in 1939 when Art Nouveau was quite out of fashion. That it was included in Lancaster's book at all probably reflects the appearance three years before of Nikolaus Pevsner's *Pioneers of the Modern Movement from William Morris to Walter Gropius*, among the earliest serious re-assessments of the style.

The Swiss Surrealist painter Kurt Seligmann, when illustrating the work of the Comte de Lautréamont (*below right*), produced the same sort of swirling forms as Masson (*opposite*). In 1939 Seligmann painted *Sabbath Phantoms* in oils on glass (*below left*). The picture has the sort of threatening sensuality that is often to be found in the paintings of Symbolist artists such as Moreau or Grasset.

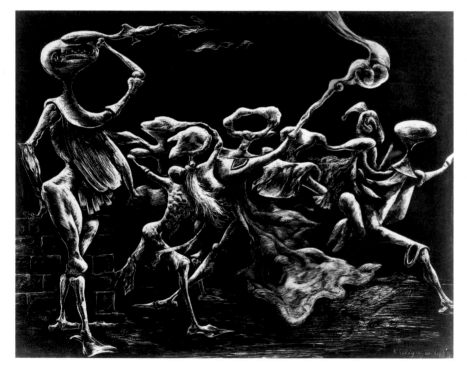

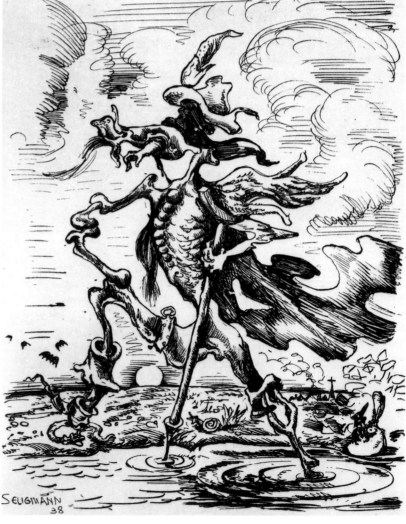

The Surrealist artist André Masson experimented
with automatic drawing, allowing his subconscious
to dictate the movements of his hand and pen. This
example (*right*) was published in *La Révolution
Surréaliste*, the journal of the movement. Masson's
illustration (*left*) to a poem by the Comte de
Lautréamont is an example of the Surrealists' regard
for nineteenth-century Symbolism which played an
important part in the Art Nouveau style.

Head of a Pipe-smoker (1925) (*below*) and *Dutch Interior I* (1928) (*left*) were painted by Joan Miró when he was close to the Surrealist movement. Companions such as the poets Louis Aragon and André Breton, and later his Catalan compatriot Salvador Dali, inspired Miró to investigate a subconscious language of swirling fantasy and subversion.

Salvador Dali delighted in the subversive, erotic forms of the Art Nouveau style. In the 1937 painting *Swans Reflecting Elephants* (*right*) motifs such as the swans and the sea-monster are drawn from the repertoire of the style; even the clouds are Art Nouveau. *The Birth of Liquid Desires* (*below*), painted by Dali in 1932, was one of a series of pictures inspired by the work of the nineteenth-century Swiss Symbolist painter, Arnold Böcklin, which with its mystery and repressed eroticism helped to create the Art Nouveau style. Dali's interest in Art Nouveau was frequently expressed, especially in his contributions to *Minotaure* on Gaudí and Guimard.

Atavistic Remains after the Rain (1934) (*left*) and the *Enigma of Desire* (1929) (*above*), both incorporate imagery drawn from the *fin-de-siècle* world of Art Nouveau.

Alastair, whose real name was Hans Henning Voigt, was born at Karlsruhe in 1887, and from his boyhood immersed himself in the drawings of Aubrey Beardsley. *Ashtaroth* (*right*) was one of his illustrations to an edition of Oscar Wilde's *The Sphinx* published in 1920. His portrait of Charles Baudelaire (*below*) comes from *Red Skeletons* of 1927; its sexual imagery is as striking as some of its precursors in Art Nouveau.

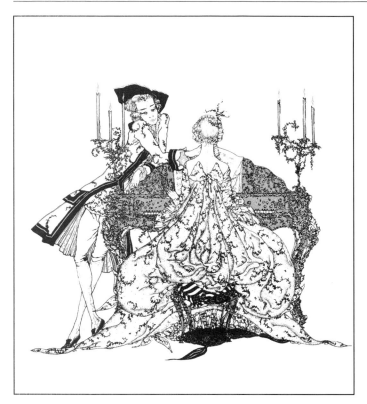

These illustrations to the Abbé Prévost's *Manon Lescaut* were drawn by Alastair for an edition published in 1928. The artist's debt to Beardsley is self-evident, and the wild rococo style of the décor and costumes is related to a trend followed by a handful of contemporary designers, such as Syrie Maugham, Cecil Beaton, Eugène Berman and Christian Bérard.

The sculptors Jean Arp (*top and right*) and Alberto Giacometti (*above*) were both associated with Surrealism. Their work is based on a close study of biological forms, often resulting in shapes and motifs reminiscent of Art Nouveau.

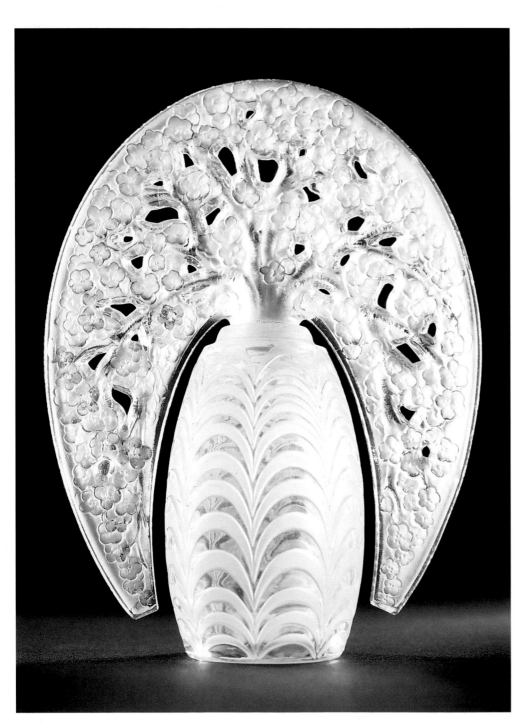

During the 1920s and 1930s René Lalique had abandoned jewellery and was designing glassware. As these three scent bottles (*left, below and opposite below*) show, the spirit of Art Nouveau often lingered in the shapes and decoration of his later production.

This silver-gilt tea service, made in Italy by Monfardini during the interwar period, is in a transitional style. It looks back to the work of Art Nouveau designers such as Henry van de Velde and forward to the biomorphism of the 1950s.

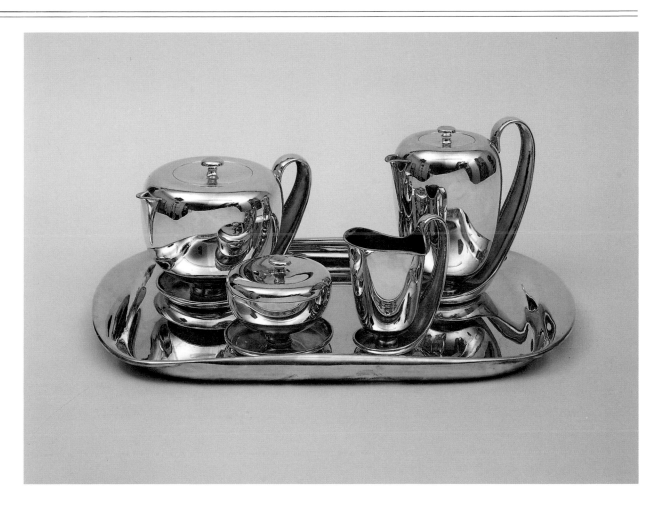

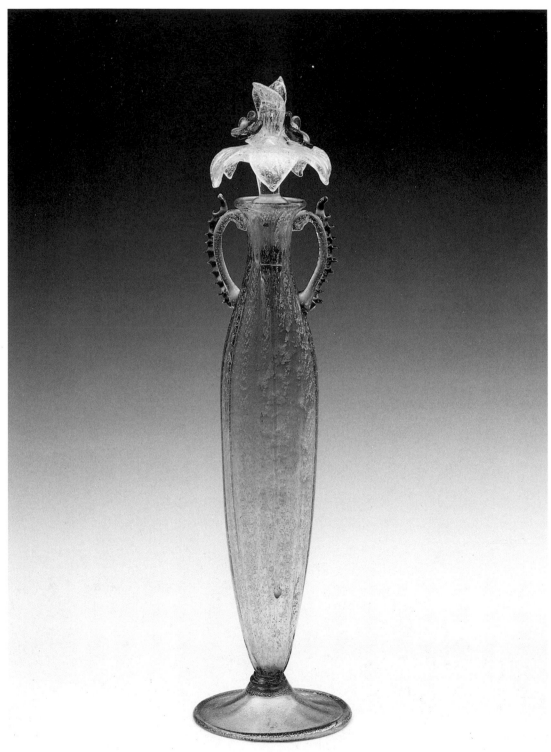

The Italian firm of Cappellin made this glass perfume bottle (*opposite right*) in the 1930s. The stopper in the form of an orchid distinctly recalls Art Nouveau designs.

These two vases by René Lalique (*opposite left above and below*) also reflect their creator's work in his heyday as an Art Nouveau jeweller.

This sofa in the form of Mae West's lips (*below*) was designed from Salvador Dali's illusionistic portrait of the film star as the interior of a room (*right*). A precedent for such a metamorphosis of a contemporary sex symbol into domestic decor was the way that the form of the dancer Loïe Fuller had been exploited by the Art Nouveau designers of the 1890s. It is worth noting, too, that Edward James, who commissioned the sofa, was very much part of the anti-modernist grouping which included Beaton and Whistler.

CURVILINEAR MODERNISM

In the climate of post-war Europe, artists faced a crisis of values: faith in human progress had reached what seemed to be its darkest hour with the revelations of the concentration camps and the nuclear destruction of Hiroshima and Nagasaki. Europe was faced with reconstruction on a vast scale and embarked with confidence and optimism, believing that if there was a dark side to Science, so to must there be a positive one. The technological acceleration of the war years brought advances in medicine and chemistry, commercial air travel expanded, aided by newly developed radar systems and aeronautical advances, and television would come into many homes, accompanied by a myriad of labour-saving household products; all to be powered by the cheapest electricity ever generated: the product of atomic fission.

While the prospect of owning such exotic items remained but a dream for most Europeans still in the grip of rationing and starved of all but the essentials of life, architects, artists and designers, fired by this spirit of reconstruction, set themselves to the task of building a better world for all. The question of a model was of paramount importance: the ascetic simplicity of Bauhaus design smacked too closely of wartime austerity and the 'utility' goods of the 1940s, already rejected by Christian Dior with the 'New Look' of 1948. As the state architecture of Hitler and Mussolini, rigid, utopian Classicism was unthinkable, and artists reacted against it, just as they had reacted against its élitism and solidity at the birth of Art Nouveau. The task in hand required a modernity which was somehow more humane, related to daily requirements and human comforts.

The passage from the clinical and efficient to the organic and sympathetic, is reflected nowhere more strongly than in furniture design. In America, certain designers looked back to the age of Art Nouveau for inspiration. In 1950, Edward J. Wormley entered into correspondence with the ageing Richard Riemerschmid, asking for advice in reproducing a chair which he had exhibited in Dresden in 1899. The chair was produced in an adapted form and appeared in the 1951 catalogue of the Dunbar Furniture Manufacturing Company of Berne, Indiana, where it was described as testifying 'to the enduring nature of good design'. Much of Wormley's other work, such as his mahogany-framed, cane-seated armchairs of the mid-1950s reflect his admiration of Art Nouveau furniture through the audacious pointed curves of their arms and spines. A similar interest in smoothly flowing, attenuated curves with an emphasis on moulded form, can be seen in the sculpted wood furniture of Vladimir Kagan and Paul Laszlo. The fluid curvilinearity and structural movement of

Kagan's 'Contour' series of armchairs recall Léon Jallot's work of fifty years earlier, while Laszlo's eccentric tables, produced in sculpted walnut and transparent acrylic for Herman Miller, transposed the whiplash line of Art Nouveau decorative motifs into three dimensions. This fascination with Art Nouveau design was reflected in the Gaudí exhibition held at New York's Museum of Modern Art in 1957, for which reproductions of Gaudí's furniture were specially produced.

Moulded chairs abound in the 1950s, whether in plywood or newly-developed artificial materials: fibre-glass, vinyl and an increasing array of plastics now made available to the industrial designer. In America, where the technical processes required to handle these new materials had reached their highest level, the designers under the veteran of the Scandinavian geometric Art Nouveau movement, Eliel Saarinen, at the Cranbrook Academy – Harry Bertoia, Charles Eames and Eero Saarinen – began to make their presence felt with revolutionary furniture that cushioned and cradled the body.

Eero Saarinen's 70 MC, better known as the 'Womb' chair, designed for Knoll in 1948, held the body in a gently curved dish of moulded plastic cushioned with latex. Eames's and Saarinen's designs for the exhibition 'Organic Design in Home Furnishing' of 1940, organized jointly by Bloomingdale's and the Museum of Modern Art (M.O.M.A.) in New York, broke new ground in the concept of furnishing that could be used individually and flexibly, allowing the body to converse, relax and lounge with freedom of movement in sculpted shells. Applying techniques derived from aeronautical research into the moulding of plastics and aluminium, and Eames's own research into the shaping and laminating of plywood for the United States Navy in the early 1940s, made possible these new designs. Eames's entire collection of moulded plywood furniture was taken up by Herman Miller in 1947, following the designer's one-man show at M.O.M.A. the previous year. Eames's definitive model, the luxury rosewood and leather chair of 1956, became a favourite of executives throughout America as much for its sheer comfort as for its imposing presence and contoured form. From his early partnership with Eames, Saarinen went on to produce a series of chairs exploiting the moulding properties of plastics, culminating in the 'Tulip' chair and pedestal furniture of 1954. In these designs, the ugly projections of the legs were dispensed with entirely by means of a two piece moulding, which presented a perfect series of elongated curves from base to apex in a manner similar to the bases of Tiffany lamps and the attenuated stems of Art Nouveau glassware at the turn of the century.

Scandinavian furniture had played an important role in shaping attitudes towards design in America. The Museum of Modern Art in New York had hosted an exhibition of the Finnish designer Alvar Aalto's furniture as early as 1938, and America provided him with his first major market. The exhibition 'Organic Design in Home Furnishing' of 1940 reflected Aalto's commitment to work for good, simple, undecorated things that are in harmony with the human being.

While Scandinavian designers, such as the Dane Arne Jacobsen, pursued an organic style of enveloping chairs in fibre-glass and plastics, such as his 'Egg' and 'Swan' designs for Fritz Hansen in 1959, post-war furniture design in Scandinavia saw a continuation of the tradition of close cooperation between designers and small manufacturers to produce hand-made, hand-finished products in the most abundant local material: wood. Scandinavian furniture had a warmer touch than the mass-produced industrial furniture appearing in America, and complemented the material with an acute awareness of its sculptural qualities, so evident in the work of the Danish designer Hans Wegner. The biomorphic sculptural projections on the splat and seat of 'Dumb Valet' of 1953 go far beyond the dictates of their function, and display the same kind of organic approach that characterized the furniture of Antoni Gaudí.

The eccentric and highly-talented Italian designer from Turin, Carlo Mollino, shared this fascination with the sculptural form of the Catalan architect's furniture designs, and paid homage to him with the 'Gaudí' chair of 1949. Consciously referring to the height of Art Nouveau sophistication, Mollino's furniture, produced almost exclusively for commissioned interiors, was designed with a bravado that flew in the face of expectation, convention and post-war Italian austerity. The elaborate, interlacing curves of Mollino's 'Arabesque' tables in moulded and perforated plywood, and the recurrent use of high, contoured backs, coupled with the sculpting of wood into elegant, attenuated curves employed in many of his chairs, hark back to the work of Hector Guimard and Victor Horta. The split, cushioned vinyl surfaces of the seats designed for Gio Ponti in 1940, and the tapering, sculpted legs of many other pieces suggest, with their overt eroticism, an almost subversive side to Mollino's work. This is amply reflected in his interior commissions of 1939 for the Miller and Devalle houses in Turin, where attention was paid to every detail from mirrors to light-fittings. With these interiors, and above all in his own private apartments, Mollino gave full range to his ability, producing complete environments that could be adapted

The American Surrealist painter Joseph Cornell made this collage entitled *Allegory of Innocence* in 1956. The sexual symbolism has been presented in a manner which evokes the *fin-de-siècle*, although it is Freud rather than Baudelaire who lies behind the imagery.

to his every whim. Controlled multi-coloured lighting and changeable backdrops were combined by Mollino with surfaces in an extraordinary range of man-made and natural fabrics to create an almost theatrical setting, somewhere between Symbolism and Surrealism. The overpowering atmosphere of these rooms recalls the refined decadence of Art Nouveau interiors such as Endell's vestibule for the Studio Elvira and the Café de Paris by Sauvage and Sarazin. Mollino has been compared to the reclusive aesthete des Esseintes, hero of J.K. Huysmans' Symbolist novel À Rebours of 1884, and this interpretation would seem to be borne out in the interior designs for the Devalle house. Here, the padded walls and ceiling of lilac velvet in the bedroom, and flesh pink and scarlet wall coverings of the living room, combined throughout with a virtuoso use of mirrors to create effects of artificial perspective, recreated something of the rarified artificiality of the more extreme high Art Nouveau interiors.

Mollino's concept of total design was a characteristically northern Italian approach, in stark contrast to the utopian emphasis on popular furniture and urban renewal, centred in Rome. The visionary aspect of northern design typified the re-established Triennale di Milano, which offered a glimpse of what the brave new world envisaged by architects and designers might look like, at its first post-war exhibition of 1948. The Triennale's promotion of links between different disciplines was highlighted with the appointment of the painters Lucio Fontana, Mario Radice and Luigi Rossi to the organizing committee of the 10th Triennale of 1951, and commitment to the development of the harmonious, artistic environment was promoted abroad, as well as at home. Carlo Mollino's interior, exhibited at the Brooklyn Museum's 'Italy at Work' show of 1950, made a significant impact in America, while in Europe, Lucio Fontana had demonstrated the possibility of creating an environment almost entirely from light with his ultra-violet neon installation at the entrance to the Triennale of 1948.

The whiplash line of Fontana's neon work and the lyrical graphism of Ettore Sottsass' textile designs of the period, reflected contemporary concerns in painting. This was the time of Art Informel, softened organic abstraction with its diffuse, cosmic space derived from a new awareness of the transience of matter and the forces at work in natural processes; and Abstraction Lyrique, gestural painting, inspired by the intertwining, vegetal drippings of the American painter Jackson Pollock, that traced the movement of the body through space. As artists at the beginnings of Art Nouveau had been fascinated by contemporary scientific developments – Darwinism and the

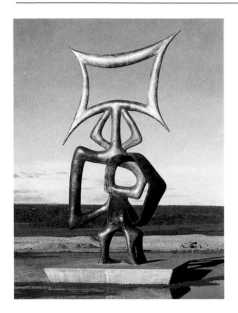

This statue by the Brazilian sculptress Maria Martins is an example of an anthropomorphic abstract style which evolved from Surrealism. Its forms are often close to Art Nouveau designs based on nature, such as the work of Hermann Obrist, Bernhard Pankok and other Munich artists.

study of primitive forms of life – so too the great theoretician of Informel, Michel Tapié, nephew of Toulouse-Lautrec, embraced advances in mathematics, physics, chemistry and micro-biology, and fed them into the world of painting and sculpture in an attempt to evolve a radically new art for a radically new age. Tapié's ideas were disseminated through exhibitions: from the initial 'Signifiants de l'Informel' in 1951 at the the Galerie Fachetti in Paris, to 'The World of New Painting' which toured Japan in 1958, and the influential 'Arte Nuova' at the Palazzo Graneri, Turin, in 1959; and through his critical writings in the Parisian art press throughout the 1950s.

Interest in the previously arcane worlds of physics and microbiology filtered through to the field of design, as in the 'Taraxacum' light by the Castiglioni brothers of 1950, which resembled some ectoplasmic cell, with its biomorphic contours and tactile skin in spun glassfibre. In Britain, the Festival Pattern Group was set up in connection with the 1951 Festival of Britain to devise graphic designs based on molecular structure as seen through the electron microscope. Even the equations of Einstein, the popular post-war symbol of human endeavour, found their way into home furnishings with the 'Relativity' fabric design of the American Ben Rose in the mid 1950s.

Articles on the relation between art and science appeared frequently in the art press of the time, in particular the new, multilingual, international art magazines *Quadrum* and *Cimaise*. The latter published Gyorgy Kepes' influential 'L'Art et la Science' in its April issue of 1955, which accompanied the text with juxtapositions of contemporary organic abstraction and photographs bearing witness to the extraordinary power of the new electron microscopes. Kepes stressed not only the importance of the links between art and science, but also the originality of eastern approaches to the understanding and interpretation of scientific phenomena: 'In the West, the anatomical study of the world predominates; our culture is centred on the objective understanding of reality, of links of forces, of structures, to the detriment of our subjective appreciation. On its side, the Orient is less occupied with the structure of the world than applying itself to feeling its harmonies.'

In the wake of western philosophy's apparent failure, it is hardly surprising that, in the search for a model, attention again focused on the east, as it had done at the end of the nineteenth century. Interest developed in non-rational Buddhist and Taoist thought, with their emphasis on the unity of man and his environment; and a spate of exhibitions – of calligraphy, ceramics, painting and sculpture – passed through Europe. Touring exhibitions such as 'L'Encre de Chine

dans la Calligraphie et l'Art Japonais Contemporain' of 1955 and major surveys such as 'L'Art Japonais à travers les Siècles' at the Paris Musée Nationale d'Art Moderne and 'Orient-Occident' at the Musée Cernuschi, both held in Paris in 1958, reinforced the Oriental arts' image of refined beauty and effortless functionalism tied to an acute awareness of the qualities of materials, that had inspired artists almost a century earlier. While Oriental painting, in particular Japanese calligraphy, had a profound effect on French painters such as André Masson and Jean Degottex in the 1950s, on a more mundane level, Oriental motifs filtered through to soft furnishings, with titles like 'Lotus', 'Mikado' and 'Shogi' featuring heavily in textile catalogues of the time. In America, which had seen the exhibition 'Japanese Painting and Sculpture' at New York's Metropolitan Museum in 1953, designers, such as Maggie Miklas and Pipsan Saarinen Swanson at the Edwin Raphael Company, utilized Chinese and Japanese calligraphy as abstract designs in their own right, in much the same way that Art Nouveau artists had adapted Japanese textile patterns and stylizations of natural forms.

Thus, it is not without significance that organic Modernism reached its height in the hands of a man uniquely placed to appreciate it: the Japanese-American sculptor Isamu Noguchi. The legacy of Noguchi's training under Constantin Brancusi in Paris and his association with the Surrealists, appeared in his radical furniture designs of the late 1930s and 1940s. Early one-off commissions for dining tables – monolithic stone pieces derived from cell structures – reflected Noguchi's passionate interest in plant and animal life and the medical studies of his youth. The coffee table he designed as a unique piece for Congar Goodyear in 1939 was refined in 1944, and went into production at Herman Miller the following year. The amoebic form of the glass top, and the plastic handling of the articulated wooden base were highly original, setting the scene for a whole generation of organic furniture designs in America. The coffee table and Noguchi's free-standing light sculptures, or *akari* – inspired by traditional Japanese lanterns – which he produced for Knoll, had already been pirated well before his own designs went into commercial production in 1944, but were to prove the most influential and enduring of his organic design projects.

As an important contributing factor to the development of organic Modernism, the legacy of Surrealism should not be forgotten; it had hit the worlds of fashion, furniture and retailing with the appearance of almost ubiquitous 'Surreal' window displays following the movement's exodus to America in 1941. Salvador Dali's 'Lobster' tele-

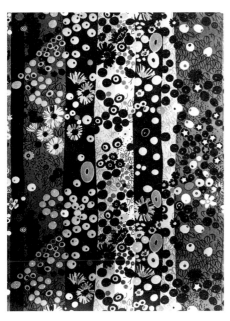

The rich profusion of deftly placed, stylized flowerheads on this printed cotton velvet, called *Primavera* and designed in 1959 by Don Wright for the New York textiles firm Larsen, is reminiscent of motifs in a number of paintings by Gustav Klimt. In both cases, the unruly power of natural growth seems to have been barely contained by the artist's design.

phone and the 'Mae West's Lips' sofa of the late 1930s did perhaps represent the extremes of organic Modernism, yet his name became associated with high-fashion and luxury goods for the wealthy American market following his cover for *Vogue* of 1944, and his retrospective at the Museum of Modern Art in New York. Dali was in great demand, decorating Helena Rubinstein's New York apartment, designing the publicity materials for Schiaparelli's new 'Shocking' fragrance, and 1949 saw his first jewellery designs, made in collaboration with the Duke of Verdure. *The Persistence of Memory* transformed Dali's familiar motif of a soft watch hanging limply like an over-ripe Camembert on the branch of a tree, into an *objet d'art* of gold, enamel and diamonds.

Italian glass design, too, reflected this awakened interest in natural, organic forms. Much of the delicate glassware that appeared from the firm of Paolo Venini in the 1950s was derived from vegetal and floral sources and utilized the fluid decorative skills of the Murano glass factories in Venice to produce designs that hark back, albeit in a simplified form, to the great age of Art Nouveau glass at the hands of Gallé. But the link between turn-of-the-century Art Nouveau glass and 1950s organic design was nowhere more apparent than in Scandinavia. Tapio Wirkkala, an outstanding designer and director of the Finnish Institute of Industrial Arts from 1951 to 1954, took charge of the Finnish pavilion for the Triennale di Milano of 1951, and produced one of the event's most memorable displays. His 'Medusa' vase treated a motif – the jellyfish – which, through the lavish plates of the German Darwinist Ernst Haeckel's monographs on the creature, had provided an important source of inspiration for many Art Nouveau designers. Wirkkala's sensitive organic designs and understanding of natural form is equally evident in his vase designs based on floral shapes. Vicke Lindstrand's work for Kosta followed similar themes incorporating foliate patterns of coloured crystal into glassware that retained the fluidity and asymmetry of its molten state in a manner unseen since the creations of François-Eugène Rousseau.

It is a testament to the strengths and radical innovation of Art Nouveau design that, in a time of rapid change and reconstruction when artists felt that they were embarking on the road to a new era, they looked back to the heights of Art Nouveau – and beyond it to its sources in the Orient and in faith in contemporary science – as a suitable and relevant source of inspiration from an age which had faced very similar problems to their own.

Jean Cocteau designed both the form and decoration of this porcelain vase (*left*) which was manufactured by the German firm of Rosenthal. The lower part appears to have an anatomical derivation, while the upper part could be based on the calyx of some flower; the whole takes up the Art Nouveau theme of the metamorphosis of human into plant. Cocteau's graphic (*below*) work, too, displayed a fondness for sinuous, curving line.

The biomorphic forms of these glass vessels designed by Fulvio Bianconi (*below*) for Venini relate them to the Surrealist sculpture of Henry Moore and Jean Arp, and also suggest the shapes of some Art Nouveau metalwork and ceramics.

These vases were designed by Fulvio Bianconi (*far left*) and Thomas Stearns (*left*) and manufactured by the firm of Venini in Venice. They show how closely the forms of Italian glassware of this era were based on nature.

Both the form and decoration of these vases by the Italian glassmaker Aldo Nason (*opposite*) recall objects from around 1900. The techniques used in making them were similar to those employed in the decoration of some Tiffany pieces, but Nason's work has closer affinities to the ceramics of the 1890s made by such potters as Jean Carriès and Paul Jeanneney.

This jewel-object, created by Salvador Dali in the early 1950s and made of 18-carat gold, is entitled *The Living Flower*. The petals can be opened and closed by a mechanism hidden in the malachite base. The petals, set with diamonds, are in the shape of hands, and the piece may be seen as a re-statement of the Wagnerian flower-maiden theme. Music from *Tristan und Isolde* had been used by Dali and Luis Buñuel in their 1929 film *Un Chien Andalou*.

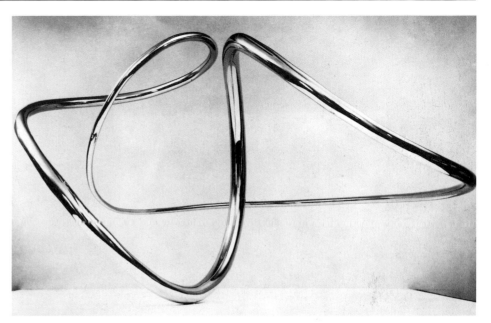

José de Rivera was one of the many sculptors who during the 1950s worked in wire. He exploited the ductile qualities of the metal to create abstract convolutions which often echo the whiplash line of Art Nouveau (*below, right above and below*).

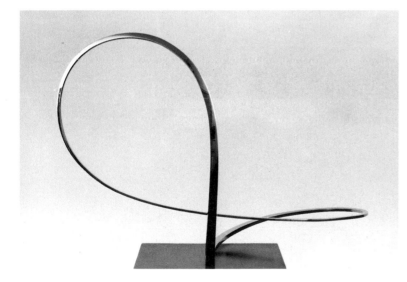

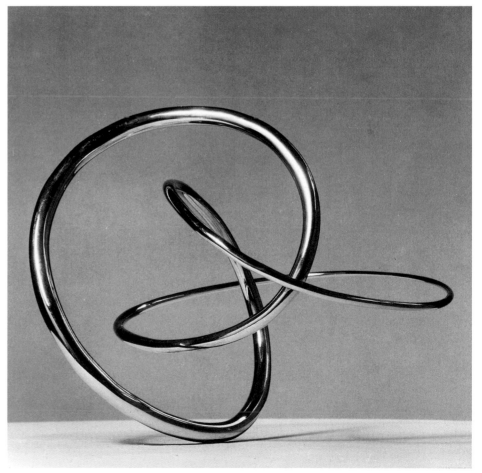

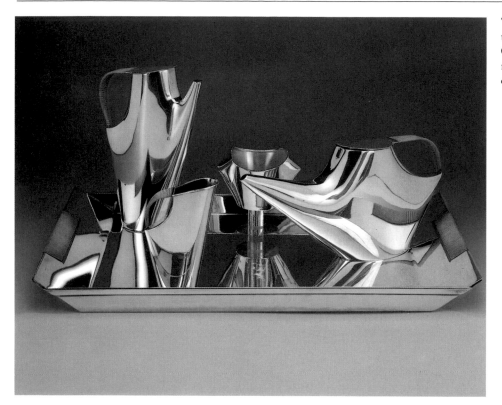

The *Como* silver tea service and tray was designed in the 1950s by Lino Sabattini for the French firm of Christofle. Its unconventional shapes are reminiscent of tea and coffee services made in silver or pewter at the turn of the century.

This partly gilded silver candelabrum was designed by Jens Andreason and made in 1956 by E.H. Skilton for the London retailers Asprey's. It is a direct descendant of the Art Nouveau candlesticks made in the form of flowers.

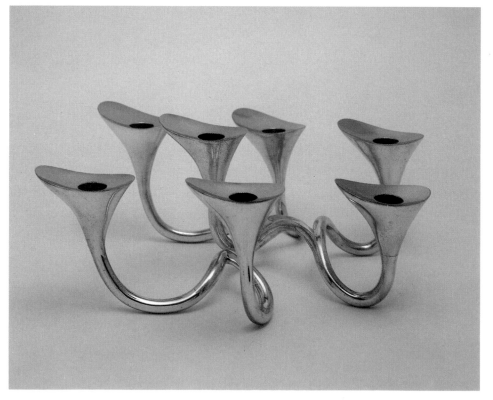

Tapio Wirkkala designed this glass vase (*opposite*) in 1946. Decorated with finely engraved lines, it was made at the Karhula-Iittala glassworks in Finland. Based on the form of an arum lily, it is not only representative of the biomorphism which dominated design in the years following World War II, but also clearly states the connection between the Fifties style and Art Nouveau.

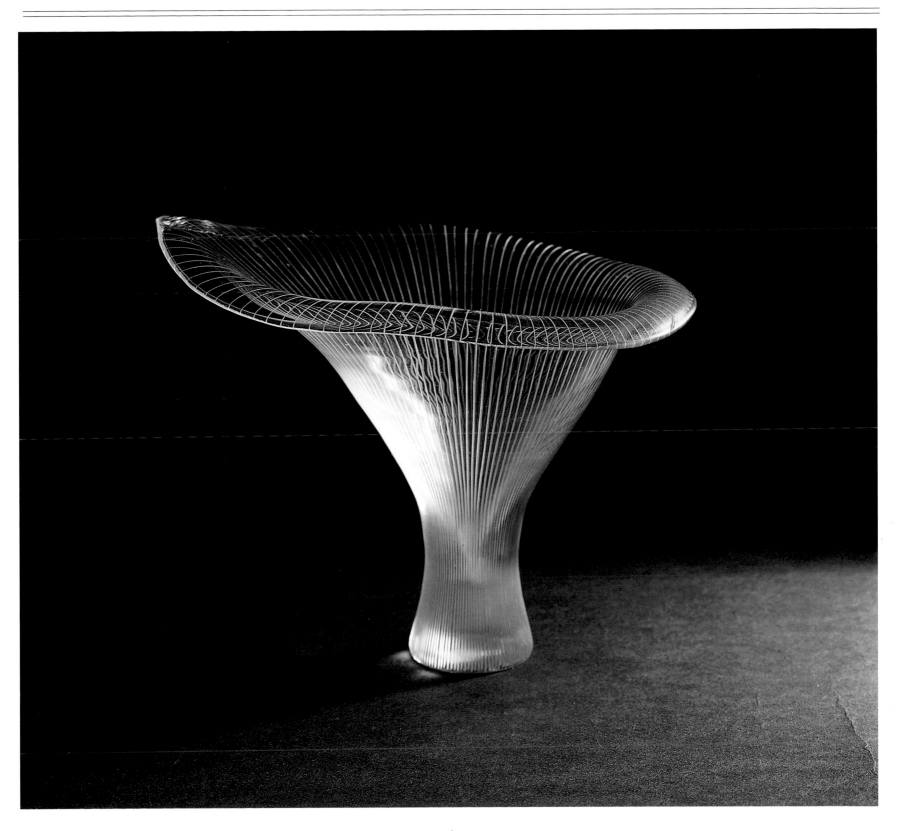

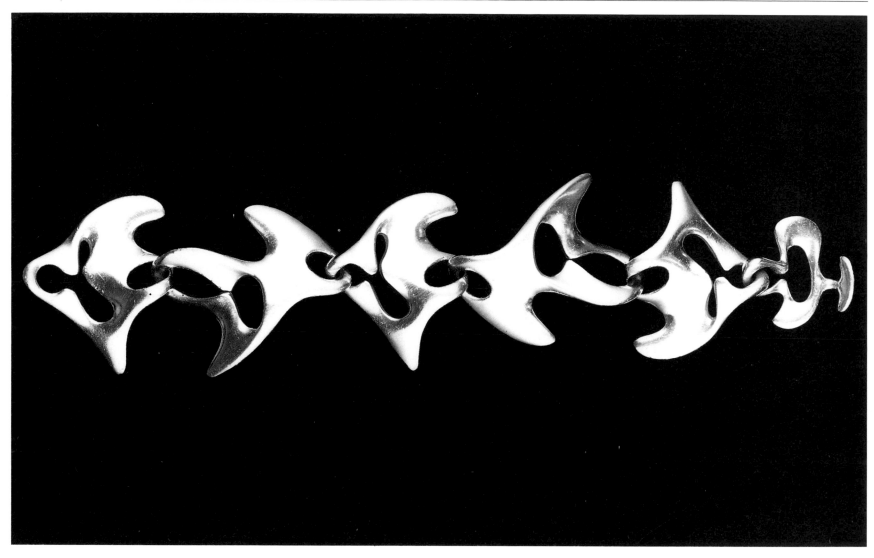

Henning Koppel designed this silver
bracelet for the Copenhagen firm of
Georg Jensen in 1947. With the work of
Koppel and other designers, the style of
Jensen's silverware and jewellery came
round full circle to the firm's origins in
the Art Nouveau era.

This wood floor lamp, by an unknown designer, indicates the relationship between 1950s design and Surrealist sculpture. The constant references to the human figure, as well as a preoccupation with the interplay of curves, link the style to Art Nouveau.

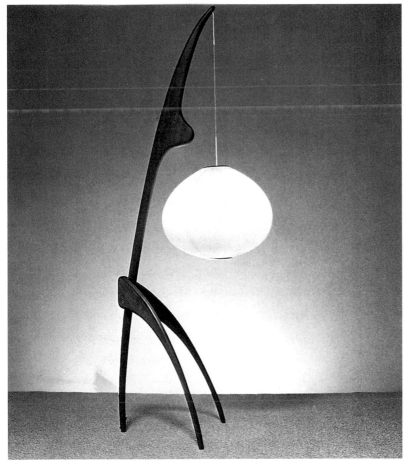

In this standard lamp of 1948 (*above*), manufactured by the Turin firm of Giorsini, the designer Carlo Mollino has shaped and twisted the shade to create a series of dynamic curves which might have been borrowed from the repertoire of Horta, Guimard or van de Velde.

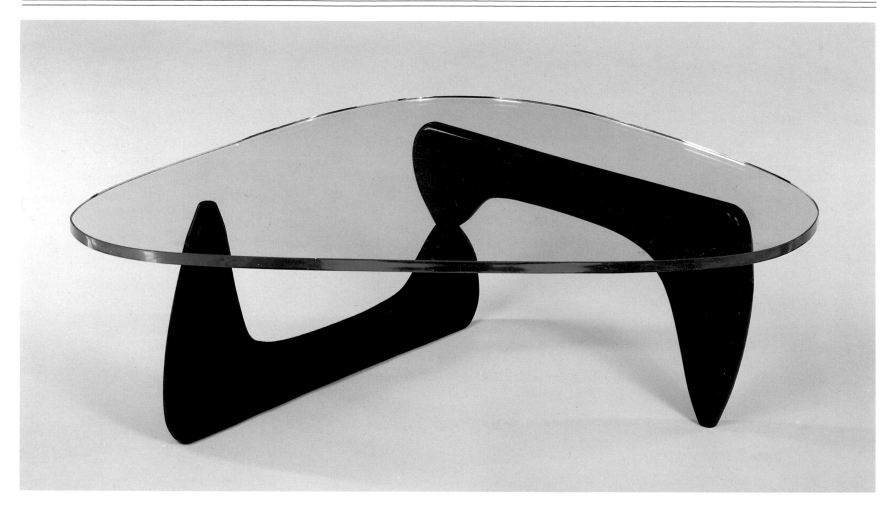

The American sculptor Isamu Noguchi designed this coffee table (*above*) for the furniture makers Herman Miller. Created by Noguchi in 1944, the table is one of the earlier examples of the biomorphic style which became prevalent during the 1950s. Noguchi spent his childhood in Japan, and the influence of that country's art on his work is as evident as it had been on Art Nouveau.

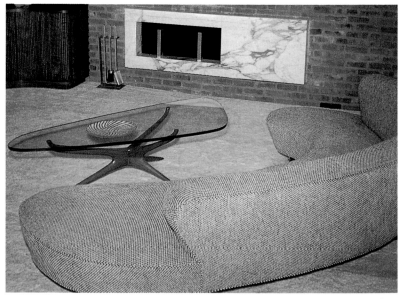

This sofa and coffee-table (*right*) were designed by Vladimir Kagan about 1952. Noguchi, Kagan and Paul Laszlo led a movement in America which produced furniture in organic shapes, often made of sculpted walnut. Wood had not been treated in such a plastic way since the furniture created by Hector Guimard or Louis Majorelle.

Carlo Mollino designed several versions of this
'Arabesque' table from 1949 onwards. Mollino was
one of the first Italian designers to be consciously
influenced by the Art Nouveau style which had
flourished at the turn of the century. He named one
of the chairs which he designed in 1949 'Gaudí'
after the Art Nouveau designer and architect of
Barcelona.

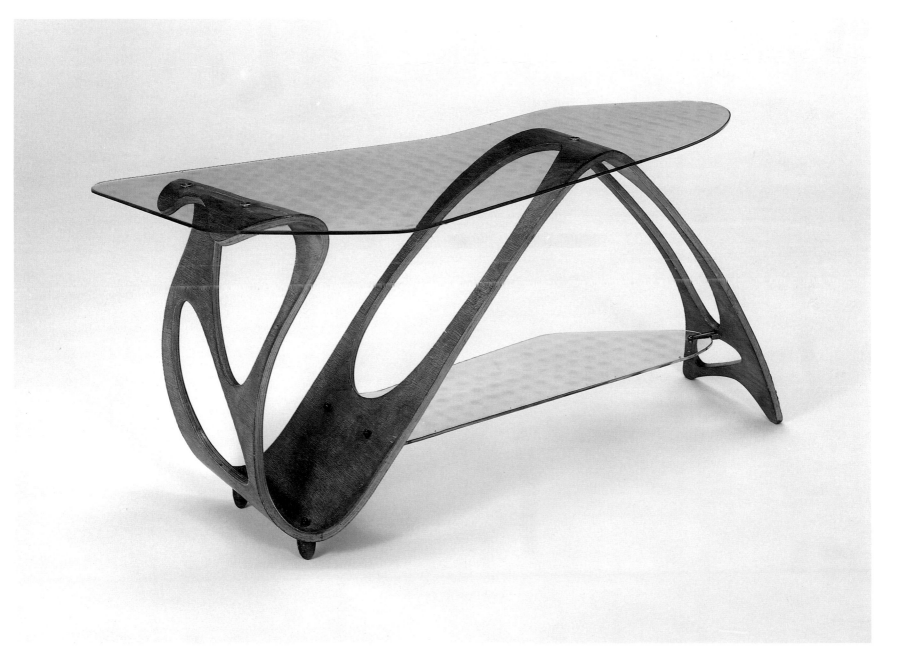

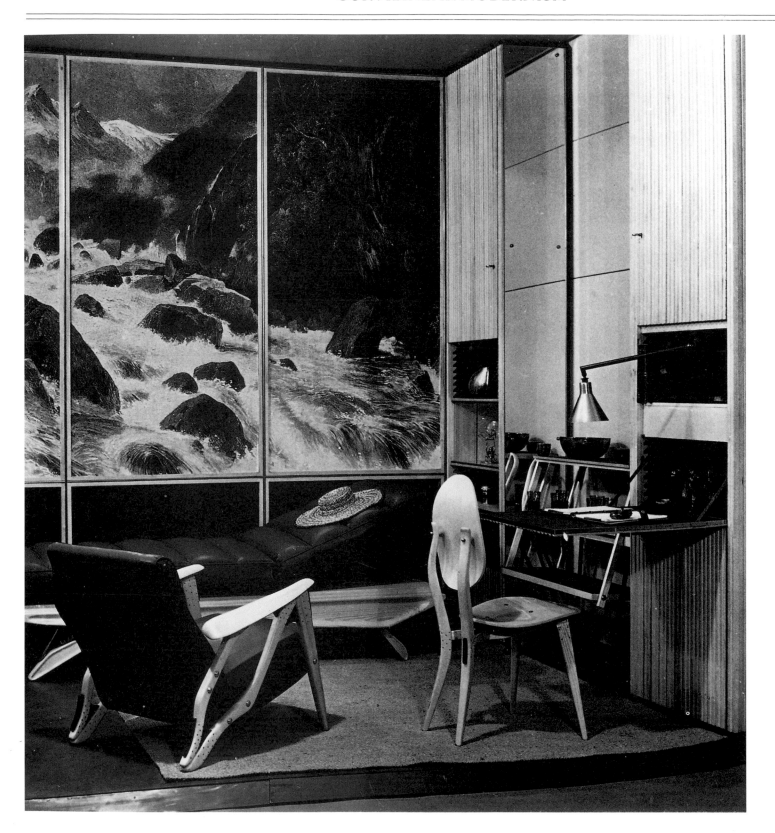

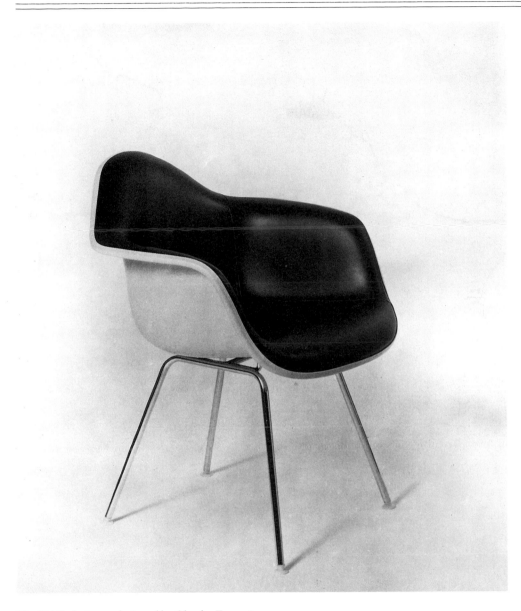

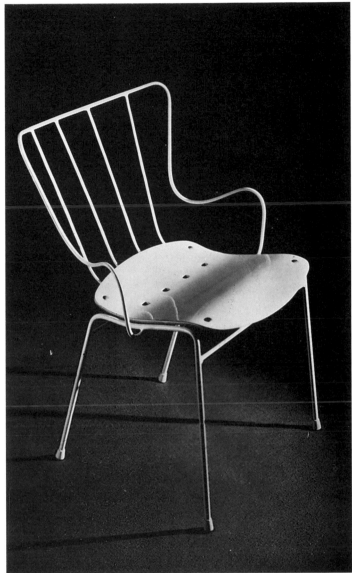

The DAR chair was designed by Charles Eames in 1948 for Herman Miller. It was one of the first designs to exploit the properties of glass-fibre reinforced plastic, a material which promoted the adoption of organic shapes.

Ernest Race designed this 'Antelope' chair for the 1951 Festival of Britain. An indication of the affinities of 1950s furniture design to Art Nouveau is given by the number of chairs named after flora or fauna – 'Peacock', 'Swan', 'Antelope', 'Butterfly', 'Egg' and 'Tulip' are some examples.

This interior designed by Carlo Mollino about 1950 (*opposite*) shows not only the Art Nouveau style of his furniture but also a mural decoration which features the kind of sexual imagery characteristic of so much painting and design around 1900.

This 'Tulip' chair and table were designed about 1956 by Eero Saarinen, son of Eliel Saarinen, one of the architects of the Finnish pavilion at the Paris Universal Exhibition. Eero collaborated with Charles Eames on a chair which won two first prizes in the Organic Design Competition held in 1940 by the Museum of Modern Art in New York.

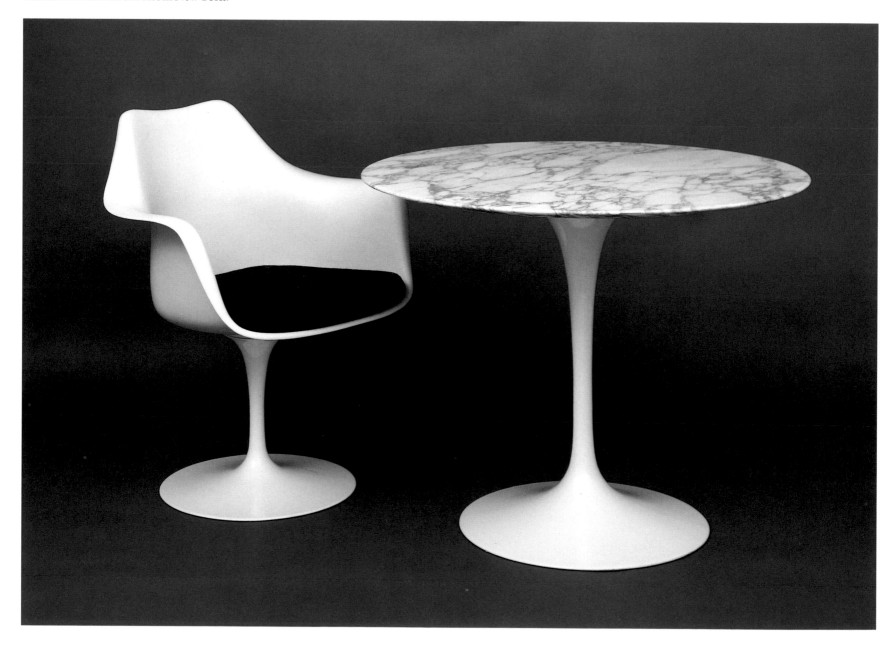

Charles Eames designed this couch in 1948, one of the earliest pieces of furniture in the organic style. The lightness and delicately curved surfaces of Eames's furniture evoke the spirit of some Art Nouveau pieces – for instance, the work of Georges de Feure for Siegfried Bing.

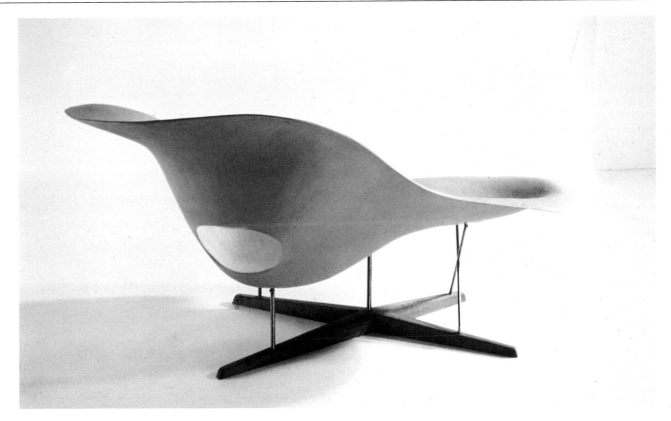

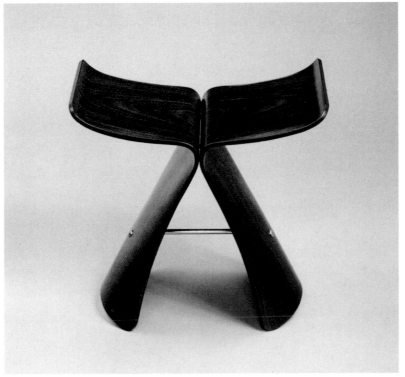

Although Sori Yanagi, who designed this 'Butterfly' stool in 1956, worked for a time in the office of the modernist Charlotte Perriand, the organic shapes and oriental elegance of his work relate him more closely to Art Nouveau than to the Modern Movement.

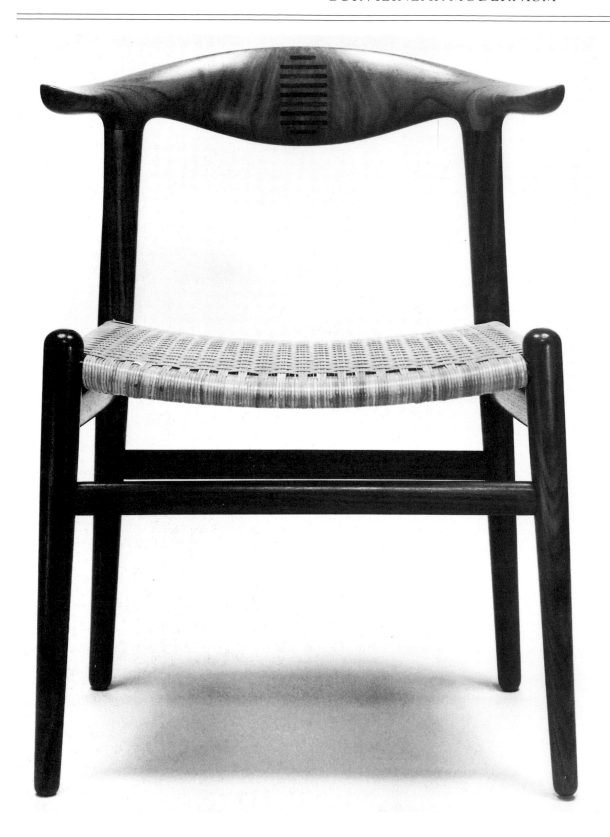

This chair of walnut and mahogany was designed by the Dane Hans Wegner in 1949 and manufactured by Johannes Hansen of Søborg. Scandinavian designers pioneered the organic style of the 1940s and 1950s.

Wegner brought his craftsman's experience of materials to his furniture design. He has made full use of the natural beauty of wood in these chairs which he designed in 1949 (*opposite left above and below*).

The 'Egg' chair (*right above*) was designed by the Danish architect Arne Jacobsen in 1957, and it was manufactured by the firm of Fritz Hansen at Allerød in Denmark. Jacobsen also designed the 'Swan' chair (*opposite right below*) that year. He created the furniture and furnishings for his architectural commissions, the most important of which during the 1950s were the SAS airline terminal and the Royal Hotel, both in Copenhagen.

THE REFLOWERING OF A R T NOUVEAU

From the end of the Belle Epoque to the beginning of the 1960s – a period of about half a century – the spirit of Art Nouveau, though alive, languished. Sometimes it surfaced as the idiosyncratic passion of an eccentric individual, such as Alastair or Salvador Dali. Sometimes, as happened during the years around 1950, the prevailing style in the decorative arts echoed the forms of the Art Nouveau that had flourished at the turn of the century. But this occurred not so much because the designers were impressed by – or even aware of – the work of their *fin-de-siècle* predecessors, but rather because they shared some of the same sources of inspiration, or were responding to analogous situations.

In the 1960s, however, a whole generation emerged on both sides of the Atlantic which was disillusioned with the materialist standards of society, just as the generation which had created Art Nouveau during the 1890s had been appalled by the absence of spiritual values from their world. The pop culture of the Sixties was more strident than *fin-de-siècle* aestheticism, but when the hippies discovered Art Nouveau they immediately recognized the work of fellow-travellers. In Europe and America museum curators unlocked store cupboards and eventually there was an exhibition of Art Nouveau on somewhere practically every week of the decade. Young people gawped in admiration at Art Nouveau buildings that their elders might have wished had been destroyed in the bombing raids of World War II. Glass by Tiffany, Loetz and Gallé was suddenly desirable; attics and cellars were ransacked for Liberty and Kayserzinn pewter. By the end of the Sixties, John Jesse and Lillian Nassau had opened shops selling Art Nouveau objects in London and New York respectively, and Sotheby's were holding regular Art Nouveau sales.

There are close similarities between the 1890s and the 1960s. Both decades witnessed moral rebellions, in which a hedonistic spirit seeking pleasure and self expression through art, sex and drugs challenged conventional bourgeois values and social practices. In both decades a rejection of the traditions of the previous generation was accompanied by an intense moral idealism which flourished hand in hand with a consumer boom. Both decades witnessed a romantic quest for new lifestyles in which the boundaries between art and life were challenged with the ultimate aim of creating a new consciousness and new forms in art and design.

The impulses behind the Art Nouveau revival during the 1960s were paradoxical. On the one hand it reflected the increasing liberalization and permissiveness of western society, assisted by progressive legislation in the areas of sexuality and self expression, including

reforms in the laws pertaining to homosexuality, the abolition of theatre censorship and a general loosening of controls over erotica. The Art Nouveau revival was also anti-Modernist, reflecting a widely-felt disillusion with the idea of a future entirely governed by the values of advancing technology.

As familiar nineteenth-century city centres in Europe and America were replaced by modern and rational, but often ugly and soulless, tower blocks and concrete flyovers there developed in design circles a distinct turning to the richness of *fin-de-siècle* decorative arts. The Art Nouveau revival came to be associated with pop culture's challenge to the systematic, analytical approach to design promoted by Tomàs Maldonado at the Hochschule für Gestaltung in Ulm. This attempted to reduce questions of intuition and taste in the design process to the bare minimum. Whereas Modernism had come to represent the rational discipline and common sense of the bureaucratic corporation, the sinuous, organic curves of Art Nouveau and the decadent imagery of late nineteenth-century Symbolist art became the stylistic hallmarks of an underground 'counterculture'.

In Britain the revival of interest in Art Nouveau was part of a wider anti-Modernist movement which can be traced back to the early 1950s, although the 1951 Festival of Britain provided a platform for the 'official' Modernism of the Council of Industrial Design.

The boom years of the late 1950s and early 1960s gave many young people their first taste of financial independence. At first many of them used their commercial power to consume more avidly than their parents, but by the mid 1960s there were signs that 'mod' culture was becoming tinged with disenchantment. Nostalgia for a flamboyant and colourful past began to make itself felt. One major impetus behind the nostalgia craze was the success of the 1963 Alphonse Mucha exhibition at the Victoria & Albert Museum in London. The exhibition displayed many of Mucha's most celebrated works, including his posters of Sarah Bernhardt (1894-5), posters for the Salon des Cent (1896), Champagne Ruinart (1896), La Trappistine (1897) and Job Cigarette Papers (1896-7). The glossy magazines featured Mucha's work and 'Art Nouveau Fever' raged around fashionable London. By early 1964 advertising had seized upon the new trend and a few chic London shops had introduced the Art Nouveau style in window displays and interior designs.

The nostalgia craze and the Art Nouveau revival were quickly incorporated into the world of pop music. The Beatles, undisputed kings of pop in the mid 1960s, appeared for the first time in 'retro' military-style jackets at a *New Musical Express* poll-winners concert

early in 1965. The sleeve of their *Rubber Soul* album of 1965 featured curving organic typography, while the record itself contained thoughtful, introspective songs very different from the familiar three-minute pop single.

Both the form and the content of *Rubber Soul* heralded major changes in the pop world. Although there had been strong links between traditional jazz and romantic bohemians for more than a decade, pop music had always been essentially working-class, more concerned with dancing than art. While the Pop Art of the 1950s and early 1960s often drew its inspiration from the glamorous world of pop music, Pop paintings were exclusive one-offs which sold for high prices in fashionable galleries. Pop music was pure pop – mass produced, expendable and cheap. The visual equivalent of pop music became the poster and the album cover, and as the lyrics of pop songs became more visual, the imagery and form of Art Nouveau became integral to the pop sensibility.

As pop musicians, their fans and followers began to turn from amphetamines to LSD around the mid 1960s, there was a corresponding surge in visual perception in the pop world. As the sounds and colours became more closely associated, lyricists like Lennon and McCartney began to work on a broader canvas. Pop evolved into rock, the cultural talisman of an entire subculture rather than simply entertainment for young people. But although music was at the core of rock culture, most of its secondary manifestations were visual: graphics, illustrations, animation and fashion. The art college was the natural habitat of rock culture and a large number of successful groups had backgrounds in art education. For many of them the recording studio and the painting studio were virtually interchangeable. Pop was becoming intellectual.

The major Aubrey Beardsley exhibition at London's Victoria & Albert Museum in the summer of 1966 played a major part in the development of the new visual consciousness. The exhibition was the most comprehensive ever devoted to Beardsley's work; it opened with a selection of book illustrations, posters, pastiches and fakes which were all indicative of the Beardsley craze which started in 1894 and spread all over the western world. The exhibition featured examples of poster art by Will Bradley and other American contemporaries deeply indebted to Beardsley's work. Also included in the exhibition were drawings for reproduction by line block in such books as *La Morte Darthur*, the *Bon-Mots* and *Salome*. There were drawings for *The Yellow Book*, two of the tamer illustrations to the *Lysistrata* of Aristophanes (the more erotic illustrations were only displayed by

special request), drawings for *The Rape of the Lock* and for Beardsley's last undertaking, *Volpone*.

Beardsley's hallucinogenic associations and decadent eroticism struck a resonant chord within the nascent underground. His cult status was only increased when the police, sensing a link between the drug culture and the Beardsley exhibition, seized several reproductions of his more erotic illustrations which had been on open display in a Regent Street bookshop. By the end of the exhibition in September 1966 it was possible to buy a folder of the forbidden illustrations from under the counter at the shop Granny Takes a Trip on the King's Road in Chelsea, London. Writing in the *Observer* in December 1967 the jazz musician and art critic George Melly wrote: 'Sometime in the early summer of 1966 I went along to the Victoria & Albert Museum to look at the Beardsley exhibition and found it packed with people. . . . Many were clearly art students, some were beats, others could have been pop musicians, most of them were very young, but almost all of them gave the impression of belonging to a secret society which had not yet declared its aims and intentions. I believe now that I had stumbled for the first time into the presence of the emerging Underground.'

Within weeks of the opening of the Beardsley exhibition the Beatles' *Revolver* album appeared with a cover designed by the band's art school friend, Klaus Voorman. The cover featured a collage of tiny photographs of the Beatles peeping through thin black and white line drawings of their hair and faces in a style clearly influenced by Beardsley. The music itself betrayed strong hallucinogenic qualities, the surreal imagery of *Eleanor Rigby*, the visual sound effects of *Yellow Submarine* and *Tomorrow Never Knows* with its appeal to 'listen to the colour of your dreams' evoked a curious combination of *faux-naif* romanticism and exploration of the subconscious.

Beardsley's influence was not confined to the world of rock music. Early in 1967 the graphic designer Paul Christodoulou designed a poster for Elliott's shoes which made direct references to Beardsley's work. Liberty's of Regent Street revived its collection of Art Nouveau printed fabrics and wallpapers, while Barbara Hulanicki and Stephen Fitzsimon's shop Biba in Kensington Church Street featured a stylish Art Nouveau logo and a décor of reproduction *fin-de-siècle* furniture and Beardsley prints. By mid 1967 Art Nouveau whirls and swirls were adorning a myriad of consumer goods as lowly as the humble carrier bag.

The striking beauty and haunting decadence of Mucha's posters and Beardsley's illustrations gained a special cultural and political

significance within the rock underground which, by late 1966, was developing a distinct form of graphic expression. Poster art and album cover design were beginning to provide a solution to the dilemma of the creation of an authentic underground style. The foremost exponents of this new underground poster art were a pair of artists and musicians. Michael English and Nigel Weymouth, who worked together under the name of Hapshash and the Coloured Coat, a title which evoked images of Gustav Klimt's *The Kiss* viewed through a haze of hashish smoke.

English had been a student at Ealing College of Art and Weymouth owned the shop Granny Takes a Trip. English first encountered Weymouth in December 1966 while the latter was painting the front of the shop and by March 1967 they had joined forces to design posters which aimed, as the contemporary phrase went, at 'turning people on'. Hapshash were fascinated by Mucha and Beardsley, not forgetting the rather sinister visions of the *fin-de-siècle* fairy tale illustrator Arthur Rackham. One thing they despised was rational Modernism; as English once said: 'We believed and adopted anything that contradicted the rational world. Our science was rooted in alchemy and black magic. Sexuality was a strong force . . . Dragons and pubic hair!'

Most of Hapshash's posters promoted the 'happenings' at the UFO and Middle Earth clubs in London. Superficially, at least, they were intended to advertise the new breed of psychedelic bands like Pink Floyd, The Soft Machine, Tomorrow and the Crazy World of Arthur Brown, but unlike conventional advertising, the beautiful, colourful posters had a secondary, culturally subversive intent. As George Melly pointed out, Hapshash and the Coloured Coat were not concerned with 'imposing their image on a product'. Their main aim was mind expansion and hallucination 'at the service of the destruction of the non-hip and the substitution of "love", in that special, rather nebulous, meaning that the word holds for the Underground.' True hippies of the late 1960s, Hapshash believed that a combination of 'Love', LSD, psychedelic rock, lightshows and hallucinogenic graphics could change the world by 'freaking out' 'straight' consciousness.

Like their contemporaries in San Francisco who shared their intentions, Hapshash and the Coloured Coat employed meticulous craft techniques in producing their posters. All their work was silk screened, the artwork for each colour being transferred onto its own individual screen before the elements of the final image were married together in the actual process of printing. Hapshash developed their

own technique of pulling two or three colours on to the screen and merging them together as the squeegee was pulled across. Unlike their late-nineteenth-century forebears, they avoided black and white or pastel hues in favour of metallic inks and vivid fluorescent day-glo colours. Despite their indebtedness to Mucha and Beardsley, Hapshash was not averse to an eclectic pillaging of others' imagery. 'Hapshash posters are almost a collage of other men's hard won visions,' wrote Melly, 'Mucha, Ernst, William Blake, comic books everything is boiled down to make a visionary and hallucinatory *bouillabaisse*.'

Martin Sharp is another Art Nouveau-influenced poster artist closely associated with the underground and psychedelic rock. He became art editor of the underground magazine *OZ* after arriving in London from Sydney, Australia, in 1966. Throughout 1967 *OZ* featured examples of his sumptuously decorative work, including a hallucinatory *Mr Tambourine Man* illustration of Bob Dylan on the cover of *OZ 7* and a free poster of the great rock guitarist, Jimi Hendrix, trembling and exploding in a cloudburst of fluorescent colours and sexual energy. Sharp was one of the first underground poster artists to design record covers for the new rock audience. His vivid, day-glo sleeve for Cream's *Disraeli Gears* (created in collaboration with the photographer Bob Whitaker), features several motifs related to Art Nouveau, including peacocks, rococo scrolls, luxuriant flowerheads and a postcard of a *fin-de-siècle* Pre-Raphaelite beauty. Sharp's cover for Cream's 1968 double LP *Wheels of Fire* features similar swirling motifs printed in black on a silver metallic ground.

Flowing colours, organic curving lines, elaborate symmetries and gnomic mystical symbols appear on several other British album covers of the late 1960s, including The Rolling Stones' *Their Satanic Majesties Request*, The Jimi Hendrix Experience's *Axis Bold as Love*, The Incredible String Band's *5000 Spirits or the Layers of an Onion* and Donovan's *Gift From a Flower to a Garden*.

The Beatles had been the first pop group to use Art Nouveau styles to signify their transition from the world of show business to a romantic bohemia of mysticism, drugs and 'progressive' artistic expression, and they continued to promote the style throughout the late 1960s. Alan Aldridge, who was made art director at Penguin Books in 1966, created an eclectic mix of images from sources as diverse as Art Nouveau, Walt Disney, 1930s children's comics and 1950s Americana in his illustrations and lettering for *The Beatles Illustrated Lyrics*, which appeared in 1969.

As pop posters became art objects, the Beatles commissioned a major series of Art Nouveau-influenced posters by the American photographer Richard Avedon. These became available in Britain in 1967, marketed through a special offer in *The Daily Express*!

Individual members of the Beatles shared their designers' enthusiasm for Art Nouveau and several of them purchased some important examples of decorative art dating from the turn of the century. Paul McCartney's taste for the style strongly influenced *The Yellow Submarine* (1968), a feature-length animated fairy tale cartoon and the group's final expression of childlike 'love and peace'. The film was created by using over five million separate sketches based on the artwork of poster artist Heinz Edelman and reflected most of the visual styles which were popular in the late 1960s. As one American critic summed up after the film's American première, *The Yellow Submarine* was a mixture of 'Art Nouveau, Psychedelia, Op and Pop, Dada and Surrealism, Hieronymous Bosch and just plain bosh.'

Another group of artists and designers loosely influenced by *fin-de-siècle* styles were Simon Posthuma, Marijke Koger, Josje Leeger and Barrie Finch, known collectively as The Fool. They designed expensive but extremely colourful, vibrant and flowing designer clothes for the Beatles and those wealthy enough to be able to shop at the Beatles' Baker Street boutique. Like some late nineteenth-century designers and most of the leading psychedelic poster artists, they distrusted mass production and created most of their work by hand. The Fool also painted the huge swirling psychedelic mural which adorned Apple Corps, the Beatles ill-fated headquarters on the corner of Baker Street and Paddington Street (much to the chagrin of the local residents who campaigned to have it removed on the grounds that it 'lowered the tone of the area'!).

As one might expect in a country as large and culturally diverse as the United States, the 1960s Art Nouveau revival assumed distinctly different forms on the West and East Coasts. The West Coast Art Nouveau revival was inextricably linked to the hippy counterculture's resistance to the modernizing, rational, bureaucratic tendencies of what the sociologist C. Wright Mills termed the 'military-industrial complex'. By the early 1960s the Bauhaus Modernism of Le Corbusier and Mies van der Rohe had become virtually synonymous with the power of central government and the multinational corporation. The romantic, irrational *fin-de-siècle* decorative arts were an obvious source of stylistic resistance and countercultural identity.

By the late 1950s San Francisco had America's most self-conscious bohemia, a community of beat poets, jazz and folk musicians, pain-

ters and sculptors and creative craftsmen and women of all sorts. At first these bohemian romantics rejected pop music, associating it with the mindless crass materialism of Middle America, but the Beatles' abandonment of pop and embrace of electronic transcendentalism in 1966 had deep repercussions in the Bay Area.

As LSD became widely available in San Francisco from early 1965 onwards, groups of artists and students began to form electronic 'acid' folk-rock bands. One of the first of these, The Charlatans, was formed by George Hunter, an artist who had been studying electronic music at San Francisco State University. Hunter, a devotee of Maxfield Parrish, the lyrical American illustrator who was strongly influenced by Art Nouveau, took scores of publicity stills of The Charlatans dressed in Victorian and Edwardian Wild West costumes as they posed on the elaborately carved porches of late-nineteenth-century San Francisco town houses. The swirling lettering of these early posters displays very obvious Art Nouveau influence.

By 1966 the Avalon Ballroom and the Fillmore West were hosting regular dance-concerts featuring California acid-rock bands like the Grateful Dead, the Jefferson Airplane, Quicksilver Messenger Service and Big Brother & the Holding Company. The promoters, The Family Dog and Bill Graham, commissioned young poster artists to advertise these events. The artists included Wes Wilson, Alton Kelly and Stanley 'Mouse' Miller (known collectively as Mouse Studios), Victor Moscoso, Rick Griffin and Bob Schnepf. As the poster artists shared the same musical tastes, lifestyle and narcotic preferences as their audiences, normal advertising considerations were abandoned. Because the lettering was so deeply integrated into the overall design, many of the best San Francisco rock posters are virtually impossible to read. This presented no problem to the initiated, however, because they responded to the Dionysiac, ecstatic, writhing visual trip the posters provided.

Ignoring the ascetic primary colours demanded by Modernist design, the San Francisco poster artists drew most of the inspiration from the flowing arabesques of Art Nouveau. Bob Schnepf and Mouse Studios often quoted directly from the work of Mucha, while Mouse Studios' celebrated *Skeleton and Roses* design for the Grateful Dead was borrowed from the macabre imagery of the English *fin-de-siècle* artist E. J. Sullivan's illustrations to *The Rubáiyát*.

Deft use of colour and shape enabled the poster artists to create abstract surface patterns similar to those found in the work of Gustav Klimt and Aubrey Beardsley's American disciple, Will Bradley. The characteristic languor of the original was often replaced by a fluores-

cent explosion of visual energy intended for street consumption.

Rick Griffin, whose publishing company Berkeley Bonapart supplied psychedelic graphics and lithographs, was also strongly influenced by Maxfield Parrish and Will Bradley. His posters of the late 1960s for bands like the Grateful Dead, the Doors and Captain Beefheart & the Magic Band brim with macabre images of skulls, snakes, bats and beetles which writhe and merge in combination with vibrant, convoluted and often deliberately indecipherable lettering.

Like most of his San Franciscan contemporaries and Hapshash and the Coloured Coat in London, Griffin insisted on a painstaking process of hand colour separation in the creation of his work. Instead of making a full colour piece of artwork to be colour separated photographically, Griffin produced a separate piece of artwork for *each* colour on a plate which was then registered by hand. The colours were then lithographed one on top of the other, from light to dark, to produce full-colour finished posters of exceptional quality and vibrancy.

Several of the San Francisco poster artists incorporated similar Art Nouveau imagery into the record sleeves they designed. Most of the best examples of this imagery are on sleeves designed for the Grateful Dead, for example, Griffin's *Aoxomoxoa* (1969), Mouse Studios' *Skeleton and Roses* (1971) and their appropriately beautiful sleeve for *American Beauty* (1971).

While the San Francisco rock posters were not so much a means of broadcasting information as a way of advertising membership of the psychedelic community, the Art Nouveau influenced posters produced on the East Coast were more firmly rooted in commercial considerations. Most of the major exhibitions of *fin-de-siècle* decorative art appeared first at the Museum of Modern Art in New York City, including the major 'Art Nouveau: Art & Design at the Turn of the Century' which included examples of the entire spectrum of late nineteenth- and early twentieth-century decorative arts, and the 1967 Aubrey Beardsley exhibition.

Beardsley's influence looms large in the work of Peter Max, who created a distinctive style, combining the visions of psychedelia with the graphic discipline of Beardsley and Will Bradley. Max's work was far more accessible to the 'straight' public than the posters of his West Coast contemporaries and he did not confine himself to promoting the activities of the counterculture. Although the aesthetic forms of his posters took prominence over the ideas which first sustained them, his *chic* work of the late 1960s was in great demand from

businesses eager to tap a market of rock-oriented, but affluent young consumers. Similar tendencies can be seen in the advertising graphics of Robert Alcorn, whose late 1960s advertisements for Pepsi Cola were directly influenced by his contact with European Art Nouveau.

In New York City, psychedelic art was organized, tamed and normalized by Push Pin Studios, founded by Milton Glaser and Seymour Chwast. During the late 1960s Push Pin served as a commercial outlet for the latest trends in pop culture. Although Push Pin's posters used heightened colour and imagery derived from Art Nouveau, their primary purpose was always to sell a product rather than express countercultural membership or anti-establishment political preferences. Milton Glaser's elegant poster of Bob Dylan for CBS Records shared the underground poster artists' obsession with swirls of long, flowing hair but skilfully exploited its symbolic connotations to attract the rock generation to the products of American business.

The decadent, erotic motifs of Symbolist art and the organic, flowing lines of Art Nouveau continued to influence poster art and album cover design throughout the late 1960s and early 1970s. Bob Seidemann's notorious sleeve for Blind Faith (1969), for example, created a furore by showing a pubescent girl with Pre-Raphaelite hair holding a phallic, aircraft-like object. Some of the work of Storm Thorgerson and Aubrey Powell, who formed Hipgnosis in 1968, reveals strong Symbolist imagery. Their cover for Led Zeppelin's *Houses of the Holy* (1973), for example, features a group of mysterious, long-haired children in postures of wonderment or adoration. Roger Dean's lettering and typography for Yes' *Tales From Topographic Oceans* (1973) is indebted to Art Nouveau and Symbolism.

Elsewhere in Europe designers evolved styles which often derived from their own indigenous Art Nouveau traditions. The French illustrator and graphic designer Philippe Druillet, for example, designed a poster for Jean Rollin's film *Le frisson des vampires* (1971) with violent effects and decadent sexual imagery deriving from a French tradition encompassing Art Nouveau and Surrealism. His illustrations to *Les 6 voyages de Lone Sloane* (1972) bear strong resemblances to the posters of Mucha and the jewellery of Lalique.

Apart from its graphics, pop culture did not produce any great quantity of applied art. Its credo was too anti-materialist for it to produce much furniture, metalwork, glassware or china. The classic pop décor consisted of detritus from consumer society. Items such as bumpers from Volkswagen 'Beetles' and US mail-boxes were featured

in the typical pop interior, combining humour with the surprise of the displaced object to achieve the total effect, in the same way that Andy Warhol's *Campbell's Soup Can* made its impact in the realm of the fine arts. Occasionally, pop artists made objects which evoked Art Nouveau, but the affinities were generally on an iconographic rather than a stylistic level. For instance, the chairs and tables made by the British artist Allen Jones in 1969, which were in the form of fibre-glass figures of girls dressed in salacious costumes and supporting the chair seat or table top, immediately recall the furniture made by François Rupert Carabin during the 1890s.

The moulded fibre-glass of Jones's furniture hardly attained to the level of craftsmanship which characterizes the carved wood of pieces by Carabin. Furniture by Peter Danko, however, was exquisitely crafted and, like Jones's, featured human limbs, though presented with less sleaziness. Danko, who started working in Washington D.C. during the late 1960s, was one of a group of American furniture makers working in a consciously revived Art Nouveau style. Like many of the Art Nouveau craftsmen of the 1890s, they were influenced by Ruskin's writings. His tendency to place art and craft in the context of social economy appealed to those American artists who sympathized enough with the ideals of pop culture to resent industrial processes. As well as Danko there was Wendell Castle, Michael Coffey and Roy Superior who all made carved wooden furniture in an Art Nouveau style.

The English furniture-maker John Makepeace shared with these American craftsmen their respect for the properties of wood. Makepeace has written that he designed a particular stool 'to give expression to the sensuous nature of yew wood', and both Castle and Coffey have developed techniques of allowing for shrinkage and expansion in the woods they use for their furniture. This acknowledgement of the life-forces in nature further aligns these craftsmen with their Art Nouveau ancestors.

A movement similar to that which occurred in the field of furniture developed in American glassmaking. During the 1960s, Harvey Littleton and Dominick Labino experimented with free-form glass vessels which were organic in shape and recalled the Art Nouveau glass of Tiffany and Loetz. They also investigated the full range of effects that had been developed at the Tiffany Studios, such as lustre and internal decoration. Another American glassmaker, Dale Chihuly, created several pieces which are particularly evocative of Art Nouveau. For instance, he made flasks with long writhing necks which look like variations – or rather, jazz improvisations – on the

theme of Tiffany's goose-neck vases. The association of this school of glass artists with pop culture was reinforced in the second half of the 1960s when two of Littleton's students, Marvin Lipofsky and Sam Herman, started teaching at the University of California in Berkeley and the Royal College of Art in London respectively. At both these locations, there have emerged numerous glassmakers whose work owes much to Art Nouveau antecedents, both in style and technique.

'In matters of great importance, style, not sincerity, is the vital thing,' says one of the characters in Oscar Wilde's *The Importance of Being Earnest*. The line was quoted by Lisa Phillips at the head of her essay on American design since 1975 which appeared in the book *High Styles: Twentieth-Century American Design* published in connection with the exhibition of the same name held at the Whitney Museum, New York, in the winter of 1985-86. It was an apt quotation. The supremacy that style was in the process of assuming in 1895, when Wilde wrote the play, has perhaps only been matched since by the significance attached to it during the 1970s and 1980s. One of the 'matters of great importance' which today is indicated by style is financial prosperity. Wilde, however, was referring to style as a way of life rather than as an indicator of wealth. For Wilde, to have style meant to recognize the superiority of aesthetic judgement over moral judgements.

The power of style to enhance the quality of life lay at the core of the beliefs and ideals of the leading Art Nouveau designers and artists. Today, though everyone recognizes the economic role of style, vital to both consumer and producer, there is much less certainty about which style. The irony is that in this era when style has been almost deified, the styles used are numerous and mostly borrowed from the past. We congratulate ourselves on our open-mindedness and call it 'pluralism', thus associating this attitude to style with such concepts as democratic government and freedom of choice. But it is virtually the same attitude which we call 'eclecticism' when we talk about nineteenth-century architecture and design. The difference is that now the repertoire of styles available to the designer includes Art Nouveau, Art Deco and Modernism, in addition to Gothic and all the varieties of Classicism.

For a brief period during the 1960s and early 1970s it seemed that neo-Art Nouveau was to become the prevalent style in western design, rather as a hundred years before neo-Gothic had dominated the decorative arts before giving way to eclecticism. In the Sixties images of Art Nouveau became familiar to everyone through illustrations in the many books about the style that were published, some of

them in conjunction with major exhibitions. The Museum of Modern Art, New York, published *Art Nouveau: Art and Design at the Turn of the Century* by Peter Selz and Mildred Constantine in conjunction with its 1959 exhibition, and the same year *Jugendstil, der Weg ins 20. Jahrhundert* (Jugendstil, the Way into the Twentieth Century), edited by Helmut Seling, was published in Heidelberg, Germany. Sir Nikolaus Pevsner's *Pioneers of Modern Design*, which had originally appeared in 1936, was reissued in 1960 and over the next twenty years the book was reprinted ten times. Another volume which was to run into several editions, *Art Nouveau – Jugendstil* by Robert Schmutzler, was published in 1962. Two years later *L'Objet 1900* (The 1900 Object) by Maurice Rheims appeared in Paris and Italo Cremona's *Il Tempo dell' Art Nouveau* (The Age of Art Nouveau) was published in Florence. In 1965, another work by Maurice Rheims, *L'Art 1900 ou le style Jules Verne* (published in English as *The Age of Art Nouveau*), Roger-Henri Guerrand's *L'Art Nouveau en Europe* (Art Nouveau in Europe) were published in Paris, and *Kunsthandwerk um 1900* (Handicraft around 1900), edited by Gerhard Bott, was issued in conjunction with an important exhibition of Art Nouveau held in Darmstadt. During 1966, *Art Nouveau* by Mario Amaya was published in London and New York, and *Il Liberty* by Renato Barilli in Milan. In conjunction with a big exhibition held in Ostend, *Europe 1900* was published in 1967, and the following year Martin Battersby's *The World of Art Nouveau* appeared in New York. 'The flood of new books [on Art Nouveau] is not yet subsiding,' wrote Pevsner in the 1968 edition of *Pioneers of Modern Design*, and during the 1970s the flood became an ocean.

Some of these books were specialist volumes aimed at the *cognoscenti*, but most were pitched at a more popular level. Amaya's and Battersby's, for instance, were both issued as paperbacks within a year of their first publication and were widely distributed throughout the English-speaking world. Nikolaus Pevsner's *Pioneers of the Modern Movement* has probably been the best-selling book which deals with Art Nouveau, but it might also be claimed to have been the most misleading. Pevsner treated the style as merely a staging-post on the route that led 'from William Morris to Walter Gropius'; he claimed that Art Nouveau was ' "Transitional" between Historicism and the Modern Movement'. Illustrations were selected which supported this view, and they were limited in number. It was left to Maurice Rheims in *The Age of Art Nouveau* to describe and illustrate some of the more significant aspects of the style, such as its relationship to contemporary biology and its references to sexuality. He

acknowledged that 'Art Nouveau has the honour, particularly in the architectural realm, of having been the first movement to recognize the demands of the modern world'; but he added: 'Moreover, it was also the first to participate in Freud's clarification of human issues and, by purging the symbols of art of their outmoded elements, to strip the mask from the human face to reveal its naked anxiety.' It is not surprising, then, to find Rheims dedicating his study of Art Nouveau to the leader of the Surrealists, André Breton, who regarded the function of art to be the revelation of hidden desires. Compared to Pevsner's forty to fifty illustrations of Art Nouveau buildings and objects, Rheims's book carried nearly six hundred photographs and has provided architects and designers ever since its publication with a wealth of source material.

With all this exposure to Art Nouveau, the images of such masterpieces of the style as Hoffmann's furniture, Guimard's entrances to the Paris Métro and Mucha's posters became as much a part of western society's visual heritage as the Colosseum or the Mona Lisa. Such images were instantly recognizable and carried an accepted message. As we have seen, following the Beardsley exhibition in London and New York, Beardsley-style graphics became identifiable with the more permissive attitude to sexual behaviour which had been gaining ground during the 1960s. Another example of the Art Nouveau style meeting with a ready response was the Charles Rennie Mackintosh exhibition, held in 1968 at the Victoria and Albert Museum in London. The clean, geometrical shapes of the Scottish architect's furniture were greeted as images of hippy cool, and very soon the Italian firm Cassina were manufacturing reproductions. Following the Josef Hoffmann exhibition held at the Galerie Metropol, New York, 1981, Richard Meier designed a range of furniture for Knoll-International, based on Hoffmann's work, which was seen to represent the exclusive chic demanded by the style-conscious. The English firm Habitat recently introduced its 'Strasse' line of furniture, again imitating Hoffmann's designs.

There is a marked difference between the revival of Art Nouveau in the Sixties and the more recent imitations of the style. The sympathy felt for the idealistic rebellion of the Art Nouveau designers has been replaced by a recognition of the style's merely visual impact. The same recognition has been granted to Art Deco with the same lack of sympathy for, or even comprehension of, the style's original context. For example, the Paris firm of Ecart has reproduced pieces designed in the 1920s by René Herbst, Eileen Gray and Robert Mallet-Stevens. Similarly, Stanley Felderman's

Café du Triangle in Los Angeles, with its classical allusions, is as much a Post-modernist work as the Princes Square shopping mall in Glasgow, designed in an Art Nouveau manner by Dawson and Dawes.

So, the Post-modernists in their use of quotations from the styles of the past, have not spared Art Nouveau. There is now a danger that the spirit of Art Nouveau will be obscured by a thick fog of plagiarism and pastiche. The Post-modernist style, so carefully geared to the sanitized consumerism of the age we live in, is not likely to want to convey either the hidden forces of nature or people's subconscious fantasies.

There is one respect, however, in which artists and craftsmen of recent times have been inspired by a concept current among Art Nouveau designers at the turn of the century. As Lisa Phillips wrote in *High Styles*: 'It is understandable that architects and designers today would see Mackintosh, Hoffmann, Frank Lloyd Wright, and William Morris as their spiritual forbears, for these earlier architects were the first to explore the conjunction of art and craft and the notion of furniture as art.'

In the catalogue of the 'Scandinavian Modern: 1880-1980' exhibition held at the Cooper-Hewitt Museum, New York, in 1982, Jan-Lauritz Opstad made much the same point: 'Crafts of the 1970s have proven the futility of dividing applied arts and the fine arts into two separate fields.' This exhibition included some items which supported that contention and which at the same time strongly recalled the Art Nouveau style. There was, for instance, a Kosta glass bottle of 1974, designed by Sigurd Persson and engraved by Lisa Bauer with curling, writhing grasses. A silver teapot made by the Swedish craftsman Olle Ohlsson in 1977, the surface of its upper part manipulated into a rippling, organic texture, was reminiscent of work by the Jugendstil designers working in Munich at the turn of the century.

In the course of the twentieth century, the Art Nouveau style has appeared from time to time. Once the full-blown version which flourished at the turn of the century had disappeared, the style was not resuscitated until the 1930s, when it was cherished by a few as an antidote to the cold, mechanistic formality of the Modern Movement, and admired by the Surrealists for its imagery of repressed desires. During the 1940s and 1950s, organic Modernism often evoked the spirit of Art Nouveau as designers again turned to the natural sciences to provide them with shapes and patterns. In the 1960s the young, seeking release from the hidebound conventions of their elders and from the materialism of an increasingly affluent

society, rediscovered the liberating qualities of the Art Nouveau style. Now, as we approach the end of the twentieth century, can we expect another revival of the spirit, not just the form of Art Nouveau? Will this century end on the same note as the last? Will there be another *fin-de-siècle*?

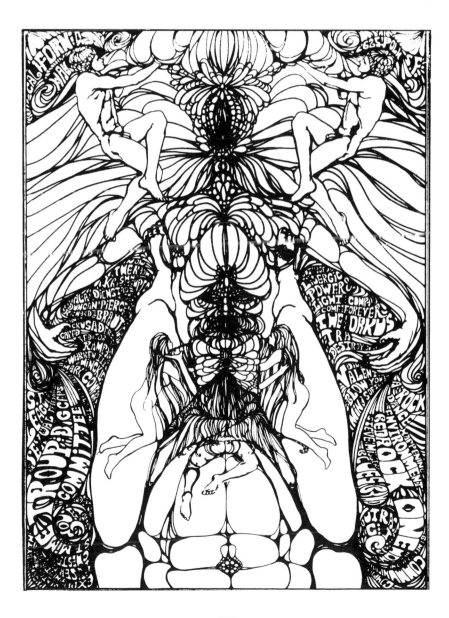

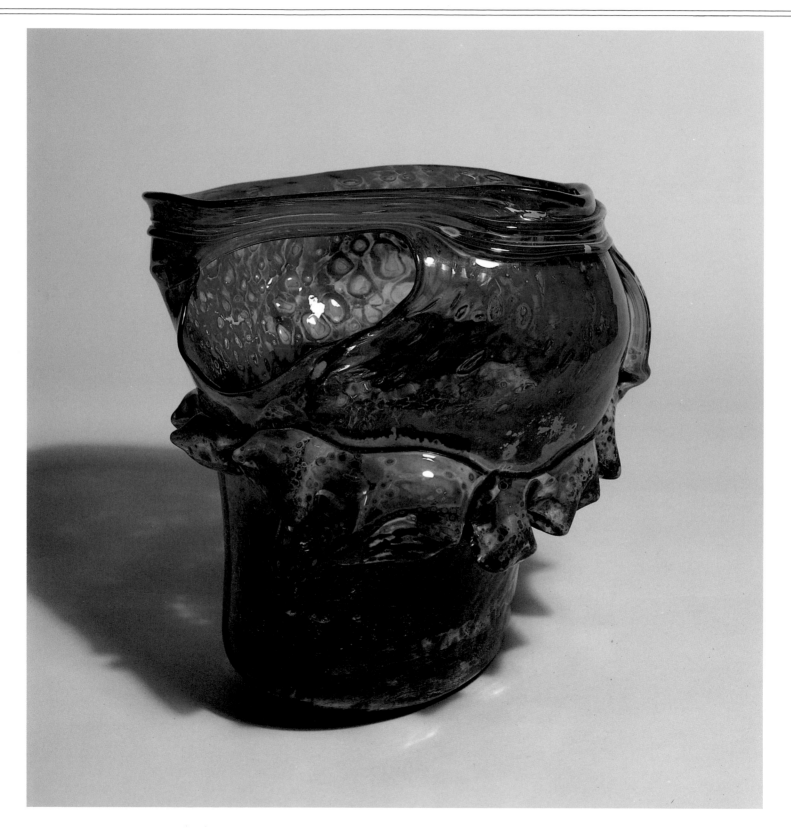

The glass artist Sam Herman was one of Harvey Littleton's students in America before coming to London where he made this blown sculptural form (*opposite*) in about 1965. Herman has been influenced by the free forms and intricate techniques of Art Nouveau glassmakers such as Louis Tiffany and Emile Gallé.

Trained as a potter in London, Ruth Duckworth crossed the Atlantic in the opposite direction to Sam Herman in 1964, when she started teaching in Chicago. Her textured, ash-glazed stoneware often recalls Art Nouveau ceramics (*right*).

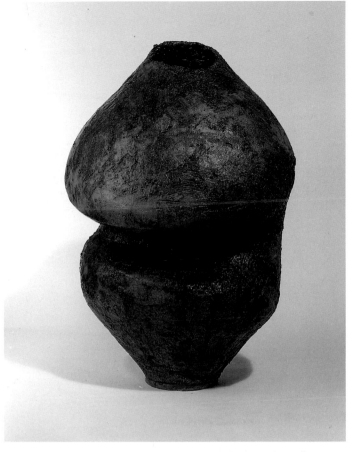

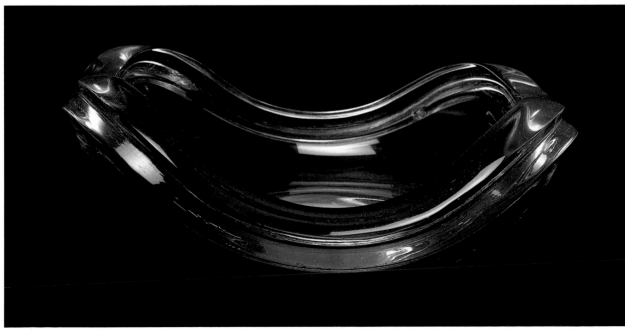

This fruit bowl of solid machined acrylic (*left*) was manufactured during the 1960s by the American company of Ritts. The decade saw a reappraisal of Art Nouveau in the United States in the wake of the important retrospective exhibition held at the Museum of Modern Art, New York, in 1959, entitled 'Art Nouveau, Art and Design at the Turn of the Century'.

The German firm of Rosenthal commissioned these sets of cutlery from Lino Sabattini (*left*) and Tapio Wirkkala (*below*), two designers who had been prominent in the heyday of the organic style, and who have continued to create forms that relate to Art Nouveau. Carlo Mollino designed this prototype cutlery for Reed and Barton in 1960 (*bottom*).

The English furniture-maker John Makepeace designed this ebony and nickel-silver chair in 1978. Its curved forms show a debt to Art Nouveau and the Gothic Revival.

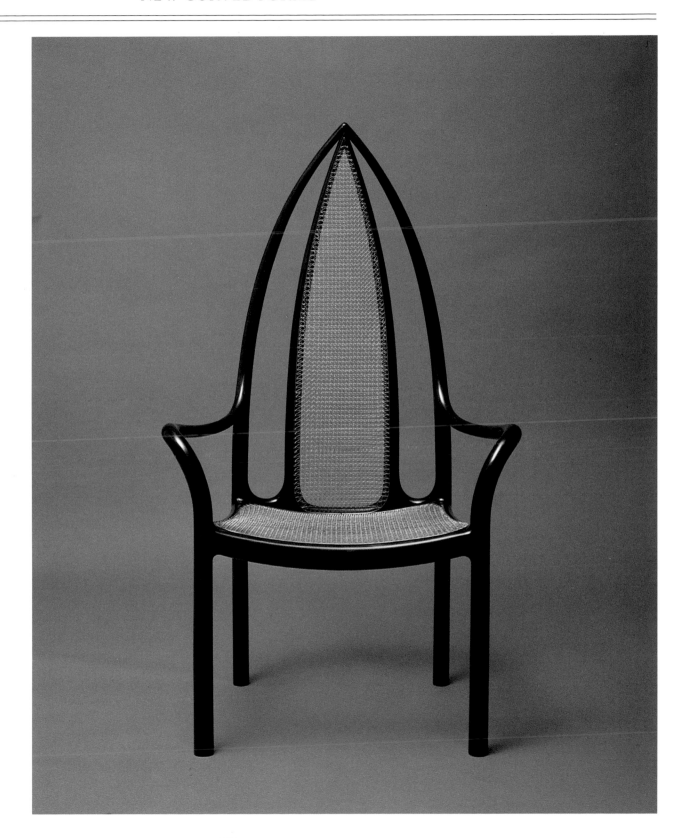

The anthropomorphic chair in fibre-glass, designed in the 1960s by Gunter Beltzig, is in a direct line of descent from the figural furniture made during the 1890s by François Rupert Carabin.

The American architect Frank O. Gehry designed this rocking chair (*opposite left below*) in 1972 for a range of furniture made of corrugated cardboard which he called 'Easy Edges'. The material was easily adapted to this elegantly curved form.
A polyester and fibre-glass chair (*opposite left above*) designed by Verner Panton, the Danish architect who worked with Arne Jacobsen during the early 1950s. The chair was manufactured by Herman Miller.
This aluminium and leather upholstered chair designed in 1988 by André Ozanne (*opposite right above*), recalls the furniture forms created by Antoni Gaudí.

French designer Pierre Paulin created this 'Ribbon' chair (*right*) in 1966. It was manufactured by the Dutch firm of Artifort.

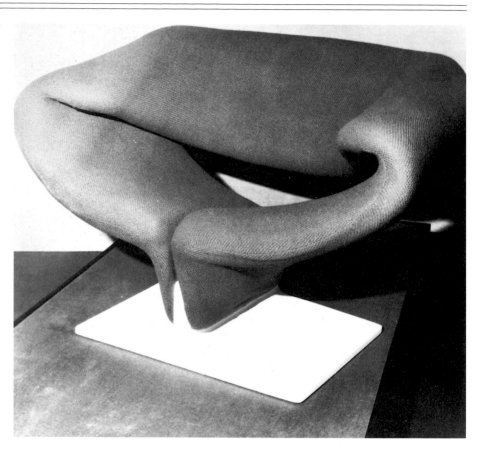

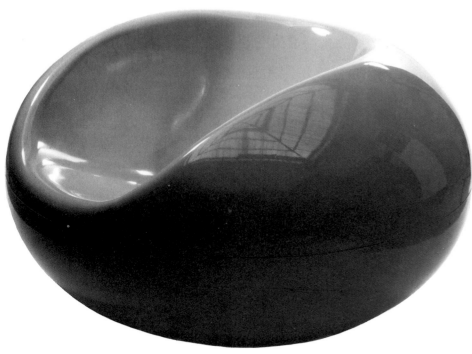

The 'Pastilli' chair in fibre-glass (*left*), designed in 1968 by Eero Aarnio, was a continuation of the biomorphic theme exploited in the 1950s but which had its origins in Art Nouveau.

Michael Coffey designed this desk and chair (*above*) which were made in the early 1970s at his workshops at Poultney, Vermont. The sweeping curves and low-relief decoration recall the furniture of Hector Guimard.

This laminated cherrywood settee (*right*) was designed and made in 1968 by Wendell Castle of Scottsville, New York. Castle's furniture is related to abstract Surrealism and emphasizes the movement's link with Art Nouveau.

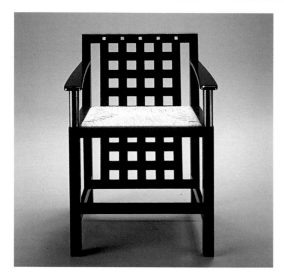

These chairs (*left above and below*) are reproductions of designs by Charles Rennie Mackintosh, which were manufactured from the 1960s by the Italian firm Cassina. They were made of ebonized ash rather than stained oak, the material of the originals.

The British furnishing store Habitat introduced the 'Strasse' line in 1985 (*below*). Many of the designs in the range are closely based on Art Nouveau models. The chairs here are derived from an original by the Austrian designer Josef Hoffmann.

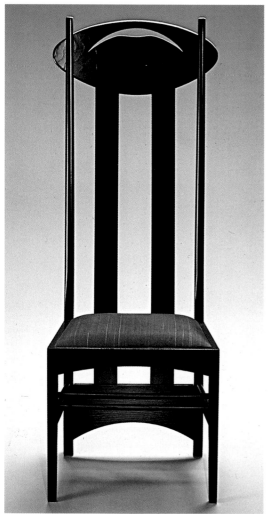

The Princes Square shopping development at 42 Buchanan Street, Glasgow, was opened in 1988. Here, within a stone's throw of some of C.R. Mackintosh's masterpieces, Alan Dawson and Brian Dawes have created a decorative scheme in a revived Art Nouveau style. Gates, railings, lighting fixtures, litter bins, phone boxes and even shoeshine stands have been consciously designed to evoke turn-of-the-century ornament.

Poster (*above*) designed by Peter Max for The Different Drummer shop in New York.

This poster (*left*), designed by Peter Max, features an economy of line reminiscent of Aubrey Beardsley's work. Max was one of a group of American artists and designers who, during the 1960s, created a graphic style derived from psychedelic visions and Art Nouveau.

Poster for Pan American Airlines by Peter Max (*right*).

Poster designed by Peter Max to advertise the United States National Book-Week in 1969; it is composed from areas of flat colour, as were many Art Nouveau posters based on Japanese woodblock prints.

John Alcorn, who designed this poster for Pepsi Cola, worked in the United States during the 1960s. When he stayed in Italy from 1970 to 1976, his style was affected by direct contact with European Art Nouveau.

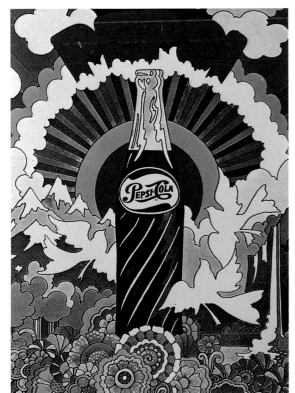

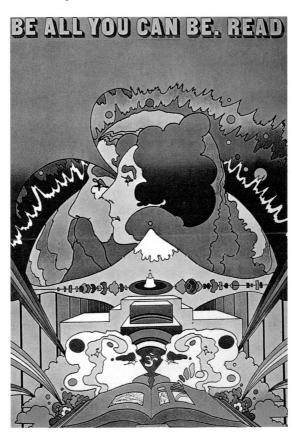

These posters for pop concerts at the Avalon Ballroom (*opposite*) in 1967 were designed by Victor Moscoso (*left*) and Bob Schnepf (*right*). With deft use of complementary colours and balanced shapes, both artists have created abstract surface patterns similar to those found in the work of Art Nouveau designers such as Gustav Klimt and Will Bradley. Schnepf's female figure framed by an arch is a direct reference to Alphonse Mucha's posters of Sarah Bernhardt.

Milton Glaser's poster of Bob Dylan (*below*), designed at the Push Pin Studios, and Bradbury Thompson's *Flower Child* (*right*), were both produced in the late 1960s and show how the artists of the hippy movement shared with their Art Nouveau precursors an obsession with hair. The figure in Thompson's poster – at once menacing and seductive – is particularly evocative of *fin-de-siècle* decadence.

Jacqui Morgan's poster for The Electric Circus of 1969 (*above*) features the woman-into-flower theme used a century earlier by G.F. Watts and Richard Wagner.

Victor Moscoso designed this poster for the Hawaii Pop Rock Festival (*left*) in 1967. The shapes of the lettering produce a pattern of abstract hieroglyphics.

Paul Christodoulou designed this poster for Elliott
Alice Boots in the wake of the Beardsley exhibition
held at the Victoria and Albert Museum, London,
during 1966. It contains numerous direct
quotations from Beardsley's work.

This poster of Stonehenge (*above*) designed by
Jimmy Cauty indicates the element of magic in hippy
culture and recalls work from the 1890s by some of
the Rose + Croix artists. This poster also shares
with some Art Nouveau designs of the turn of the
century a debt to Celtic art.

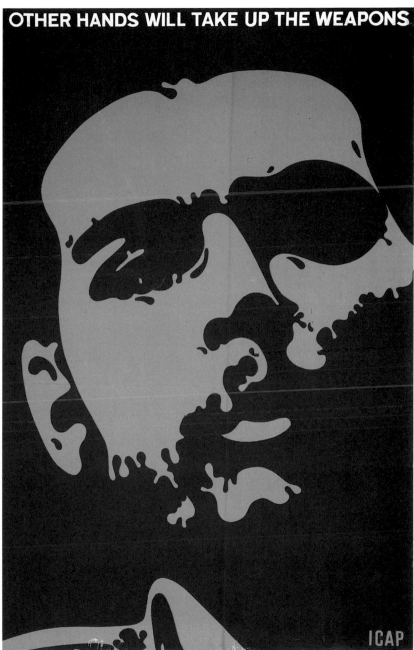

Poster for a production of *Medusa* in Mexico City (*opposite*) designed by Palladini in 1968; the subject, so dear to *fin-de-siècle* illustrators, has been treated by the artist in an appropriately Art Nouveau style.

Two posters from Cuba, one for a film (*left*), the other for political propaganda (*right*), show a kinship with the psychedelic art of the 1960s. The breaking up of the image into organic shapes which can be read as positive or negative was a feature of West Coast poster design.

This record sleeve for the pop group Cream's album 'Disraeli Gears' (*opposite*) features several motifs related to Art Nouveau, for example peacocks, rococo scrolls, luxuriant flowerheads and a postcard of a *fin-de-siècle* beauty posed *à la japonaise*. It was created by the Australian illustrator Martin Sharp working with the photographer Bob Whitaker.

In 1967 the British artists Michael English and Nigel Weymouth formed a partnership to produce graphic work for the pop music industry. Calling themselves 'Hapshash and the Coloured Coat' they designed posters and record sleeves in a style which drew heavily on Art Nouveau. These posters for The Who (*right*) and Island Records (*below*) date from the late 1960s.

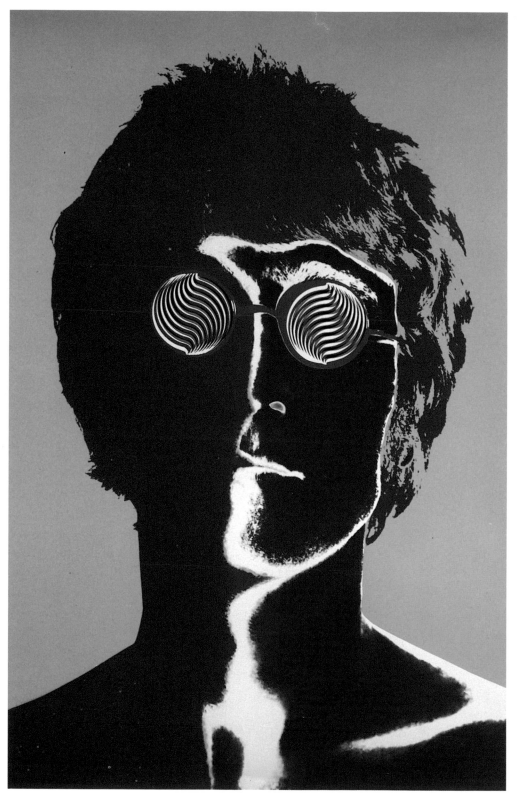

The Beatles inspired a wide range of graphic art in Britain during the 1960s, and many designs were influenced by Art Nouveau. The Beatles themselves shared the designers' enthusiasm for the style; Paul McCartney bought some important examples of decorative art dating from around 1900. The poster portrait of John Lennon (*opposite left*) was created by the photographer Richard Avedon in 1967. Alan Aldridge designed the cover of *The Beatles Illustrated Lyrics* published in 1969 (*opposite right above*). *The Yellow Submarine*, the animated film made by the Beatles in 1968, was designed by Heinz Edelman (*opposite right below*). The poster (*right*) was designed by Simon and Marijke (otherwise known as 'The Fool') for Apple, the trading company set up by the Beatles.

Philippe Druillet designed the poster (*right*) for
Jean Rollin's film *Le frisson des vampires* in 1971
and the illustration (*above*) to *Les 6 voyages de Lone
Sloane* of 1972. The violent effects and sexuality of
Druillet's art are derived from a French tradition
encompassing Art Nouveau and Surrealism.

The film *Barbarella*, directed by Roger Vadim, was released in 1968. 'Who nearly dies of pleasure?' asks the space nymph, to which she might well have had a response from the shades of *fin-de-siècle* writers like D'Annunzio and Huysmans whose books had helped to create the Art Nouveau style.

This card, *Red Madonna* (*above*), was designed about 1970 by Barbara Swiderska for Gallery Five of London. Apart from the hair, which has similarities to the tresses of Mucha's maidens, the identification of the female with flowers is a theme taken directly from the Art Nouveau of around 1900.

Biba grew from a mail order business started in 1964 by Barbara Hulanicki to be one of London's leading fashion stores. In the 1960s the graphic style used by the shop (*right*) was based on the variant of Art Nouveau which had been developed at Darmstadt during the early years of the century.

This poster was designed by Martin Battersby for the exhibition of his collection of Art Nouveau which was held in 1964 at the Brighton Museum. Other important exhibitions, including those devoted to Beardsley and to Mackintosh at the Victoria and Albert Museum, created the atmosphere for an Art Nouveau revival in Britain.

ACKNOWLEDGMENTS

Special Acknowledgments

The author thanks Julian Stallabrass, James Roberts and Alex Seago for their major contributions to Chapters 5, 6 and 7 respectively.

Illustration Credits

Photo ACL, Brussels 102 a;
Amsterdam, Rijksmuseum Vincent van Gogh 17;
Photo Annan, Glasgow 94 al&bl;
Artine Artinian Collection, Miami, Florida 161 r;
Athena International and Jimmy Cauty 209 r;
Atlanta, Georgia, Virginia Carroll Crawford Collection, Permanent Collection of the High Museum of Art 18;
K. Barlow Ltd, London 69, 87, 103 l, 106 b, 127 a&b;
Barsoti, Florence 61 l;
Bayreuther Festspiele Bildarchiv 36 a;
Photo Tim Benton 103 r;
Grace Borgenicht Gallery Inc, New York 165 l&ar;
Photo N. Borsje 70 l;
Brasilia, Alvariadi Palace 158
Galerie Brokstedt, Hamburg 126 cl;
The Brooklyn Museum 172;
Photo Will Brown 175 b, 199 b;
Photo Richard Bryant/Arcaid 67 r, 131 r;
Photo Bulloz 41;
Wendell Castle, Scotsville, New York 201 b;
Owen Cheatham Foundation, New York 164;
Chicago, Courtesy of the Art Institute of Chicago 153 r; Courtesy Chicago Historical Society 73 l&r;
Christie's, Amsterdam 162, 163 l&r;
Christie's, Geneva 166 a;
Christie's, New York 96 l;
Cobra and Bellamy, London 150 l&r;
Copenhagen, Museum of Decorative Arts 128 l;
Darmstadt, Hessisches Landesmuseum 12 a, 126 b;
Detroit, Courtesy of the Detroit Institute of Arts 24 r;
Dillenberg-Espinar Collection 117 r;
Edinburgh, Royal Commission of Historic Monuments (Scotland) 95 r;
Photo W. Feldstein Jr 68 a;
Photo Fulvio Ferrari 7 r;
Fischer Fine Art Ltd, London 13 r;
Photo Ferran Freixa 6 l;
Glasgow, Hunterian Art Gallery, University of Glasgow, Mackintosh Collection 2, 93;

Photo Ezio Godoli 61 r;
GRE Properties Ltd 203 l&r;
Peggy Guggenheim Foundation, Venice 9 al, 145 l, 149 al;
Calouste Gulbenkian Foundation, Lisbon 79;
Habitat 202 br;
Hamburg, Museum für Kunst und Gewerbe 122 bl;
Courtesy of David Hanks and Associates, New York 94 r;
Photo Fritz Hansen 177 al;
Collection of Marilyn and Wilbert Hasbrouck 105 br;
Helsinki, Museum of Finnish Art 107;
Photo Angelo Hornak 67 l, 92 l&r;
Photo Etienne Hubert, Paris 59 ar;
Formerly Edward James Foundation, Sussex 153 l;
Vladimir Kagan 170 b;
The Kay Collection 11 al;
Krefeld, Kaiser Wilhelm Museum 120 r;
London, British Library 23; British Museum 47, National Film Archive 140 l&mr&br; Tate Gallery 26 bl; Victoria and Albert Museum 13 l, 26 al, 138, 200 a&b, 210;
Nancy Lott 58 r;
Photo Luceblu 6 r;
John Makepeace 197;
Manchester, City Art Galleries 31 l;
The Manney Collection 72l;
N. Manoukian, Paris 100 l;
Veronica Manoussis/John Kaine 195 b;
Bildarchiv Foto Marburg 57;
Collection Félix Marcilhac, Paris 75 r;
Photo Mas, Barcelona 19, 64 l, ar&br;
Photo MID 1988 196 l;
Herman Miller Inc, Michigan 175 a;
Herman Miller Ltd, London 173 l;
Photo Studio Minders 102 b;
Minnesota Historical Society Collections, St Paul, Minnesota 98 bl;
Collection of the Charles Hosmer Morse Museum of American Art, Winter Park, Florida. Photo Theodore Flagg 43;
Jacques Nestgeu, Paris 63 b;
New York, Collection of Cooper-Hewitt Museum, the Smithsonian Institution's National Museum of Design, Gift of Marcia and William Goodman 74 l; Solomon R. Guggenheim Museum 149 bl, 165 br; Macklowe Gallery 8 l, 70 r, 76, 77 al, 126; Collection of the Metropolitan Museum of Fine Arts (Purchase, Edgar J. Kaufman Foundation and Edward C. Moore Jr, Gifts 1967) 97 ar, (Gift of Cyril Farny in memory of Phyllis Holt, 1976) 106 a; Museum of Modern Art 12 br, 59 br, 142 l, 156, 208 l (Mrs Simon P. Guggenheim Fund) 144 l;
Richard Nickel 82;
Norwich, Anderson Collection of Art Nouveau, Sainsbury Centre for Visual Arts. University of East

Anglia 55, 126 a;
Oslo, Munch Museet 24 al;
Otterlo, Rijksmuseum Kröller-Müller Museum 24 bl;
Oxford, Bodleian Library 83 ar&br;
André Ozanne 199 ar;
Paris, Librarie Documents 121 r; Musée des Arts Décoratifs 34 l&r, 41, (Photo L. Sully-Jaulmes) 11 ar, 15 r, 27 l&r, 54, 71 l&r, 116 l&r, 117 l;
Perls Galleries, New York 146 l;
Photo Giorgio Pezzato 81 r, 101 l;
Phillips, London 33 l&r;
Phillips, New York 98 al;
Piccadilly Gallery, London 40 l;
Port Sunlight, Lady Lever Art Gallery 31 r;
Poster Prints Conshohocken, Pennsylvania 208 r;
Print Mint, California 206 l;
Private Collections 10 l&r, 12 bl, 14 c&l, 20, 32 l&r, 46, 77 ar, 78 a, 97, 117 c, 128 r, 144 r, 145 r, 149 r, 151 l, 152 al&bl, 161 l, 166 b, 167, 168, 169 r, 170 a, 171, 174, 176, 194, 195 a, 198, 201 l, 204 l&r, 207 l, 212 l&r, 214 l&ar, 215, 217, 218 l&r&c, (Photo Courtesy Christie's, New York) 96 br;
Private Collection, London 144 r;
Photo Race Ltd, a member of the Alcocks Laird Group 173 r;
Rhode Island Museum of Art, School of Design 36 b;
Photo François René Roland 7 l, 65;
Collection Christian Sapet, Paris 77 br;
Collection Oskar R. Schlag, Zurich 146 r;
Schleswig Holsteinisches Landesmuseum 38 l;
Louis Schnakenburg 177 bl;
Photo Ira Simon 68 r;
Solingen, Deutsches Klingenmuseum 118 l&r, 119 l&c&r;
Sotheby's, London 101 r, 105 l, 124 l, 151 r, 152 r;
Photo Dr Franz Stoedtner 56, 130;
Photo Tim Street-Porter/Downtown, New York 169 l;
Tokyo, University of Fine Arts 26 r;
Trondheim, Nordenfjeldske Kunstindustrimuseum 125 l&r;
Vienna, Österreichische Galerie 100 r; Österreichisches Museum für angewandte Kunst 99 br;
Virginia Museum of Fine Arts, Sydney and Frances Lewis Collection 98 r (Photograph by Katherine Wetzel) 11 ac&b, 14 l, 35, 72 r, 74 r, 75 l, 78 bl&br, 80 l&r, 104 al&ar&bl&br, 124 r;
Collection of Tod M. Volpe 105 ar;
Collection of Robert Walker 14 r, 40 r;
Walthamstow, William Morris Gallery 28 l&r, 30 l;
Zurich, Kunstgewerbe Museum 59 l, 60 r.

SELECT BIBLIOGRAPHY

Amaya, Mario *Pop as Art*, London, 1965

Bairati, Eleonora (et al) *La Belle Epoque*, New York, 1978

Barnicoat, John *Posters, a Concise History*, London, 1986

Barr, A.H., Jr (ed) *Fantastic Art, Dada and Surrealism*, New York, 1937

Becker, Vivienne *Art Nouveau Jewellery*, London, 1985

Bestetti, Carlo (ed) *New Forms in Italy*, Milan, 1962

Birkett, Jennifer *The Sins of the Fathers*, London, 1986

Bony, Anne *Les Années 50*, Paris, 1982

Booth-Clibborn, Edward, and Daniele Baroni *The Language of Graphics*, New York, 1974

Christoffersen, Agner *Applied Arts in Denmark*, Copenhagen, 1948

Dean, Roger (Hipgnosis) *Album Cover Album*, Limpsfield, 1977

Dijkstra, Bram *Idols of Perversity*, New York, 1986

Garner, Philippe *Contemporary Decorative Arts*, London, 1980

Gillon, Edmund V. *Art Nouveau: An Anthology of Design and Illustration*, New York, 1969

Greenberg, Cara *Mid-Century Modern*, New York, 1984

Grushkin, Paul D. *The Art of Rock, Posters from Presley to Punk*, New York, 1987

Hald, Arthur *Swedish Design*, Stockholm, 1958

Hillier, Bevis *The Decorative Arts of the Forties and Fifties*, New York, 1975

Johnson, Diane C. *American Art Nouveau*, New York, 1979

Krivine, John *Juke Box Saturday Night*, London, 1977

Lucie-Smith, Edward *Symbolist Art*, London, 1986

Madsen, Stephan Tschudi *Sources of Art Nouveau*, New York, 1976

Magee, Bryan *Aspects of Wagner*, Oxford, 1988

Nadeau, Maurice *The History of Surrealism*, Harmondsworth, 1973

Pevsner, Nikolaus *Pioneers of Modern Design*, Harmondsworth, 1960

Pevsner, Nikolaus *The Sources of Modern Architecture and Design*, London, 1968

Phillips, Lisa (ed) *High Styles*, New York, 1985

Schmutzler, Robert *Art Nouveau*, New York, 1962

Selz, Peter H., and Mildred Constantine *Art Nouveau, Art and Design at the Turn of the Century*, New York, 1975

Waddell, Roberta (ed) *The Art Nouveau Style*, New York, 1977

Waldberg, Patrick *Surrealism*, London, 1965

GALLERIES

Belgium
L'Ecuyer, 187-9 Avenue Louise, Brussels
Marc Heiremans, Galerij Novecento, 44A Kloosterstraat, Antwerp

France
Didier Lecointre, Denis Ozanne, 9 rue de Tournon, Paris
Galerie Jacques de Vos, 7 rue Bonaparte, Paris

Italy
Robertaebasta, 2 via Fiori Chiari, Galleria Strasburgo, Milan

United Kingdom
Editions Graphiques Gallery, 3 Clifford Street, London W1
John Jesse & Irina Laski, 160 Kensington Church Street, London
 W8
Pruskin Gallery, 73 Kensington Church Street, London W8
Themes & Variations, 231 Westbourne Grove, London W11

United States
Barry Friedman Ltd, 1117 Madison Avenue, New York, NY
Chuck & Rita's, 5515 Lankershim Boulevard, North Hollywood,
 California
Fifty/50, 793 Broadway, New York, NY
Mobili, 1812 Adamsmill Road, Washington DC
Postermat Gallery, 401 Columbus Avenue, San Francisco,
 California

W. Germany
Galerie 1900, 28 Milchstrasse, Hamburg
Pabst, 11 Stolbergstrasse, Munich

MUSEUMS

The following museums hold significant collections of twentieth-century applied art

Austria
Vienna: Österreichisches Museum für angewandte Kunst

France
Nancy: Musée de l'Ecole de Nancy
Paris: Musée des Arts Décoratifs
 Musée d'Orsay

The Netherlands
Amsterdam: Stedelijk Museum
Otterlo: Rijksmuseum Kröller-Müller

Norway
Trondheim: Nordenfjeldske Kunstindustrimuseum

Switzerland
Zurich: Kunstgewerbemuseum

United Kingdom
Brighton: Brighton Museum and Art Gallery
Glasgow: Hunterian Art Gallery
London: Victoria & Albert Museum

United States
New York: Cooper-Hewitt Museum
 Metropolitan Museum of Art
 Museum of Modern Art
Richmond, Va: Virginia Museum of Fine Arts

W. Germany
Berlin: Kunstgewerbemuseum
Darmstadt: Hessisches Landesmuseum
Munich: Stadtmuseum

INDEX